# SEA GIRT LIGHTHOUSE

## — THE —
## COMMUNITY
## BEACON

## BILL DUNN

Charleston London

THE
History
PRESS

Published by The History Press
Charleston, SC 29403
www.historypress.net

Color cover photos by Robert S. Varcoe; copyright © 2014 Robert S. Varcoe. Back cover
black-and-white photo courtesy of the Theodore Wilson family.

First published 2014

Manufactured in the United States

ISBN 978.1.62619.506.6

Library of Congress CIP data applied for.

# CONTENTS

# CREDITS

Many photos and some documents contained in this book are from the Sea Girt Lighthouse Collection and are identified as such. Photos and documents from other collections are identified by the name of the holding institution. Items from personal collections are indicated by the notation "Courtesy" followed by the name of the collector. The photographer of an image is identified when known. Photos by these photographers are copyrighted as follows: Copyright © 2014 Eric S. Martin; Copyright © 2014 Robert S. Varcoe.

# ACKNOWLEDGEMENTS

This book was written with the encouragement of fellow trustees of the Sea Girt Lighthouse Citizens Committee (SGLCC) Inc., the volunteer organization responsible for preserving the landmark and its history. All proceeds from the sale of this book will go to the committee's ongoing preservation efforts.

The lighthouse archives and exhibits provided a wealth of material gathered over decades. Numerous people provided additional historic details for this story. I thank them. They include: Commander Timothy R. Dring, U.S. Navy Reserve (retired), historian and author; Don Ferry, past president of the SGLCC; Dan Herzog, SGLCC member; Nancy MacInnes, SGLCC's first president; Robert McKelvey, SGLCC financial advisor and a founding trustee; the New Jersey Lighthouse Society; Barbara Reynolds, Squan Village Historical Society; Richard O. Venino, former SGLCC trustee and legal advisor; SGLCC head docent and former trustee Conrad Yauch; Mary Ware, Borough of Manasquan historian; Kraig Anderson of LighthouseFriends.com; James Claflin of Kenrick A. Claflin & Son; Henry Osmers, Montauk Historical Society; Friends of Absecon Lighthouse, especially Elinor Veit; R. Hugh Simmons of the Fort Delaware Society; Jeff Gales and Wayne Wheeler of the United States Lighthouse Society (www.uslhs.org); and Deborah Whitcraft of the New Jersey Maritime Museum. In Sea Girt, where I was given full access to Borough archives, I thank Mayor Ken Farrell and Councilwoman Anne Morris, as well as Justin Dooley, who retrieved the bound council minutes and photocopied many pages.

Special thanks to Christine Dunn, my wife and editor, herself a lighthouse docent and former trustee, who provided invaluable research help and a close reading and editing of the manuscript that improved it.

# CHAPTER 1

# BEGINNINGS: PHAROS TO SANDY HOOK

From the dawn of time, fishermen and mariners have put to sea, facing the constant risk of storms, shoals and shipwrecks. They navigated by stars and natural landmarks. And for more than two millennia, sailors have also scanned the coasts looking for lighthouses, man-made landmarks whose beacons guided them.

The first lighthouse is believed to have been Pharos, built in the third century BC on the small island of Pharos, in the harbor of Alexandria, Egypt. One of the Seven Wonders of the World, it stood some 450 feet tall. At the top was a curved mirror, probably polished bronze, to capture and project sunlight. At night, timber and other fuel, lifted up through a shaft, was set on fire. In daylight, the fire was extinguished. Smoke from the smoldering embers provided a signal, along with the reflected sunlight from the mirror.[1] Pharos stood for 1,500 years, surviving but weakened by earthquakes and invaders until the fourteenth century, when another earthquake brought it down.[2]

Pharos would become a synonym for "lighthouse." The oldest lighthouses in the British Isles were built by the Romans on the Cliffs of Dover in the first century AD; only one survives. The Romans also built La Coruña, known as Tower of Hercules, in the second century AD on Spain's northwest coast. La Coruña is the world's oldest active lighthouse.[3]

In America, Sandy Hook Lighthouse, built in New Jersey by New Yorkers and seized by the British, survived the Revolution and qualifies as the oldest U.S. lighthouse. The *New York Mercury* of June 18, 1764, reported its activation:

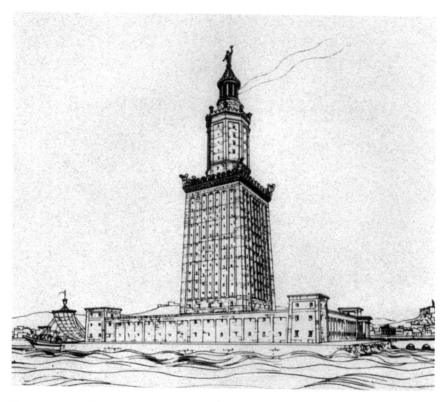

Pharos, the world's first lighthouse, was built in the third century BC in Alexandria, Egypt, and stood for centuries. *Drawing by Hermann Thiersch, 1909.*

*On Monday evening last* [June 11], *the NEW-YORK LIGHT HOUSE erected at Sandy Hook was lighted for the first time. The House is of an Octagonal Figure, having eight equal sides; the diameter at the base, 29 feet; and at the top of the wall, 15 Feet. The Lanthorn* [lantern house] *is 7 feet high; the circumference 33 feet. The whole construction of the Lanthorn is iron; the top covered with copper. The building from the surface is nine stories; the whole from bottom to top, 103 Feet.*

The lighthouse was proposed and promoted by merchants and manufacturers of New York City, who wanted a lighthouse at the entrance of the narrow and shallow Sandy Hook Channel to New York Harbor to protect their goods and minimize shipwrecks and loss of cargo.[4]

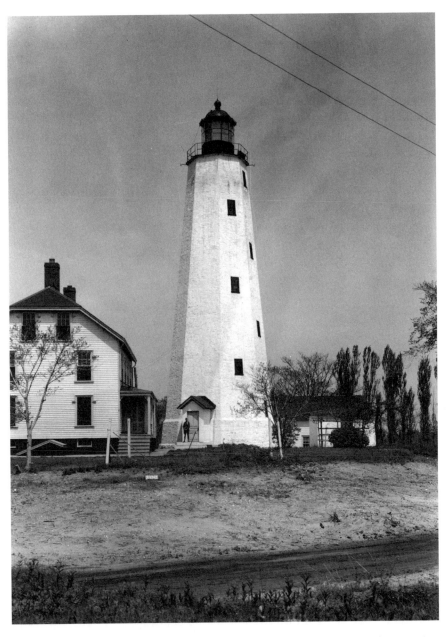

Sandy Hook Lighthouse, built in 1764, is America's oldest surviving light and is still active.
*Nathaniel R. Ewan, Historic American Buildings Survey, Library of Congress.*

# AMERICAN REVOLUTION

The American Revolution began with the Battle of Lexington and Concord on April 19, 1775. As the war spread, General Washington's Continental army and the British fought to control America's lighthouses. By March 1776, amid fears of a British invasion of New York City, the congress of New York ordered Major William Malcolm and his troops to extinguish the beacon and remove the lens from Sandy Hook.

By June 1776, British troops controlled Sandy Hook Lighthouse and had rigged a replacement lens to project a beacon to British ships. U.S. sailors under the command of Captain John Conover attempted to extinguish the light by bombarding the tower. Cannon balls did hit their mark but, thankfully for posterity, failed to destroy it. Sandy Hook Lighthouse survived the bombardment, although damage from direct hits can be seen today on the stone exterior.[5]

Boston Light, the first lighthouse in the American colonies, was built in 1716 on Little Brewster Island in outer Boston Harbor. British troops controlled the island until 1774. American troops attacked on July 20, 1775, setting fire to the wooden parts of the lighthouse. The British made repairs. On July 31, 1775, the Americans destroyed the repairs. The British remained another year. On June 13, 1776, the British fleet came under attack in Boston Harbor and withdrew. Before abandoning Little Brewster Island, British troops blew up Boston Light.[6]

Peace negotiations began in the spring of 1782. In a demonstration of resolve, the Massachusetts legislature appropriated £1,450 to build a new lighthouse of similar design on the exact spot of the original Boston Light, but this one would be fifteen feet taller, standing seventy-five feet. The Revolution ended on September 3, 1783, with the signing of the Treaty of Paris. The new Boston Light was activated that same year.

By the time the Constitution was signed in 1787, there were twelve lighthouses in the United States, including the rebuilt Boston Light and the other lights from colonial times that survived the Revolution. "No two were constructed from the same set of plans, and all were built from local materials. By examining the ones which remain, and the evidence of those which have not survived, reveals that these lighthouses shared some common features," writes Coast Guard historian Robert M. Browning Jr. in his work "Lighthouse Evolution & Typology." Browning continues, "All the early lighthouses were constructed of wood or stone. Those built of wood

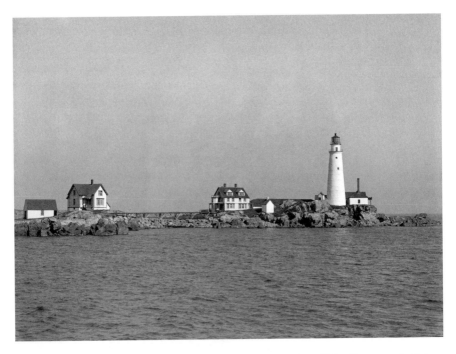

Boston Light—America's first—was destroyed in the Revolution. This taller tower, built in 1776 on the same spot, remains active. *Library of Congress.*

fell victim to fire sooner or later. The stone towers were built simply by piling one stone on top of another."[7] Most of the stone towers topped out at 90 feet, approaching the maximum practical height, according to Browning, although Sandy Hook reached 103 feet.

The original dozen lighthouses were all flashing their beacons at the birth of a new nation. Of the earliest lighthouses, only two still exist and remain active: Sandy Hook and the second Boston Light.

# PRESIDENT WASHINGTON FEDERALIZES LIGHTHOUSES

On April 30, 1789, General George Washington, standing on the balcony of Federal Hall on Wall Street in New York City, took the oath of office as the first president of the United States of America. The first Congress held

its first sessions at Federal Hall. President Washington, according to Coast Guard historian Robert Browning, "took an active interest in lighthouses."[8]

President Washington and the other founding fathers realized the vital importance of lighthouses not only to navigation but also to the security and the economic and population growth of a new nation. Initially, the president was actually involved in site selection for new lighthouses and approving contracts. On August 7, 1789, he signed the Ninth Act of the first Congress, creating the U.S. Light-House Establishment as the federal agency responsible for all U.S. lighthouses—existing, under construction and proposed—as well as their funding, staffing and daily operations. The establishment was the second agency created in the federal government. The legislation was titled "An Act for the Establishment and Support of Light-Houses, Beacons, Buoys, and Public Piers."[9]

Congress put the U.S. Light-House Establishment within the Treasury. Alexander Hamilton, first secretary of the Treasury, was also the first director of the U.S. Light-House Establishment. Despite the demands of being Treasury secretary, Hamilton immersed himself in lighthouse matters, at least initially. He reviewed appointments of keepers and contracts for building new light stations.

The Light-House Establishment, with funding authorized by Congress, was building a few new light towers every year and making repairs or improvements as needed to them and other existing lighthouses.

On June 21, 1790, Hamilton wrote and signed a letter to a contractor that reads, "The President of the United States directs me to inform you that he approves of the enclosed contract for timber, boards, nails and workmanship for a Beacon to be placed near the Lighthouse on Sandy Hook."[10]

The first new lighthouse to be funded by Congress in 1790 and built and activated by the Light-House Establishment in 1792 was the Cape Henry Lighthouse near Virginia Beach, Virginia. The ninety-foot-tall octagonal sandstone tower stands near the site of the "First Landing," where English settlers arrived in 1607 to establish the first English settlement—Jamestown—in North America. The lighthouse identified the entrance to the Chesapeake Bay from the Atlantic Ocean to the ports of Norfolk, Baltimore and Washington, D.C.[11]

Despite New York Harbor's importance, no lighthouses had been built in the city or state of New York. But at the Fifth Session of the Second Congress in Philadelphia, "An Act to Erect a Light-House on Montok Point" was passed on April 12, 1792, and signed by Secretary of State Thomas Jefferson. On January 4, 1796, President Washington authorized the purchase of land. The

## CHAPTER IX.

*An* ACT *for the establishment and support of* LIGHT-HOUSES, BEACONS, BUOYS, *and* PUBLIC PIERS.

Section 1. **B**E it *enacted by the* SENATE *and* House *of* REPRESENTATIVES *of the United States of America in Congress assembled*, That all expences which shall accrue from and after the fifteenth day of August, one thousand seven hundred and eighty-nine, in the necessary support, maintenance and repairs of all light-houses, beacons, buoys and public piers erected, placed, or sunk before the passing of this act, at the entrance of, or within any bay, inlet, harbour, or port of the United States, for rendering the navigation thereof easy and safe, shall be defrayed out of the treasury of the United States : *Provided nevertheless*, That none of the said expences shall continue to be so defrayed by the United States, after the expiration of one year from the day aforesaid, unless such light-houses, beacons, buoys and public piers, shall in the mean time be ceded to, and vested in the United States, by the state or states respectively in which the same may be, together with the lands and tenements thereunto belonging, and together with the jurisdiction of the same.

The Ninth Act of the first Congress created the U.S. Light-House Establishment in 1789. *National Archives and Records Administration.*

act acknowledges the need for a lighthouse at that vital point, concluding, "And the President is hereby authorized to make the said appointments. That the number and disposition of the lights in the said lighthouse shall be such as may tend to distinguish it from others, and as far as is practicable, prevent mistakes." The lighthouse was built in 1796 at the eastern tip of the island on a rocky bluff, 125 miles from New York Harbor. The lighthouse and surrounding village took their name from the Montaukett Indian tribe that had long lived there. The lighthouse tower, constructed of sandstone blocks from Connecticut, stands 110 feet high. Montauk's beacon, first lighted in 1797, could be seen at a distance of 19 miles.

New York State's first lighthouse, Montauk, was one of the early lights built in the Federal period and is today America's fourth-oldest surviving lighthouse. "Montauk Point Lighthouse was the most important for the nation's foreign trade during the first eight decades of the United States lighthouse service. This was altogether the most important landfall light for the ships bound for New York from Europe during the period when New York's importing of European manufactured goods was the major part of

America's foreign trade," according to the National Parks Service, which maintains the surrounding parklands.

Historian Browning notes, "At first, President George Washington took an active interest in lighthouses. It was not too long before the President had to delegate this responsibility. First, the responsibility passed to the Commissioner of the Revenue, and then it went to the Secretary of the Treasury."[12]

Of the forty masonry towers built in the Federal period, the first three decades of the U.S. Light-House Establishment (1789–1820), fewer than a dozen survive, including Portland Head in Maine and Georgetown Lighthouse in South Carolina, as well as Montauk Point and Cape Henry.

As the nation expanded and the need for more lighthouses and staff grew, the administrative duties became too much for the secretary of the Treasury. By 1820, authority for America's lighthouses was delegated to the fifth auditor of the Treasury, Stephen Pleasanton, whom historian Browning describes as a "bookkeeper and a financial zealot." He was in charge of the Light-House Establishment for more than thirty years. Browning adds, "This period, which begins in 1820, might well be labeled the era of 'the lowest bidder,' and the lighthouses built during this period were inferior structures constantly in need of replacement. In addition, the lighting system used was not only grossly inferior too, but far less expensive than that employed in Europe."[13] The auditor managed to return appropriated monies to the Treasury as lighthouse projects came in under budget. But a special congressional investigative committee, appointed in 1851, found that the system was inadequate and needed reform.

On October 9, 1852, Congress dissolved the U.S. Light-House Establishment and created the U.S. Light-House Board, which consisted of two navy officers, two from the U.S. Army Corps of Engineers, "two civilians of high scientific attainments" and two secretaries drawn from the navy and the army, while the Treasury secretary was board president. The U.S. coast was divided into twelve districts. In each, the president assigned a navy or army officer to be lighthouse inspector. The board, with members intimately familiar with navigation and others current with technological development, was expected to better plan, design, locate and build lighthouses and properly equip them. Its record was an improvement on the prior administration.[14]

# CHAPTER 2
# NEW JERSEY COAST:
# BRIGHT LIGHTS AND A DARK SPACE

S hips in open water or passing through inlets or harbors are vulnerable to storms, reefs and sandbars, as well as calamity aboard ship, no matter how skilled the crew. Risks mount when mariners are unsure of their location and what hazards lie beneath the water's surface.

New Jersey has some 130 miles of ocean coastline, plus rivers and bays. The state's coastline has proven treacherous because of the many shifting sandbars, hidden rocks, narrow channels and storms and fog that can come up quickly.

The number of shipwrecks in New Jersey waters from colonial times to the present range from estimates of a few thousand to twice that. "The staggering number of reported shipwrecks over the centuries—about 4,000 including both documented and undocumented—has earned New Jersey waters the sorrowful epithet 'Graveyard of the Atlantic,'" writes shore historian Margaret Thomas Buchholz in *New Jersey Shipwrecks: 350 Years in the Graveyard of the Atlantic*.[15]

Veteran wreck diver Dan Lieb noted the following in an e-mail to the author on April 12, 2013: "Shipwrecks occurred along the Jersey Shore at an alarming rate. Our proximity to the Port of New York, the prevailing winds and shifting sand bars led to the wrecking of many a vessel." Dan is president of the New Jersey Historical Divers Association and a founding member of the New Jersey Shipwreck Museum in Wall Township, where many wreck artifacts are displayed.

Lighthouses not only project a guiding beacon—they are also strategically located near inlets and/or hazards as markers to mariners. Lieb added, "It is

New Jersey's rocky seabed and sandbars proved a challenge in the days of sail. The British bark *Windermere* ran aground off Deal in 1892. *New Jersey Maritime Museum.*

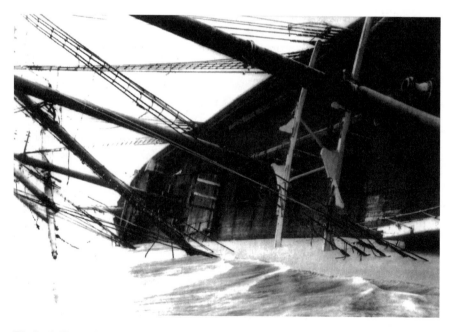

The bark *Fortuna* beached in heavy fog near Ship Bottom on Long Beach Island en route to New York from Montevideo with a shipment of coal, January 18, 1910. *New Jersey Maritime Museum.*

impossible to hold and complete a thorough discussion about the history of shipwrecks along the New Jersey coast without mentioning the Lighthouse and Life-Saving Services. One was intended to prevent shipwrecks, and the other went into action when a shipwreck occurred."

Throughout the 1800s, the need for more lighthouses and lightships increased, fueled by the Industrial Revolution, rapidly growing shipments of cargo and the arrival of immigrants. Merchants, shipping companies and mariners pleaded and petitioned the U.S. Light-House Establishment and its successor, the U.S. Light-House Board, to build more lighthouses along the coast and position lightships in the channels. And the lighthouse agencies, in turn, lobbied Congress to appropriate the necessary funds to build more light stations to keep up with the demand of a maturing nation.

Since the beginning of America's commercial shipping, New Jersey waters have served as crucial entryways to the Ports of New York and Philadelphia and the ocean highway to points farther north and south. It's not surprising, then, that several of America's early light stations were built in New Jersey.

As early as 1679, the colonial governor of New York proposed a lighthouse on Sandy Hook. Many decades passed before action was taken, prompted by a series of shipwrecks on the sandbars and rocks off Sandy Hook. Forty-three New York merchants petitioned the Colonial Assembly of New York in 1761 to build a lighthouse there. The lighthouse, financed by two lotteries and a tax on ships entering the Port of New York, was activated in 1764.[16]

While built in New Jersey, Sandy Hook Lighthouse was originally called New York Lighthouse. The 103-foot-tall tower projected its beacon 19.0 nautical miles (21.8 statute miles) to identify the entrance to Lower New York Bay and New York Harbor beyond.[17] The lighthouse also served as a warning of the dangers along the narrow, curving and shifting tip of the peninsula the Dutch called Sant Hoek and the English translated to Sandy Hook. Sandy Hook Lighthouse was built 500 feet from the tip of Sandy Hook.

"As commercial ship traffic in and out of the harbor increased tremendously after 1800, so did the need to better mark the sea approaches leading to the Port of New York," writes historian Thomas Hoffman. The Light-House Establishment looked four miles south to the Highlands of the Navesink, rising two hundred feet from the sea, as an ideal location for a new New York Harbor light—or two. The Highlands have been a landmark from the days of the earliest explorers.

As early as 1746, there was a system of lighting pots of whale oil to alert colonists of any invasion attempts by the French. That was abandoned when a fire erupted. Thomas Pownall, a British colonial officer appointed New

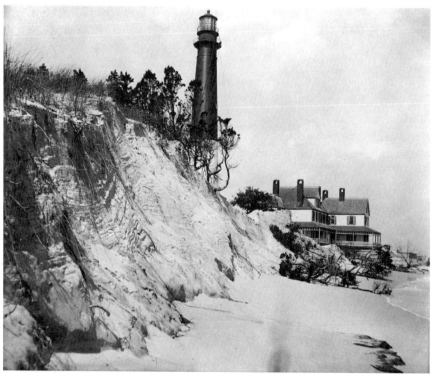

Jersey lieutenant governor, wrote in 1755, "The first land you discover in coming from the sea is the high land the Nave-sinks."[18]

In 1827–28, the Light-House Establishment built two forty-foot-high towers on the Highlands, one with a blinking light and the other with a constant light so that mariners would not mistake the twin lights for Sandy Hook. In 1862, the towers were replaced by the current Twin Lights, the brownstone fortress with "two non-identical towers linked by keepers' quarters and storage rooms. This unique design made it easy to distinguish Twin Lights from other nearby lighthouses in daylight. At night, the two beacons, one flashing and the other fixed, provided another distinguishing characteristic."[19]

The next lighthouse south of Twin Lights for more than six decades was a succession of Barnegat Lighthouses at the north end of Long Beach Island at the entrance to Barnegat Bay Inlet. "The inlet was christened 'Barendegat,' or 'Breakers Inlet,' by early Dutch explorers because of the large cresting waves which made navigation difficult," notes the Barnegat Lighthouse State Park visitors' pamphlet. "The site of the lighthouse was considered as one of the most important 'change of course' points along the eastern seacoast for sailing vessels." The first Barnegat Lighthouse, lighted in 1835, was a forty-foot-tall brick tower built three hundred feet from the water's edge. But the water came ever closer as tidal waters and storm surges eroded the beach. The tower collapsed in 1856. A temporary wooden tower was built farther inland.

Lieutenant George G. Meade, an engineer in the U.S. Army Corps of Engineers who, just a few years later, would be the Union army's commanding general at the Battle of Gettysburg, was assigned to supervise construction of the third and present Barnegat Lighthouse to stand as a warning to local sandbars and hidden rocks and also to project a beacon far out to sea. It is a 172-foot-tall tower with two circular brick walls surrounding an iron staircase on a foundation of granite. "Old Barney," as it's known, was first lighted in 1857 and equipped in 1859 with a first-order Fresnel lens that projected a flashing beacon more than twenty miles.[20]

*Opposite, top*: Two differently styled towers, each projecting a distinctive beacon, distinguished Twin Lights from Sandy Hook. *Twin Lights Historical Society.*

*Opposite, bottom*: Old Barney, the third lighthouse on this site, was built in 1857 under the supervision of George Meade. *Nathanial R. Ewan, Historic American Buildings Survey, Library of Congress.*

# DARK SPACE BETWEEN THEM

The distance between Twin Lights on the Navesink Highlands and Barnegat Lighthouse is more than thirty-eight nautical miles, or forty-four land miles.[21] The stations were equipped with the most powerful lenses available. Yet they weren't powerful enough, for at the midpoint, sailors often found themselves unable to see either light, particularly in bad weather.

In early 1886, the Light-House Board went to Congress to present its case for a new light in Monmouth County midway between those two giants. On March 20, the Light-House Board wrote to the House Commerce Committee requesting congressional funds for a lighthouse "at or near a point about midway between Barnegat and Navesink lights."

In its annual midyear report to the Treasury secretary, the board pressed for action:

> *In good weather, at the extreme limit of visibility of the lights, both can be in sight only when close in to the beach. In hazy weather, there will practically be a dark space between them. In view of the immense quantity of commerce passing both ways in this vicinity, this dark space should be lighted and vessels off-shore should be enabled, when nearing the port of New York, to fix their positions by cross bearing. These conditions can be had by establishing the proposed light. It is therefore recommended that a light be established at or near a point about midway between Barnegat and Navesink light-stations, and it is estimated that this can be done for $20,000, which amount it is recommended be appropriated for that purpose. A bill authorizing the establishment of this light was passed at the current session of Congress, but no appropriation was made for this construction. The Board therefore calls attention to this case with renewed urgency.*[22]

In a letter dated January 12, 1888, Rear Admiral S.C. Rowan, chairman of the Light-House Board, wrote Representative Lloyd Bryce (D-NY), chairman of the Commerce Committee, to reiterate the need for funding and identified Squan Inlet as an appropriate midway location.[23]

The Squan Inlet to which Admiral Rowan refers is not Manasquan Inlet of today, which was excavated in the late 1920s to connect the ocean and Manasquan River. Rather, Squan Inlet was a natural inlet between Manasquan and Sea Girt. It was tricky to navigate, curving as it connected the ocean with Stockton Lake. The inlet was bordered to the north by Commodore Robert Stockton's estate, a part of which later became the New

Jersey National Guard Training Center in Sea Girt. In 1889, Congress did appropriate $20,000 to build a lighthouse near Squan Inlet.

Problems developed after the title to the selected property was secured, and the deal fell through. The *Annual Report of the Light-House Board for the Fiscal Year Ended June 30, 1891* contained this update: "The title papers for the purchase of the site for this light were completed, but before payment was made the lot was located from the description given in the deeds, when it was found that the lot to be transferred was not the site selected and agreed upon by the Light-House Board and was totally unfit for light-house purposes. The owners have consequently been notified that the sale will not be completed."[24]

# CHAPTER 3
# SEA GIRT: THE MIDWAY SOLUTION

The Light-House Board's *Annual Report for 1893* said of the proposed Squan Inlet Light Station, "A new site was selected. Measures were taken for its purchase and for obtaining title."[25]

The location was not in Manasquan but rather in Sea Girt. And just as there had been complications with the Manasquan parcel, so too there were with the newly selected property. The *Annual Report for 1894* noted, "The site was selected, but, owing to difficulties which have arisen in the way of procuring a clear title, the purchase has not been completed."[26]

The very next year, the Light-House Board advised, "The difficulties in the way of procuring a clear title to the site selected have, it is believed, been removed."[27] The Sea Girt property, a mile north of the first parcel, measures one hundred by one hundred feet. The location is sixteen nautical miles (eighteen and a half land miles) south-southwest of Navesink Twin Lights and twenty-two nautical miles (twenty-five and a half land miles) north of Barnegat Light.

The lighthouse to be built in the next year would not only illuminate the midpoint but also serve as an identifier of Sea Girt Inlet, which mariners often mistook for Squan Inlet. Of the two inlets, in the 1890s, Sea Girt Inlet and Wreck Pond to the west were shallower than Squan Inlet and Stockton Lake. Squan Inlet, before it shoaled up and disappeared, was considered a refuge for shallow-draft vessels in a storm. Sea Girt Inlet was not.

Wreck Pond, which many assume was named for shipwrecks, was only a few feet deep then as it is now. It was not where mariners would ride out

a storm. They would want to be warned away from such shallow waters. While the origin of the name is unknown, Spring Lake Historical Society research found a 1715 reference to Rack Pond, which is also found on the 1765 John Lawrence map of New Jersey. A 1781 map refers to Rack Creek; Captain William Giberson's 1892 map identifies it as Rock Pond. Wreck Pond Inlet appears on an 1851 map. Wreck Pond and Sea Girt Inlet are identified in Wolverton's 1889 color *Atlas of Monmouth County, New Jersey*.

Archaic definitions of "rack," according to Merriam-Webster, include "a wind-driven mass of high often broken clouds" and, from the Middle English *rak*, "rain cloud." *Wrack*, also Middle English, has various definitions, including "shipwreck," "driven by the sea" and "seaweed."

"Title to the site was finally obtained, designs and specifications for the necessary buildings were prepared, contracts were made, and erection was begun," according to the *Annual Report for 1896*.[28]

Sea Girt is an L-shaped, live-in lighthouse, meaning that the tower is integrated into the house. Sea Girt was the last live-in lighthouse built on America's East Coast. The house and tower were constructed of brick and mortar, which would be painted over the years. The lighthouse's location, construction and painting would pose challenges in the decades ahead.

The square tower stands at the junction of the two legs of the L. Atop the tower is the octagonal steel lantern room, surrounded by a square railed gallery. Inside the lantern room stood the revolving lens that projected its beacon to sea. The distance from the vent at the top of the lantern room to the ground is forty-four feet, although it is sixty feet above sea level. The structure erected in Sea Girt was the building the Light-House Board planned to put up in Manasquan at Squan Inlet, evidenced by architectural blueprints dated 1895 and labeled "Squan Inlet Lt Sta."

The front steps lead to the porch and front door, which opens to an eight-by eight-foot office at the bottom of the tower. The keeper spent time at the desk in that office every day, making daily entries in the logbook and responding to official communiqués. The room also played an important role in the flashing of the beacon. In the era before electricity, a weight dropped down a shaft, called the channel, in the northeast corner of the tower from the top to the keeper's office. The weight drove gears that caused the lens up top to revolve, creating the sequence of a bright flash, followed by dimness that repeated as long as the lens revolved. As the weight neared the bottom, it came into view and triggered a gong to remind the keeper to go upstairs to crank the weight up the channel to start a new descent, keeping the lens revolving and the light blinking. To go from the office to the

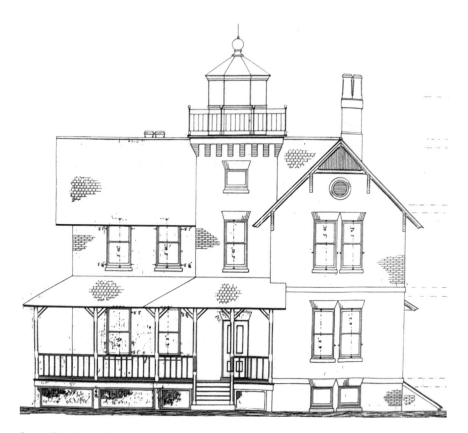

Squan Inlet Light Station blueprints (1895) were used the following year to build the lighthouse by Sea Girt Inlet. *Sea Girt Lighthouse Collection.*

top of the tower requires entering the living quarters through double doors on the west side of the office, climbing the stairs to the second-floor hallway, walking east to reenter the tower and then climbing spiral steps and, finally, up a ladder into the lantern room.

There are 42 steps from the keeper's office to the top, a short climb compared to the 217 steps to the top of Barnegat Lighthouse and 228 steps to the top of Absecon, New Jersey's tallest lighthouse and America's third tallest. With its short climb and location in a quiet but not isolated town, Sea Girt became a sought-after posting.

On the west lawn, there was an oil house for fuel storage and a windmill to pump water from a well into the house. The lighthouse was occupied by early December 1896 even though construction was not finished. Workmen completed the job in the new year.

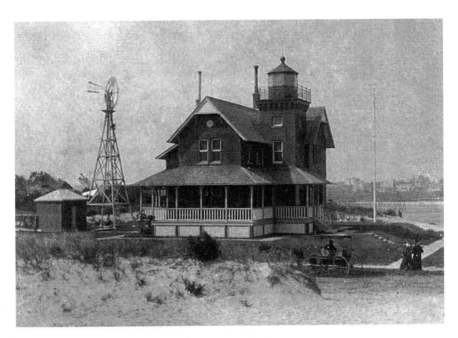

*Above*: The earliest known photograph of Sea Girt Lighthouse, activated in 1896. Note the horse-drawn carriage and windmill. *U.S. Lighthouse Society.*

*Left*: Tucker's Island Lighthouse, long threatened by beach erosion, finally collapsed into the sea on October 12, 1927. *National Oceanic and Atmospheric Administration.*

One lighthouse feature unusual at the time was the indoor bathroom located off the center hallway on the first floor. The living quarters had a parlor on the southeast side, a dining room in the northeast corner and a kitchen and pantry in the northwest corner. Upstairs there were two bedrooms on the north side off the center hallway and the master bedroom on the south side. Every room had a fireplace.[29] There was a chimney centered on the north side of the building and a second one rising out of the southwest corner of the roof over the master bedroom. The basement had a workroom and a coal bin.

Lieutenant Colonel W.A. Jones, of the U.S. Army Corps of Engineers and the engineer for the Fourth Light-House District, inspected Sea Girt Lighthouse in the spring of 1898. In his April 5 report, he wrote, "With the exceptions to be noted, the station is in excellent order. The new model Fourth Order lamps are working very well indeed…The dwelling is a very fine one with convenience of bath and hot and cold water distributed by pipes. It will be rather hard work for a man with a salary of $46 per month to properly care for and preserve this sort of thing. His allowance of three tons of coal per year will not enable him to heat the house sufficiently in winter to keep the water pipes from freezing."

The inspecting engineer, however, faulted the mortar work: "In many places, only enough mortar was placed in the joints to enable the bricks to lay up level, the face of the joints being carelessly covered with a thin skin of mortar." In storms, water was getting into the house. A crew would be dispatched to make necessary repairs.[30]

Water penetrating into lighthouses—both the towers and the living quarters—was not a rare occurrence. "Saltwater spray and blowing sand typically have a corrosive effect on brickwork/mortar, as well as on poorly painted or preserved wood surfaces, and it was not uncommon for regular repairs to be needed to the exterior walls and roofs of both USLHS (Lighthouse Service) and USLSS (Life-Saving Service) buildings," according to Commander Timothy R. Dring, USNR (retired), an author and historian.[31]

Because of their strategic locations near or in the water, lighthouses have been vulnerable in other ways as well. Offshore lighthouses, sitting atop caissons or rock piles, are particularly vulnerable not only to storm surges and deteriorating foundations but also to being struck by ships. Some land-based stations, particularly those in low-lying areas and on barrier islands, risked repeated flooding, which could undermine their foundations. Tucker's Island Lighthouse, built in 1868 on an island off the southern tip of Long

Beach Island, was closed in 1927 because it was unstable. The building fell into the ocean in a storm that October. A replica of the lost light stands today at Tuckerton Seaport.

Despite the advantage of standing on a bluff, Sea Girt Lighthouse was not in service long before it became apparent that beach erosion, caused by ocean storm surges, as well as Sea Girt Inlet and Wreck Pond overflowing their banks, posed a threat. As early as 1898, the U.S. Army Corps of Engineers was on site taking remedial action.[32]

Investigators and engineers would return again and again over the decades, trying various strategies and designs to protect the lighthouse, including sodding the lighthouse property, sandbagging the perimeter and building up sand dunes. The U.S. Army Corps of Engineers also installed wooden bulkheads and, later, steel bulkheads as protective walls along the property line to hold the topsoil in place.

To slow or hopefully halt erosion affecting long stretches of the beachfront in Sea Girt and other towns, wooden groins or barriers and, later, rock jetties were also built eastward from the beach out into the water to break and weaken the ocean's waves. But it would be decades before the engineers finally contained Wreck Pond, the body of water between Sea Girt and Spring Lake.

# FRESNEL, HIS LENSES AND SEA GIRT'S FRESNEL LENS

S ea Girt Lighthouse was equipped with a fourth-order Fresnel lens. The lens, a network of hand-cut glass prisms, projected a blinking light fifteen statute miles out to sea.

The Fresnel lens, a major breakthrough in lens design and light projection, was developed in 1822 by Augustin-Jean Fresnel (fray-NELL), a French engineer and physicist. His experiments in light led to his developing a type of lens that produced more concentrated, focused and intense beams of light than previous lenses. His lens, which would eventually come in different sizes and two basic shapes, became the standard throughout Europe and, later, America.[33]

Light scatters in all directions. Earlier lenses, using reflectors, were able to capture only 17 percent of the light from a fire. But the Fresnel prisms surrounding the light source capture more than 80 percent of the light and refract or bend the light into a horizontal beam that is reflected for many miles.[34]

The first Fresnel lens, consisting of several vertical panels between thin horizontal panels, was installed in France's Cardovan Tower Lighthouse on the Gironde River in 1822. It projected a constant beam twenty miles.[35] A drawback of the stationary lens was that the constant light made it difficult for mariners to distinguish one lighthouse beacon from another.

Fresnel then created a revolving multi-sided, beehive-shaped lens with a convex bull's-eye prism centered on each side, with horizontal prisms above and below the bull's-eye. The bull's-eye prism orients, focuses and intensifies the beam at its center. Each bull's-eye prism was designed like a magnifying

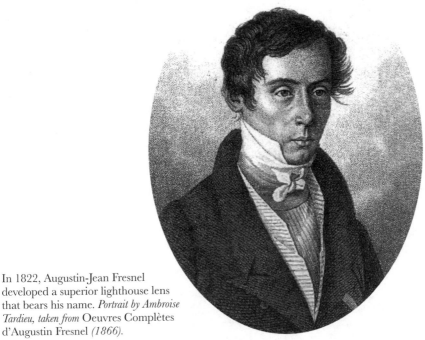

In 1822, Augustin-Jean Fresnel developed a superior lighthouse lens that bears his name. *Portrait by Ambroise Tardieu, taken from* Oeuvres Complètes d'Augustin Fresnel *(1866)*.

glass. Like a magnifying glass, the bull's-eye has a thin leading edge, a thick middle and a thin trailing edge. As the lens revolved, the light first passed through the thin leading edge of the bull's-eye, projecting a dim light; then through the thick middle, projecting a bright light; and finally through the thin trailing edge, where it appeared to go dim. This sequence was repeated as the other bull's-eye prisms came into play one by one.[36] By making the lens revolve, Fresnel was able to produce a pulsing beacon—dim, bright, dim, repeat. Since a revolving lens sent a distinctive beacon based on the speed of its revolution and the number of bull's-eye prisms, sailors could more easily identify one lighthouse beacon from another.

By the 1840s, Fresnel lenses came in two basic shapes (a multi-sided beehive and the two-sided clamshell or bivalve lens) and in seven sizes or orders (first, second, third, third and a half, fourth, fifth and sixth). A first-order lens, the largest, could project a beacon twenty-two statute miles or more.

The first two Fresnel lenses in America were installed at the original Navesink Twin Lights in 1841—a first-order beehive lens in the South

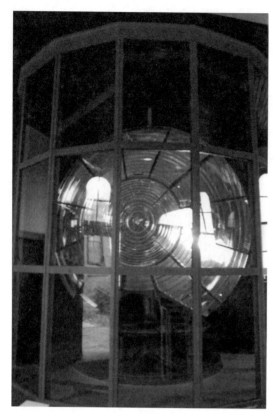

The clamshell or bivalve Fresnel lens, activated in 1898 in the South Tower of Twin Lights, is nine feet in diameter and projected a beacon twenty-two miles. *Sea Girt Lighthouse Collection.*

Tower and a second-order beehive lens in the North Tower. The current Navesink Twin Lights, built in 1862, was also equipped with Fresnel lenses. In 1898, the U.S. Light-House Board installed in the South Tower an electrically lit, rotating bivalve or clamshell Fresnel lens. It measured nine feet in diameter.[37]

Appropriate for its duty as a midpoint light, Sea Girt was equipped with a fourth-order revolving Fresnel lens standing almost three feet high and capable of projecting a beacon up to fifteen statute miles. (A sixth-order lens, the smallest lens, projects a beacon five miles.) The role of the lighthouse and its location determined the size, optics and design of the lens. Lights installed to identify a major harbor or at a lighthouse identifying a crucial point in navigation (such as Barnegat, denoting the Fortieth Parallel) were typically given the most powerful, brightest first-order lights. Mid-sized lenses were used at midpoints, such as Sea Girt Lighthouse, between the larger lights. The smallest, fifth- and sixth-order lights, were typically used along rivers, inland channels and small harbors.

Sea Girt's revolving fourth-order, beehive-shaped Fresnel lens had twelve sides, each with a bull's-eye prism in the center and with curved prisms above and below each bull's-eye. While the original Sea Girt lens was removed by the Coast Guard in 1942, its fate unknown, the same-order revolving beehive-shaped Fresnel lens is on display at the Lyceum Museum in Alexandria, Virginia.

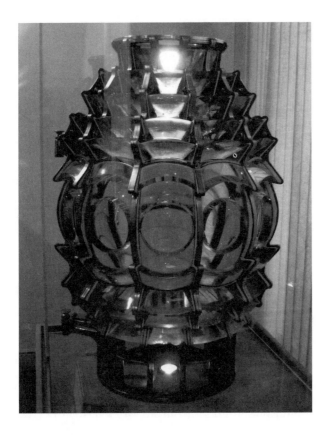

Sea Girt's fourth-order Fresnel lens was the same design as this twelve-sided lens displayed at the Lyceum Museum in Alexandria, Virginia. *Eric S. Martin.*

Each lighthouse had a beacon that was distinct from the beacons of neighboring lighthouses. That's how mariners were able to figure out which beacon they were looking at and thereby know where they were in their journey. There are several variables or characteristics that determine a light station's signature:

- Color of a beacon (white, red, green, etc.)
- One color or changing colors
- Intensity of the light
- Constant light or a blinking light
- If a blinking light, length and number of flashes and dim periods per minute

In the era before electricity, when a fuel-burning lamp was the light source, the number of bright flashes and the length of each flash and period of eclipse per minute were determined by the speed of the revolving lens and its number of bull's-eye prisms. Electrification of lighthouses in the twentieth century eliminated the need for the dropping weight to power the revolving lens. Electrification also made it possible for a stationary lens to project a flashing light by using a timer to turn the light bulb on and off.

As mariners scanned the waters and shore for navigational aids, once they spotted a light, they would note its signature. If it were a flashing light, they would time the flash sequence. Then they would consult their chart books, such as *United States Coast Pilot*, to help identify the observed light.

The *Coast Pilot*, first published by the Lighthouse Service and now by the Coast Guard, is a multi-volume annual series. There's a volume for each coastline, listing and describing every official aid to navigation (both land based and offshore), as well as natural and man-made landmarks and hazards. A listing for a light gives its location and flash sequence, describes its appearance and notes any nearby hazards.

Sea Girt's flash changed over time on orders of the Lighthouse Service. For the first sixteen years, Sea Girt repeatedly flashed 2.0 seconds of bright light followed by a 6.0-second eclipse (dim light). A red beacon was produced by a ruby chimney put around the burning wick inside the Fresnel lens.[38] In 1912, the red chimney was removed to produce a brighter white light. The revolving lens was sped up to produce a bright 0.3-second flash followed by a 0.7-second eclipse.[39]

# DAYMARKS

At sunrise, light keepers turned off their beacons to conserve fuel. When the lights were extinguished, lighthouses still played an important role in navigation as landmarks known as daymarks. Mariners would spot a daymark and then consult their chart books to identify the lighthouse and their location.

To make it easier to distinguish one lighthouse from another, the U.S. Lighthouse Service and its predecessors purposely designed and built each lighthouse within a region to look different from neighboring lighthouses. In

this way, each became readily recognizable, with confirmation in the chart books. The 1916 edition of the *Coast Pilot* contains the following entry: "Sea Girt Lighthouse, 16 miles south-southwestward of Navesink Lighthouse, is a square brick tower in front of a dwelling."[40] It then describes the light color, flash and distance projected.

Finding and identifying a lighthouse by its flash or its appearance is the first step in traditional navigation by sight, which was used by mariners long before GPS (global positioning system) and even now to confirm GPS readings. Tim Dring, who served in the U.S. Navy Reserve, explained in a May 2013 e-mail how mariners use lighthouse beacons or other aids to navigation and landmarks to fix their ships' positions—their distance to shore and position in relation to other points of reference.

After identifying a lighthouse or other reference point, the mariner would then find that same point on a nautical chart, which presents a detailed view of the water, surrounding landmasses and location of aids to navigation, landmarks (such as bridges and causeways) and obstructions and other dangers—including sunken vessels—plus water depth, latitude and longitude. Next, the mariner would take a visual bearing in degrees to the beacon, landmark or whatever other reference point using an alidade—a turning board mounted on a compass set to true north or magnetic north.

Atop the turning board is a horizontal bar with a vertical vane at either end, and at the top of each vane is a hole or notch. The navigator turns the alidade to the position where the beacon or daymark is visible through the two holes of the vanes. The navigator then plots in pencil on the nautical chart the bearing back to the ship. Even now, in the age of GPS, mariners still use the alidade not only as a backup to GPS but also to confirm GPS.

Having spotted and then plotted the beacon or landmark with the alidade, the mariner would have two options to fix the position of the ship—a running fix or a triangulation fix. In a running fix, the navigator would take subsequent bearings to the same aid over time, plot them and then advance/ retard these sequential lines of bearing a direction and distance equal to the speed and heading of the ship to obtain its position.

# CHAPTER 5
# IN LIGHTHOUSE SERVICE: CONSTANT AND FAITHFUL ATTENTION

L ighthouse keepers tended to be individualists, focused with a discipline that enabled them to carry on their duties despite their long days. They were mechanically inclined yet creative thinkers and resourceful because they had to keep the operation running smoothly and be ready to handle any emergency. They were problem solvers.

In the view of Isaiah William Penn, a sea captain who came ashore to become a civil engineer and inspected lighthouses from 1845 to 1856:

> *The best keepers are found to be old sailors, who are accustomed to watch at night, who are more likely to turn out in a driving snow storm and find their way to the light-house to trim their lamps, because in such weather they know by experience the value of a light, while on similar occasions the landsman keeper would be apt to consider such weather as the best excuse for remaining snug in bed.*[41]

Many dedicated keepers came from port cities or seacoast towns and grew up with a respect for the sea. There were keepers whose fathers—and a few mothers—were keepers. Still others came from fishing families or had relatives who were the daring volunteer rescuers of the U.S. Life-Saving Service. Most lighthouse keepers were married men. Young single men in the service were often assigned to offshore lights as assistant keepers or to lightships, a lonely existence.

Ahead of its time, the Lighthouse Service did have female keepers. "Women were first officially assigned as keepers in the Lighthouse Service

beginning in the 1830s, although many wives and daughters of keepers had previously served as keepers when their husbands or fathers became ill," according to the Historian's Office of the U.S. Coast Guard.[42] "Many of these intrepid widows, and women appointed in their own right, served their country for many years with distinction in a time when employment for women was extremely limited. They were true trailblazers."[43]

# NOT A NINE-TO-FIVE JOB

By necessity, light keepers were nocturnal and had the stamina to keep on going well past sunrise. Being keeper of Sea Girt Light—or any lighthouse—was not a nine-to-five job. A typical tour of duty began before dusk and continued past dawn. The keeper's most important responsibility was to keep the light burning throughout the night. The keeper also attended to routine tasks, made repairs as needed and was prepared to respond to emergencies.

Lives depended on the light keeper. And the light keeper depended on the 124-page *Instructions to Employees of the United States Lighthouse Service*. The manual detailed routine but essential daily duties and contingency plans in emergencies. "Constant and faithful attention to their duties shall be required of all persons in the service," states the 1927 edition. It continued:

> *Strict observance of these instructions is required of all persons in the service, and each person shall promptly report to the proper authority any disobedience or infraction of the instructions coming to his knowledge. Employees shall familiarize themselves with the contents of the instructions...Lights must be exhibited punctually at sunset and kept lighted at full intensity until sunrise, when the lights will be extinguished and the apparatus put in order without delay for relighting.*[44]

In addition to tending the light, the keeper's routine duties included:

- Cleaning the tower and lantern, refilling fuel and trimming wicks daily.
- Making daily logbook entries and responding promptly to all official correspondence.

- Maintaining, repairing and replacing equipment as needed.
- Painting as needed.
- Cleaning chimneys, stove and heaters regularly.
- Cleaning living quarters daily.
- Planting and tending a vegetable garden and tending the grounds.
- Conducting tours for USLHS inspectors and approved civilians and dignitaries.

The messy but essential task of replacing and trimming the lamp's wick earned keepers the nickname "Wickie." Family members had their household chores and were ready to fill in for the keeper during illnesses or absences.

While much was routine, the keeper was prepared to deal with the unexpected. Fire was a constant worry due to wall-mounted lamps, hand-held lamps, the tower lamp that illuminated the Fresnel lens and the fuel they required. There were also lubricating oil, paints, varnish and household fuel for the fireplaces and cookstove. To minimize the risk of fire, oils and paints were kept in a separate oil house, while coal for the fireplaces was kept in the basement, dropped down a coal chute. Brass measuring cans in different sizes were used to transport the oil from the oil house to the lighthouse. Once inside, the keeper poured the desired amount of fuel into a spouted feeder that was used to top up the tower lamp or a hand-held or wall-mounted lantern. There were buckets filled with water or sand in the lighthouse and thin blue-glass fire grenades filled with salt water and brine mounted on the walls. In the event of fire, the grenades were grabbed by the neck and thrown at the flames.

And at all times, the keeper was ready to respond to shipwrecks. "It shall be the duty of light keepers and their assistants, and officers and crews of vessels of The Lighthouse Service, to give or summon aid to vessels in distress, whether public or private, and to assist in saving life and property from perils of the sea whenever it is practicable to do so," according to *Instructions to Employees*.[45]

Where keepers previously could wear whatever they wanted, the Light-House Board announced in 1885 a new dress code: "Uniforming the personnel of the service, some 1,600 in number, will aid in maintaining its discipline, increase its efficiency, raise its tone, and add to the esprit de corps."[46]

*Regulations for Uniforms*, a fourteen-page illustrated guide, advised what should be worn at certain times: "All males employed on tenders or light-vessels, or at shore light stations and all seamen and firemen, shall wear the uniform prescribed at all times on duty, and when visiting the Lighthouse Board's office or inspector's or engineer's office, they will always appear in their proper uniform."

A keeper wears the regulation cap and dress uniform, a double-breasted jacket with brass buttons. *U.S. Coast Guard.*

When receiving Lighthouse Service inspectors or other scheduled community leaders and tourists, or when away on official business, the keeper was expected to be in dress uniform—a double-breasted navy blue jacket with eight brass buttons and matching trousers, a vest over a white shirt, a tie and a cap.

Sea Girt was assigned one keeper. Taller stations with bigger lights would be assigned a head keeper and a few assistant keepers. "They will wear on each lapel of the sack coat a loop embroidered in gold…If principal keeper, the letter 'K' will be worn within the loop. For assistant keepers, the figure '1,' '2,' '3,' etc., indicating their respective rank, will be worn."[47] Aboard lightships, where the crew could number up to fifteen, rank was indicated by markings on the sleeves, not the lapels. The master had three stripes.

While tending the light, the keeper was to wear regulation fatigues—a work shirt and denim or khaki pants or overalls—and the distinctive round

A keeper and assistant keeper wear the regulation overalls and white summer caps while on routine duty at their station. *U.S. Coast Guard.*

cap, which was embroidered with a lighthouse tower in silver thread, surrounded by a wreath in gold thread.

Apparently, some keepers hadn't closely read *Uniform Regulations* or were detected disregarding the instructions. The following advisory was issued in 1887:

> *Sir: Your attention is again called to the regulations of the Light House Service in regard to wearing the uniform. Under penalty of dismissal, keepers are required to wear uniform at all times on the reservations. Citizen's clothing may be worn by keepers while off reservation on private business…*[but mixing] *part citizen's clothing and part uniform is strictly prohibited at all times; either the fatigue uniform or the dress uniform must be worn.*

Women, whether assistants or head keepers, were exempted from the uniform regulations,[48] but they were expected to be modestly and

appropriately dressed. Whether writing reports or tending the light, female keepers typically wore long-sleeved dresses or long-sleeved blouses, jackets and long skirts. When required to do dirty work, women typically put on aprons, smocks or protective jackets over their dresses.

A lighthouse keeper's salary was adequate at best. The pay was below what a person could have earned in the private sector for comparable work but in line with government pay. Sea Girt's first keeper earned $550 a year in the late 1890s, while the last keeper earned $1,680 in 1940.[49]

A keeper was tethered to the station, unable to go on leave unless an acceptable replacement were found, whom the keeper had to pay to fill in. Many keepers worked until they died or became ill and could work no more. It was not unusual to find keepers still on the job in their late sixties and older. Sea Girt's fourth keeper was seventy-one when he died on the job. He was the second Sea Girt keeper to die on the job.

Keepers were given a coal allowance. The allowance for Sea Girt in 1898 was three tons. There was also a modest food allowance. In the nineteenth century, meat and other provisions were delivered to the lighthouse along with fuel for the lens by a supply tender. In the early twentieth century, food deliveries were dropped in favor of a stipend.

Some keepers, particularly at lighthouses where there might be two or more keepers, would moonlight (or, more precisely, daylight) on the side to make extra money. While there is no evidence that Sea Girt keepers did this, it is possible and even likely that at least a few did some occasional work on the side based on their interests, skills and/or connections.

For example, Sea Girt's fourth keeper, who previously was a lightship engineer, could have repaired small machinery and appliances brought to him. And the fifth keeper, married to a realtor, could well have dabbled in real estate. And we can imagine the keepers might cast a fishing line off the jetty or set crab traps to put food on the table, if not to sell their catch. The second keeper was known to be a waterman, a term applied to fishermen.

Since much of lighthouse work occurred overnight, keepers had more flexibility during daytime to do other things that might generate extra money. It was not uncommon for wives to fill in while their keeper husbands were in the basement or out in the village doing some freelance work.

Arnold Burgess Johnson, chief clerk of the Light-House Board, addressed the subject of outside work in his 1890 book *The Modern Light-House Service*:

> *Keepers are forbidden to engage in any business which can interfere with their presence at their stations, or with the proper and timely performance of*

*their light-house duties; but it is no unusual thing to find a keeper working at his station as a shoe-maker, tailor, or in some similar capacity, and there are light-keepers who fill a neighboring pulpit, who hold commissions as justices of the peace, and there are still others who do duty as school teachers without neglecting their light-houses.*

*As the dwellings of the light-keepers are often tastefully planned, well-built, and located on picturesque sites, people in search of summer quarters have so besought keepers for accommodation that the Board has been compelled to prohibit them from taking boarders under any circumstances.*[50]

Motivation to stay focused and vigilant came in quarterly visits by an inspector from the district office who graded the keeper on operations. Low-rated keepers risked reprimand, reassignment or dismissal. Top-rated keepers received commendations, which could advance their career and pay.

Despite long hours and low salaries, the job of a lighthouse keeper had its rewards. Many land-based stations, such as Sea Girt, were comfortable quarters in desirable settings, especially attractive to keepers with families. "Generally a keeper and his family did not have to pay anything for their quarters but sometimes had to supplement the allowance they received for food supplies with some of their own money. Otherwise, most everything else was paid for by the government," notes Mr. Dring. There was usually enough land for a vegetable garden, and the local waters offered a plentiful supply of fish. Neighbors tended to be welcoming and respectful. Keepers were held in high regard in their communities and among seafarers.

There were no pensions in the nineteenth century except those for war veterans. But the Retirement Act of 1918 established pensions for many federal workers, including qualifying Lighthouse Service employees. Disability benefits came two years later.[51] The pensions were modest but provided some income, and the amount was increased over the years. The prospect of retiring with a pension no doubt kept many keepers on the job and working diligently. The last keeper assigned to Sea Girt by the Lighthouse Service retired in 1941 with an annual pension of $1,015.[52]

While often repetitive, the work of a keeper was invaluable. A keeper not only carried a weighty responsibility but also had the satisfaction of helping people every day by keeping bright the light that guided countless ships—their crews, passengers and cargo—safely to the next beacon.

# CHAPTER 6
# EARLY YEARS: KEEPERS WOLF, YATES AND YATES

As local tradesmen began construction of Sea Girt Lighthouse in the early spring of 1896, the Light-House Board, as well as Congress and the White House, continued efforts to expand and improve the service and the people it hired, trained and assigned to America's growing roster of light stations.

Politics and favoritism had long plagued the Light-House Board and the predecessor Light-House Establishment in hiring and appointments. President Grover Cleveland set out to reform the lighthouse system and introduce an objective standard in hiring and promotion of personnel.

On May 6, 1896, President Cleveland issued Executive Order—Civil Service Rules, which put lighthouse administration and operations into the classified civil service system, thereby eliminating patronage, requiring minimum qualifications and examinations and instituting a merit system.

"Appointments and promotions are on a strictly merit system. This is of great importance for the maintenance of good organization and rigid discipline in a purely technical service," wrote George R. Putnam in his history *Lighthouses and Lightships of the United States*.[53] Putnam was lighthouse commissioner from 1910 to 1935.

The order put Light-House Board employees into the civil service system, as well as other agencies dealing with mariners: the U.S. Life-Saving Service, the tariff-collecting Revenue Cutter Service, the Steamboat Inspection Service and the Marine Hospital Service. The order also put workers of the U.S. Postal Service, Railway Mail Service, State Department and Treasury Department into the civil service.

Rule IV, Section 1 of the executive order states, "There shall be provided, to test fitness for admission to positions which have been or may hereafter be classified under the civil-service act, examinations of a practical and suitable character involving such subjects and tests as the Commission may direct."[54]

Excepting the very first keeper appointed to Sea Girt in 1896, all but one of the keepers who followed him were assigned to Sea Girt under the federal civil service system. But there was one, serving as acting keeper, who ultimately was rejected because of the civil service requirements.

Sea Girt's keepers included a retired military officer who served in the Union army during the Civil War, while another was the son of a lighthouse keeper. There was a pioneering woman who took charge under difficult circumstances, followed by an inventor who had spent the previous three decades on lightships. During World War II, there were more than two dozen men of the U.S. Coast Guard who transformed the lighthouse into a coastal watch post.

The keepers ranged in age from thirty-seven to sixty-five upon their arrival. There was a fifty-five-year-old woman who served as interim keeper for two months. There was also a twenty-year-old woman, the daughter of a Sea Girt keeper, who was approved by the Lighthouse Service to be his substitute for one day.

For all the keepers assigned to Sea Girt, it was their last post. While they and their families had been many places before, most seemed to like the community because it was Sea Girt or neighboring towns where the families stayed after their lighthouse days. The people given responsibility of running Sea Girt Lighthouse were a diverse group of colorful individuals.

# FIRST KEEPER: ABRAHAM GEORGE WOLF

## *(December 2, 1896–September 30, 1902)*

Abraham G. Wolf, a retired U.S. Army officer, served more than two decades as keeper of Absecon Lighthouse in Atlantic City. Then, on September 14, 1896, he was named keeper at Barnegat, an appointment cancelled in early December, when he was selected to be the first keeper at Sea Girt Lighthouse.[55] He was fifty-seven years old and a widower.

Abraham Wolf was the first keeper at Sea Girt Light, activating it on December 10, 1896. *Donated to Sea Girt Lighthouse Collection by Friends of Absecon Lighthouse.*

Wolf's posting to Sea Girt was part of a four-way reassignment of keepers devised by Commander Charles J. Train, a U.S. Navy officer and the inspector of the Fourth Lighthouse District, who was particularly eager to make personnel changes at Absecon. Train promoted younger assistant keepers to head keepers at Absecon and Barnegat, two major light stations, while an assistant keeper at Absecon was made the lone keep at Cohansey Lighthouse, a small river lighthouse by Delaware Bay in Greenwich, New Jersey.

In sending Wolf to Sea Girt, a secondary station, Train gave an aging keeper easier duty while also taking advantage of his experience to start things right at Sea Girt.[56] At Sea Girt, there are only forty-two steps from the first floor to the top of the tower, requiring only one keeper to operate, compared to more than 200 steps at Absecon and Barnegat, each of which was permitted a keeper and a few assistants. The reassignment meant a pay cut. As lone keep at Sea Girt, Wolf earned $550 a year, compared to $700 or more at Absecon and $760 at Barnegat, each of which had two assistants.[57]

Although he stood just five feet, seven and a half inches tall, Wolf made a striking impression with his mane of white hair, moustache and long goatee and wire-rimmed glasses. He had a military bearing. A fellow keeper described him as a "convivial soul" and referred to him as "Major Wolf," as many others did throughout his lighthouse days.

Wolf served in the Union army during the Civil War. He was a native Pennsylvanian, born and raised in Harrisburg. It was there that Wolf was recruited into Independent Battery G, Pittsburgh Heavy Artillery, on August 22, 1862. He was given the rank of sergeant, according to *History of the Pennsylvania Volunteers, 1861–65*.[58]

Battery G was assigned to Fort Delaware on Pea Patch Island on the Delaware River. The fort was built in the early 1820s. During the Civil War, the brick fort was converted into a Union prison to house captured Confederate soldiers, as well as privateers, political prisoners and Federal convicts. In 1863, Sergeant Wolf was promoted to junior first lieutenant in Ahl's Battery and presented with an accordion by his men. He was put in charge of the prison barracks where Confederate officers were being held, according to details provided by the Fort Delaware Society in e-mails to the author on March 21, 2013.

There are reports of Wolf's donning a Confederate uniform to disguise himself as a prisoner as he mingled among the Southern POWs in an attempt to observe them, eavesdrop and gather information.[59] One prisoner, who kept a diary that is now in the Library and Archives of the Fort Delaware Society, wrote, "Lieutenant Woolf was again detected in the pen last night, slipping from division to division disguised in Confederate uniform. Much good it did him!"[60] The diarist reports that Wolf was detected by a Confederate officer, who complained of "such fellows as the Wolf, who tries to play the Fox but isn't half as smart as the Dutchman."[61] The "Dutchman" was another Union soldier who guarded the POWs.

After the war, Wolf was referred to as "the Major" or "Major Wolf." "No military records have yet been found indicating promotion to that rank.

He was mustered out of U.S. volunteer service in July 1865 as a Junior 1st Lieutenant," noted historian R. Hugh Simmons of the Fort Delaware Society in a March 2013 e-mail exchange with the author. "References to 'Major' Wolf found in postwar documents represent an honorary form of address popular in nineteenth-century America."

A year after his discharge, Wolf was back in uniform, appointed head keeper at Old Reedy Island Light on Reedy Island on the Delaware River on July 19, 1866. He earned $520 a year.[62] The 1870 U.S. Census shows he was married to Kate Wallen Bonner, twenty-two, born in Scotland.[63] On May 3, 1871, John Bonner—Wolf's father-in-law—was appointed assistant keeper. On June 28, 1872, Bonner was "removed" from the position, according to the Reedy Island Lighthouse staffing report. There's no further explanation.[64]

On March 13, 1873, Wolf was appointed head keeper of Absecon Lighthouse in Atlantic City at an annual salary of $700.[65] The lighthouse was allotted two assistant keepers. Following Wolf to Absecon as acting assistant keeper was John Bonner.[66] Again, Bonner didn't last long. By early July 1874, Wolf was recommending Bonner's removal, citing insubordination and general incompetence. Bonner left.[67]

Bonner was replaced by his daughter and Wolf's wife, Kate, who was nominated for the assistant keeper position by Israel Scull Adams, the local collector of customs and the Treasury official in charge of local aids to navigation in southern New Jersey. Adams was a political powerhouse, and a recommendation from him in that era of political patronage cleared the way for Kate.

Kate retired in 1884 and tended to housework. Her health began to fail. Four years later, at age forty, Kate Bonner Wolf died of Bright's disease, a broad medical classification of the day covering kidney diseases.[68] The widowed Wolf remained eight more years at Absecon. Much of what we know about Wolf's lighthouse assignments before Sea Girt comes from Light-House Board documents that Absecon Lighthouse docent Elinor Veit has generously shared.

In mid-September 1896, Wolf was sent to Barnegat Lighthouse. The appointment was cancelled in early December, and Wolf moved up the coast to his last post.[69] Construction of Sea Girt Lighthouse was not complete at that time, but the quarters were livable and all the equipment tested and functioning. The Light-House Board finally gave the order to activate the station.

And so, on Thursday, December 10, 1896, as the sun was setting, Abraham Wolf climbed the forty-two steps from the keeper's office to the lantern room. He lighted the lantern inside the fourth-order Fresnel lens

and started the weight down the channel, causing the lens to revolve. The light from the lantern's burning wick projected through the bull's-eyes of the revolving lens, projecting a flashing beacon some fifteen miles to passing ships. The dark space of which mariners long complained had finally been lighted. Keeper Wolf activated Sea Girt Lighthouse at 4:29 p.m.

The Light-House Board, which had referred to the station during its planning phase, construction and early days of operation as Squan Inlet Light, corrected itself in early 1897. The name change was announced in the board's *Annual Report*: "Squan Inlet, seacoast of New Jersey—Name of station changed to Sea Girt, February, 1897."[70] (While the *Annual Report for 1900* and the *Annual Report for 1904* identified the station as Seagirt, the Light-House Board corrected itself again and in the 1906 report referred to the station as Sea Girt.)

Keeper Wolf, a widower when he arrived at Sea Girt, was in Philadelphia on May 3, 1897, applying with Eliza (Lidie) Helen Reiter for a marriage license. He was fifty-eight; she was forty-seven.[71] One newspaper article of the day described Eliza Reiter as "a rich widow from Pittsburgh." The couple was married that same day at the Tabernacle Presbyterian Church near the leafy campus of the University of Pennsylvania.

Mr. and Mrs. Wolf lived well, certainly not in the spare style of most light keepers. They had a live-in housekeeper and eventually built a house next door. Keeper Wolf was not in good health. On June 6, 1898, he applied to the War Department for an invalid pension, citing disability due to "small pox, typhoid fever, varicose veins, rheumatism and pneumonia." The application was rejected on July 15 because Wolf had "no ratable disability shown under Act June 27, 1890."[72]

In 1899, the U.S. Army Corps of Engineers dispatched a team to Sea Girt to investigate how to stop beach erosion that threatened the lighthouse. The proposed solution was a double-paneled, four-foot-high wooden sand fence to be installed across the east and north sides of the property and a portion of the south side. The sand fence was to be braced at the corners and stand on a ground plate. The *Annual Report for 1900* contained this entry for Sea Girt: "The exterior of the lighthouse, including the lantern and the brick walls, was repainted. A sand fence 240 feet in length was erected to protect the grounds from drifting sands. Various repairs were made."[73]

The paint color is not indicated, although it was most likely a dark red for the brickwork and black for the metal lantern room and gallery at the top of the tower. I have found several cryptic references to red oil-based paint in logbook entries of Sea Girt keepers in later years.

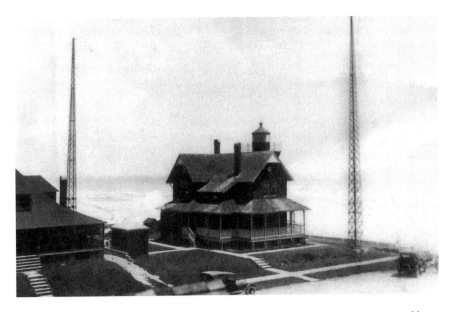

Abraham Wolf and his wife built the house next to the lighthouse, which is now owned by a member and former president of the Sea Girt Lighthouse Citizens Committee. *Sea Girt Lighthouse Collection.*

The 1900 U.S. census listed the Wolf household as being in Wall Township, which then did include the village of Sea Girt. The enumerator visiting the lighthouse recorded three people living in the household: Abraham G. Wolf, age sixty-one, head of household; Eliza H. Wolf, fifty-two, wife; and Letice Adams, fifty-two, servant. The entry for Letice Adams indicates she was born in North Carolina and was single. In the "Color or Race" column, the enumerator put down "B," which stood for black, indicating that Ms. Adams was an African American.[74] While a housekeeper at a light station was a rarity, Mrs. Wolf was known to be a wealthy woman able to afford a housekeeper.

In declining health, Abraham Wolf resigned his post as light keeper on September 30, 1902.[75] He and his wife moved to the house they had built next door to the lighthouse, according to Donald Ferry, a lighthouse member who has owned the Wolf house for many years. Wolf reapplied for an invalid pension as a Civil War veteran and was approved. He was given a partial pension of six dollars per month.[76]

Mrs. Wolf, according to the 1910 U.S. Census, was living in Wall Township (of which Sea Girt was still a part) in what we can assume is the house next to the lighthouse. She was listed as the head of the household. But

neither Abraham nor Letice was listed as a household member.[77] Wolf, long a member of the Elks fraternal organization, had entered an Elks Lodge retirement home in Bedford City, Virginia, on November 2, 1906.[78] That same census lists a Lettice (spelled with a second "t") Adams living in a Pittsburgh household, where she was employed as a servant.[79] The census records were researched by SGLCC member Dan Herzog. Abraham Wolf died at age seventy-six on December 9, 1912.[80] Mrs. Wolf applied for and eventually received a widow's pension. At some point, she moved back to the Pittsburgh suburb of Edgewood.[81]

# SECOND KEEPER: ABRAM LEWIS YATES

## (October 1, 1902–May 29, 1910)

Sea Girt's second keeper, Abram L. Yates, was the son of a keeper, according to a family history. His father, William C. Yates, was keeper at Barnegat Lighthouse from 1873 to 1875, confirmed descendant Elizabeth Yates Collini in an e-mail to the author on March 15, 2013. In 1879, Abram followed in his father's footsteps, becoming keeper at Cohansey Lighthouse in Greenwich, New Jersey, by the Cohansey River, which leads to Delaware Bay. In 1880, Abram married Harriet Wood Mills of Greenwich.[82] He later served at the offshore Cross Ledge Lighthouse in Delaware Bay. His bride might have joined him, but it is more likely that she stayed ashore while awaiting him on shore leaves. In 1888, according to the *Bridgeton News*, Yates was named keeper at Egg Island Lighthouse, located near Maurice River Cove in south Jersey.

A tall, imposing figure with a handlebar moustache and long sideburns, Yates was once described as "a typical waterman with 'round the face whiskers."[83] Yates was fifty-one when he was appointed keeper of Sea Girt Lighthouse. He and his wife arrived with their four children: William, twenty-two; Arthur, fifteen; Harriett, ten; and Elizabeth, eight.[84] The Yates children were the first youngsters to live at Sea Girt Light. Bill worked as a building contractor, while his brother and sisters attended school.

During Abram's tenure, organizational changes were made affecting the Light-House Board, while engineering changes were made at Sea Girt. In 1903, Congress created the Department of Commerce and Labor in

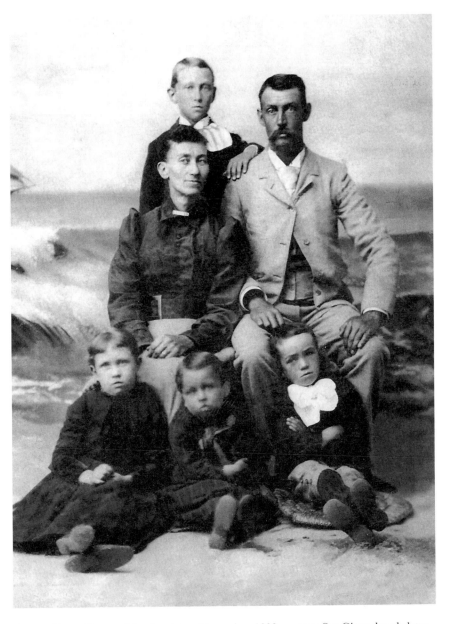

Keeper Abram Yates and family, pictured here circa 1892, came to Sea Girt a decade later. The youngsters were the first children to live at Sea Girt Lighthouse. *Donated to Sea Girt Lighthouse Collection by Tom Irving.*

*Above*: Sea Girt Inlet, pictured here circa 1900, connected Wreck Pond and the ocean. *Sea Girt Lighthouse Collection.*

*Opposite*: Keeper Yates often rode his bike about town, accompanied by his faithful dog. *Donated to Sea Girt Lighthouse Collection by Marjorie Yates Irving.*

recognition of the changing and growing U.S. economy, which had matured from a largely agricultural economy into an industrial powerhouse with rapidly increasing shipments by sea of cargo and people. The Light-House Board was moved from the Treasury Department to the new agency.[85]

The *Annual Report of the Light-House Board to the Secretary of Commerce and Labor for the Fiscal Year Ended June 30, 1904* noted the continued use of the sand fence, which was "kept in position during the winter. The sand that had drifted upon the lawn was removed, a quantity of fertilizing material was applied and some resodding and reseeding was done. Various repairs were made."[86]

On May 25, 1905, keeper Yates recorded in the logbook that a lighthouse inspector and an engineer "visit[ed] this station, took measurements of distance of inlet from the Light House lot & order[ed] a report sent in if the inlet comes within 36 feet of the lot."[87]

"The Sea Girt Inlet approached very near to the northeasterly corner of the reservation. Sand bags were stored at the station for use in making temporary revetments in case of necessity," warned the *Annual Report of the Light-House*

*Board for 1906.*[88] In the spring of 1907, a team of workers hired by the board was in Sea Girt to build a "short pile jetty...for the protection of the northeast corner of the reservation."[89]

The U.S. Army Corps of Engineers dispatched an engineer on November 12, 1907, to inspect the building and grounds, conduct an inventory and write a report of conditions. He found the lighthouse itself to be in "excellent" order. His inventory listed a windmill on the north lawn, no longer used to pump water from the well. The lighthouse was then getting its water piped into the house by the local water company.

The inventory was a checklist, numbered 1–176, with room at each entry for comments. On line 34 (Color of the Tower), the inspector wrote, "Red, with lead colored trimmings and green blinds. Lantern [room] black." On line 35 (Color of Tower, How Produced), the inspector wrote simply, "Paint."

While the lighthouse was functioning efficiently and he judged the lighthouse and the vicinity to be "healthful," the engineer noted on page five in the miscellaneous remarks section, "The site of the light-house is threatened by the encroachment of Sea Girt Inlet (locally known as Wreck Pond Inlet)." He repeated the warning in the conclusion of the sixteen-page report, adding, "If encroachment continues, works of protection will be required."[90]

More than his predecessor, keeper Yates was often seen about town, riding his bicycle on errands, followed by his faithful dog, a cocker spaniel, believed to be the first and only dog at the lighthouse. The tall, whiskered man was unmistakable in his keeper's uniform and cap. Regulations required he wear his full uniform whenever he was off the light station reservation on official business. When he was away from the lighthouse, Yates made sure to record

his absence in the Light Station Journal, including the two hours when he was "in Manasquan on business." At such times, Mrs. Yates filled in, as the wives of keepers typically did.

She soon would be in total charge, however, as Abram Yates died of heart failure on May 29, 1910. He was just fifty-eight years old, the first Sea Girt keeper to die on the job. Mrs. Yates entered her husband's death in the lighthouse logbook: "The keeper Abram L. Yates pass[ed] away today." He was buried in the Atlantic View Cemetery in Manasquan in the Yates family plot.[91]

# THIRD KEEPER: HARRIET WOOD MILLS YATES

## *(May 29–July 23, 1910)*

Upon the death of her husband, Abram, courageous and pioneering Harriet W.M. Yates immediately took command of Sea Girt Lighthouse. It was the tradition and a requirement of the U.S. Light-House Board and its successor, the Lighthouse Service, that when a keeper died, the surviving spouse and family would keep the lighthouse beacon burning bright to guide mariners in their voyages. Even as Mrs. Yates was waking her late husband in the lighthouse parlor, she was also making trips up the tower to replenish the fuel and trim the wick to keep the flame burning, as well as keeping the lens cleaned and turning to project the blinking beacon.

On June 7, 1910, Commander H.A. Bispham, the inspector for the Fourth Lighthouse District, wrote to the Light-House Board in Washington, D.C. The subject was the "Temporary appointment of Mrs. Harriet W. Yates as Keeper of Sea Girt Light-Station, N.J." He acknowledged the "honor to transmit herewith the nomination…for temporary appointment for a period not to exceed one month from May 30, 1910."

He forwarded the nomination late, one week into the one month for which Mrs. Yates was nominated. Despite the flowery introduction acknowledging his honor in passing along her name, he did not endorse her.

In the second numbered paragraph, Commander Bispham detailed the limitations of the temporary appointment: "It is proposed to fill the vacancy caused by the death of the regular Keeper by transfer of a person already in the service; and, as is customary in such cases, the Keeper having been

Harriet Yates, seen here with the children circa 1890, took command of Sea Girt Lighthouse upon her husband's death in 1910. *Donated to Sea Girt Lighthouse Collection by Marjorie Yates Irving.*

domiciled with his family at the light-station, a competent member of his family is designated for temporary appointment pending the vacation of the dwelling within the limits stated in the nomination."[92]

Mrs. Yates proved a capable keeper, having observed her husband on the job over many years and assisted him as needed. She grew confident in the keeper role, evidenced by how she signed her entries in the Light Station Journal. Initially, she signed her name "Mrs. Abram L. Yates." A few weeks later, she wrote, "Mrs. Harriet W. Yates, acting keeper." By the end of her tour as acting keeper, she signed as "Harriet W. Yates, keeper."

Enjoying the work and no doubt needing the money, Mrs. Yates applied for a permanent appointment. Mrs. Yates recruited an impressive list

of backers, including the governor of New Jersey, the state senator for Monmouth County, the former mayor of New Brunswick, the Spring Lake postmaster, the keeper of the Spring Lake Life-Saving Station and the keeper of the Squan Beach Life-Saving Station. The petition went to the top and was submitted to Rear Admiral Adolph Marix, chairman of the U.S. Light-House Board.[93]

It appears the Light-House Board was seriously considering Mrs. Yates, as it sent the petition to Commander Bispham at the district office in Philadelphia for his review and comment. Commander Bispham responded to the Light-House Board on June 9:

*Sirs:*

*I have the honor to acknowledge the receipt of the Board indorsement* [sic] *of June 8, 1910, transmitting a petition for the appointment of Mrs. Abram L. Yates to Keeper of Sea Girt Light-Station, N.J., in the place of her deceased husband, Mr. Abram L. Yates, late Keeper. In reply, I have the honor to inform the Board that, in my opinion, Mrs. Yates is not qualified for the position which she seeks, and that I would not recommend her appointment even were the position not covered by the Civil Service rules.*[94]

On June 11, the *Asbury Park Press* reported on page one that the application of Mrs. Yates had been rejected, the reason given being that she did not belong to the civil service. "Rules of the civil service commission require that the position shall be filled thru transfer of some persons already in the service, or by the appointment of someone from the eligible list of those who have taken the required civil service examination."

Mrs. Yates had not taken the exam. Department regulations limited the length and extensions of temporary appointments. "Therefore, on account of the civil service regulations, Mrs. Yates will be obliged to relinquish the place within another month."[95] The swift rejection of Mrs. Yates's application fueled controversy. Some suspected she was turned down because she was a woman. But such speculation is not supported by the historical record. There were and had long been female lighthouse keepers. Still, the majority of keepers were married men who had started as assistant keepers and risen through the ranks.

After her successor arrived at Sea Girt Lighthouse, Mrs. Yates and her younger children moved to a house on Marcellus Avenue in Manasquan.

She left the lighthouse being owed $1.72, a payroll mix-up that would be corrected a few months later, when she finally was paid for her last day on the job. Eventually, Mrs. Yates relocated to a Spring Lake neighborhood near Lake Como. The last reference to her is found in a November 26, 1917 letter written by her son Arthur, a mason living in Spring Lake, to his sister Elizabeth, living in Philadelphia with their eldest brother, Bill: "Well Lizzie, it is cold here at Spring Lake and not any work here. I have about 5 days and then I am going to look for a job and I think I will go to Bristol, Pa., as there is a lot to do up there…I want to go and see Mother some time soon but not before I can get some money in."[96]

Arthur passed away the following year. He was thirty. There have been no further details found regarding Sea Girt's third keeper, Harriet Yates.[97]

# CHAPTER 7

# YEARS OF MODERNIZATION: KEEPERS HAWKEY AND LAKE

As the nation and economy grew, so too did the number of light stations, and the Light-House Board showed signs of strain and bureaucratic inefficiencies. The Treasury secretary served as board president, but there was no clear boss for everyday oversight and decision-making. And divided authority in each district between the U.S. Navy and U.S. Army Corps of Engineers created rivalries.

Congress responded by enacting the Lighthouse Service Reorganization Act of 1910, which dissolved the Light-House Board and created the all-civilian Bureau of Light-Houses to take charge of America's aids to navigation.[98] The bureau was commonly known as the Lighthouse Service (the hyphen had been dropped, and lighthouse was now spelled as one word). The new service was put in the Commerce Department because lighthouses helped to promote commerce by making shipping safer.

More importantly, President William Howard Taft named George Rockwell Putnam, a highly regarded government engineer, to be the first lighthouse commissioner. Putnam had spent twenty years in the charts and mapmaking office of the U.S. Coast and Geodetic Survey. He had performed boundary surveys of Alaska, Mexico and the Philippines and was a member of Rear Admiral Robert Peary's 1896 expedition to Greenland to recover a meteorite.

"Under the Lighthouse Service Reorganization Act of 1910, Commissioner Putnam's first task was to convert the organization from a military-directed service to a fully civilian organization. He accepted the

George Putnam, the first lighthouse commissioner, sits at his desk beneath the Lighthouse Service flag in this photo portrait from the Library of Congress collection. *Courtesy Lucy Grace Barber, great-granddaughter of George Putnam.*

appointment after getting a fairly reasonable assurance of freedom from political interference," wrote Captain Jean Butler in *Coast Guard* magazine.[99]

In his twenty-five years as lighthouse commissioner, Putnam modernized, streamlined and expanded America's lighthouse and lightship operations, introducing new technology that improved navigation and efficiency. Several technological improvements were introduced at Sea Girt on Putnam's orders, as seen in the lighthouse archives. Under his direction, Sea Girt went into the history books (as well as one of his own books) as the first land-based station equipped with a radio transmitter specifically designed to enable mariners to navigate by radio beacons when fog obscured the flashing light beacon. Putnam mentions Sea Girt's distinction in his 1931 book, *Radiobeacons and Radiobeacon Navigation.*

During his tenure, the number of aids to navigation more than doubled. "Putnam also championed many personnel actions that improved working conditions for employees, things that are taken for granted today, such as performance awards, compensation for on-the-job injuries, annual leave for crews of tenders, paid sick leave for hospitalized crews of tenders

and lightships, and reimbursement for provisions and clothing provided by employees to shipwreck victims. Most notably, his commitment and perseverance led to the passage of the Retirement Act for Lighthouse Service field personnel," according to historian Butler.[100]

# FOURTH KEEPER: JOHN L. HAWKEY

## (July 28, 1910–March 15, 1917)

For over three decades, John L. Hawkey served aboard lightships anchored at sea near the shipping channels. He was the engineering officer aboard Five Fathoms Banks Lightship and, later, Northeast End Lightship, both of which were located off Cape May. He maintained the machinery and equipment, including lanterns and lenses. Engineer Hawkey would be three weeks at sea, followed by ten days of shore leave[101] spent at his Cape May home with his wife, Viola.[102]

Hawkey finally came ashore for good in 1910 at age sixty-five—but not to retire. The Lighthouse Service had no mandatory retirement age at that time, and Hawkey was posted to Sea Girt, arriving on July 28. The payroll office mistakenly paid him twice that day—for a full day's work at both the lightship and the lighthouse. When the error was discovered, the district lighthouse inspector fired off a letter to newly arrived Hawkey, alerting him. The inspector advised, "You are therefore indebted to this office in the sum of $1.72, and you will please forward that amount to this office. The amount referred to above is payable to Mrs. Harriet W. Yates."[103]

After settling into lighthouse life, Mrs. Hawkey became involved in the community and at the Methodist church in Manasquan. The couple had no children.

For Hawkey, his new assignment must have been liberating and relaxing but at the same time challenging. No longer was he confined aboard a cramped lightship, isolated miles offshore, counting the days until his next shore leave and wondering what was happening in his community. Instead of being surrounded by water for weeks on end, Hawkey had fertile land on which he and his wife could tend a vegetable garden, neighbors with whom to chat and a village to explore on foot or by train or trolley only a few blocks west. In Sea Girt, Mr. and Mrs. Hawkey found a community they liked and

in which they eventually planned to stay.

Running a lighthouse was definitely less stressful than maintaining a lightship, which was accompanied by the constant worry of the ship's being rammed by an off-course vessel in a fog or storm. While much was routine at the lighthouse, there were times when Hawkey was called on to use the mechanical skills he had honed as a lightship engineer. For example, on instructions from headquarters in mid-1912, Hawkey changed the light source inside the Fresnel lens from a kerosene wick lamp to a thirty-five-millimeter incandescent oil-vapor lamp. The ruby chimney was removed to produce a brighter, white light.

As instructed, he also reengineered the timing and pedestal of the Fresnel lens to accelerate its revolutions to create more flashes per minute. Headquarters ordered the timing of the flash be changed from one flash every 6.0 seconds to one flash every second (0.3-second flash, 0.7-second eclipse or dimness, repeat).[104] "Notice to Mariners, No. 23," published in early June, announced the change would take effect "about June 24."[105]

While the Lighthouse Service was a civilian outfit, there was a top-down organizational structure, including ranks and inspections, and the men were uniformed in what were basically naval officer uniforms (except for the Lighthouse Service markings). And like military regimentation, regulations as well as direct orders were to be followed, and most everything involved paperwork.

Just to be on the safe side, keeper Hawkey wrote to district headquarters in early September 1912 to request permission to build a henhouse, apparently wanting to ensure a steady supply of breakfast eggs. District superintendent Joseph Taylor Yates gave what is now called a "non-response response": "You are directed to take this matter up with the Inspecting Officer when the station is next inspected, at which time the Inspecting Officer will make report and recommendation to this office."[106] It's unclear if Hawkey ever got his henhouse because no further correspondence on the subject has been found. But the son of the next keeper once recalled there was a chicken coop at the lighthouse during their time there,[107] which would seem to suggest that Hawkey prevailed and got his breakfast eggs.

While lighthouses were regularly inspected beginning in the early Federal period, Commissioner Putnam, in 1912, instituted the Efficiency Star program to recognize top-rated keepers. "To promote efficiency and friendly rivalry among lighthouse keepers, a system of efficiency stars and pennants has been established. Keepers who have been commended for efficiency at each quarterly inspection during the year are entitled to wear

the inspector's star for the next year, and those who receive the inspector's star for three successive years will be entitled to wear the Commissioner's star."[108] To eliminate subjectivity, the service devised a uniform system—a checklist—for inspectors to run through during inspections.[109] The inspections were typically performed by the district superintendent or a deputy from the district office.

But in a surprise move, George Putnam, the top man in the entire Lighthouse Service, apparently visited Sea Girt Lighthouse himself in late 1913. He was most likely there not on a routine quarterly inspection but to inspect the beach erosion and the level of threat it posed to the lighthouse. The only record of the visit so far uncovered is a curious one-sentence letter sent by an assistant at the direction of the district superintendent in Staten Island to John Hawkey. The letter, dated January 6, 1914, reads, "Returned herewith is two cents in postage received with your letter referring to alleged visit of Commissioner Putnam to the station in your charge."[110]

By mid-July 1914, a work crew from the district depot had been dispatched to Sea Girt to make several repairs, including putting a new shingle roof on the house, repairing the tower's gallery railing, rebuilding the sand fence and building a retaining wall. On Form 80, detailing the work, budgeted at $976, approval came from Washington with the following initialed notation: "To be paid for from funds allotted when available."[111]

A severe storm on March 6, 1915, prompted Hawkey to submit urgent reports dated March 7 and 18 to the Lighthouse Service command in Staten Island.[112] U.S. Army Corp of Engineers investigators soon arrived to assess the situation.

Almost a century later, over a dozen photos were uncovered in the National Archives in Washington, D.C., that dramatically document the uncertain situation the lighthouse was in as a result of beach erosion. While the lighthouse standing on a bluff offered some protection, the beachfront was being steadily washed away. East of the lighthouse property, there was a sharp drop to the beach.

Measures taken earlier were helping but not solving the problem, as the inspecting engineers documented. Erosion was occurring along long stretches of the Jersey coast. The U.S. Army Corps of Engineers began building wooden groins as early as the 1880s in Squan Inlet and at Sea Girt Inlet after 1900. Rock jetties began being built a decade or two later. The state, county and oceanfront communities were also getting involved.

District superintendent Yates wrote to Commissioner Putnam on March 27, reporting on the evidence gathered by the investigators: "The high

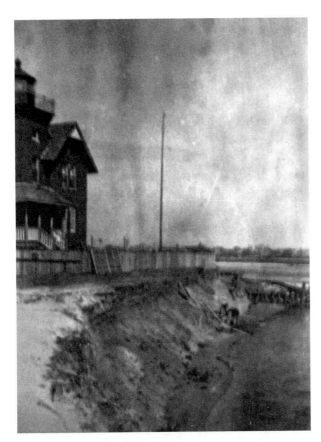

*Left*: U.S. Army Corps of Engineers documented beach erosion near the lighthouse in March 1915. *National Archives and Records Administration.*

*Below*: An investigator wrote the following beneath this photo: "Shows creek flowing past station, damage done to embankment by the storm and temporary bulkhead under way." *National Archives and Records Administration.*

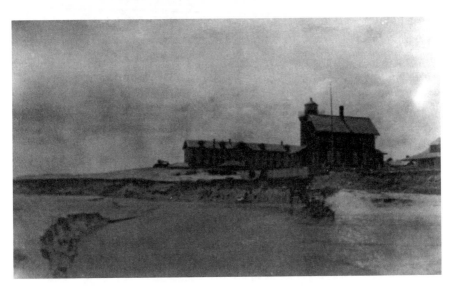

ground and roadway in front of the reservation have been washed away, the washout (edge of bank) is within 25 feet of the reservation at the south corner, and up to the boundary fence for a distance of 20 feet at the north corner…Immediate action is necessary at this point."[113]

Four days later, the chief construction engineer of the Lighthouse Service, H.B. Bowerman, wrote to Putnam of his own Sea Girt inspection, adding more detail and supporting Yates:

> *There is now an opening in the beach in front of the light station and the water coming down the creek north of the light has an outlet there to the ocean. Also found Asst. Supt. Hingsburg and two men at work constructing a temporary bulkhead inside the line of the proposed permanent bulkhead…The 3rd Inspector thinks that an interlocking sheet of steel pilings driven along the 100 feet of the east side and about 25 foot back on both the north and south sides, on the line of the present fence, will answer the purpose very well. The piles should be about 30 feet long…It will cost at least $5,000, but the Inspector thinks that it is worth it and is well inclined to make the recommendation, if necessary, in which I would concur. The station is of some importance and is probably worth about $12,000. While it should have been originally located about three miles farther south, in order to equally divide the intersection of the ranges of visibility of Navesink and Barnegat, the station cannot readily be moved, as the buildings are of brick.*[114]

Eventually, steel bulkheads were installed. Thirty-foot-long interlocking steel plates were pounded into the ground along the front of the reservation and twenty-five feet inland along the north and south sides. The bulkheads secured the property, but erosion along the beachfront and Wreck Pond's overflowing its banks due to ocean storm surges continued. The *Annual Report of the Lighthouse Service* included in its list of projects in fiscal 1915 "grading and protecting site from erosion" at Sea Girt Light Station at a cost of $4,771.[115]

Hawkey was the first Sea Girt keeper to be covered by health insurance, a reform spearheaded by Superintendent Putnam. The enabling legislation passed by Congress on August 28, 1916, stated that "light keepers and assistant light keepers of the Lighthouse Service shall be entitled to medical relief without charge at hospitals and other stations of the Public Health Service under the rules and regulations governing the seamen of the merchant marine."

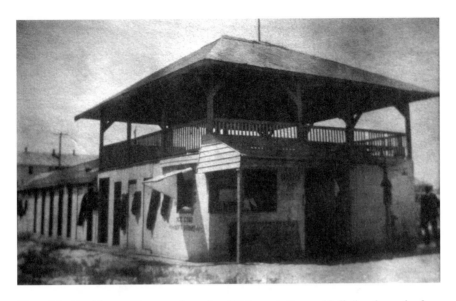

The original bathing pavilion, seen here circa 1916, was built on a bluff directly south of the lighthouse. *Courtesy Richard O. Venino.*

The day after Congress extended hospital benefits to light keepers, it approved the Naval Appropriations Act, giving the president authority to mobilize the Lighthouse Service "whenever in his judgment a sufficient national emergency exists, to transfer to the service and jurisdiction of the Navy Department, or of the War Department, such vessels, equipment, stations and personnel of the Lighthouse Service as he may deem to the best interest of the country." Congress was readying America for World War I, which had been raging in Europe since 1914.

Despite the beach erosion threatening the lighthouse and the war threatening the nation, a bathing pavilion was erected around this time on a bluff directly across the sandy road from the lighthouse. With a refreshment stand, changing rooms and a small upstairs porch, the pavilion attracted swimmers and sunbathers to the beach by the lighthouse.

On March 15, 1917, John Hawkey, like Abram Yates seven years before, died on the job of a heart attack. Hawkey was seventy-one years old, the oldest of Sea Girt's keepers. He was returned to Cape May, where he was buried in historic Cold Spring Cemetery.

Soon after her husband's death, Mrs. Hawkey moved to a Sea Girt house two blocks from the lighthouse that the couple had built in 1913 as a vacation house where they hoped to retire. She lived a long life, spending more than

Light keeper John Hawkey was also an inventor, receiving Patent #274,765 in 1883 for his "automatically operating door." *U.S. Patent and Trademark Office.*

three decades in Sea Girt.[116] She spent her final years in a nursing home, dying in 1949 at the age of ninety-four. She joined her husband at Cold Spring Cemetery.

John Hawkey is the only Sea Girt keeper for whom a photo has not yet been found. However, a patent issued to him in 1883 for an invention of his has been uncovered. Dan Herzog, a lighthouse member who researched his own family tree, joined the photo hunt and search for more details about Mr. Hawkey. Dan greatly expanded our knowledge of Mr. Hawkey and his wife, Viola; their many years in Cape May; and the keeper's extracurricular activities.

During his lightship days, Hawkey might have passed his spare time the way many off-duty sailors did—playing cards, reading books and magazines from the ship's library, writing letters, whittling, tying knots and painting. Or he might have had brainstorms for inventions, one of which was awarded a patent: "Be it known that I, John L. Hawkey, a citizen of the United States of America, residing in Cape May city, in the county of Cape May and State of New Jersey, have invented certain new and useful improvements in Automatically Operating Doors."[117] On March 27, 1883, the U.S. Patent and Trademark Office issued Patent 274,765 to J.L. Hawkey.

So in addition to being a lightship engineer and, later, a lighthouse keeper, John Hawkey was an inventor. Until a photo of Hawkey is discovered and added to its rightful place in the Keepers Photo Gallery, the lighthouse will proudly display the drawings for his invention there.

# FIFTH KEEPER: WILLIAM HENRY HARRISON LAKE JR.

## (Spring 1917–October 29, 1931)

William (Pappy) Lake, a veteran of the U.S. Lighthouse Service, transferred from Shinnecock Lighthouse on Long Island to Sea Girt, arriving in the early spring of 1917. Bill Lake, thirty-seven, was married and the father of a four-year-old son. He was the youngest keeper ever assigned to Sea Girt, serving during a time of transition and startling change at the lighthouse, in the town of Sea Girt and across the nation.

Just before Lake's arrival, Sea Girt residents wanting more control of their community sought to incorporate as a municipality, independent of the sprawling Township of Wall, to which the mile-square village belonged. On

*Top*: William Lake, Sea Girt's fifth keeper, vowed to outlast his predecessors and did so by several years. *Donated to Sea Girt Lighthouse Collection by the Lake family.*

*Left*: Edith Lake—a realtor, elected official and loving mother—with son Elvin, known to all as Toots. *Donated to Sea Girt Lighthouse by the Lake family.*

March 29, 1917, Sea Girt became a municipality via an act of the New Jersey legislature. Then, on April 6, after nearly three years of neutrality, the United States entered World War I. President Woodrow Wilson sought and Congress passed the Declaration of War after Germany resumed U-boat attacks on commercial vessels. The president next issued Executive Order 2588, activating a plan devised in 1916 by the U.S. Navy and Commerce Department.

Some 1,100 lighthouse personnel, four lightships and twenty-one lighthouses, including Twin Lights and Cape May, went on temporary navy duty. The War Department took thirty tenders and used them in placing mines. The ships and crew were later reassigned to the navy, which also received sixteen more tenders.[118] Sea Girt Lighthouse and most U.S. light stations were still under the command of the Lighthouse Service, and keeper Lake remained a civilian.

Bill Lake began his new assignment with a promise. "All hands in the village expected me to pass out after seven years," he said. The driver who brought him from the train station to the lighthouse told him that the previous light keepers lasted at most seven years and that two had died on the job. Lake recalled advising the driver, "Well, I'll tell you right now that I'll be damned if I do." Lake vowed to outlast them all. And he did, serving fourteen years and becoming the longest-serving keeper at Sea Girt Lighthouse.[119]

Born on Staten Island, Lake entered the Lighthouse Service at age eighteen. He spent twelve years at Fire Island Lighthouse, followed by postings to Warwick Lighthouse in Rhode Island and then Shinnecock Lighthouse on Long Island. It was during his Shinnecock tour that he met and married Edith Fildes, a bright woman who would become a pioneer in her chosen fields in Sea Girt and a doting mother to their son, Elvin, whom they and everyone else called Toots.[120] The youngster definitely livened things up at Sea Girt Lighthouse.

Jack Little, a childhood friend of Toots, recalled years later that the lighthouse became "more or less a headquarters for all the kids of the area." Mr. and Mrs. Lake, a friendly couple, welcomed their son's playmates to the lighthouse, which children viewed as a magical and adventurous place—with its long porch, tall tower, spacious grounds and proximity to the beach, inlet and ocean.[121]

Toots had many interests. He loved animals and had a rabbit. He sailed his rowboat on Wreck Pond. He liked to fish there. He was a good swimmer and, years later, became a lifeguard. As Sea Girt did not then have a school, he attended the Mountz Elementary School in Spring Lake.

The porch steps were moved to the south side in 1920. Lifeguards stand ankle-deep in storm waters. *Donated to Sea Girt Lighthouse Collection by the Theodore Wilson family.*

Mrs. Lake was an independent woman. She opened one of the first real estate offices in town and was a founding member of the Sea Girt Women's Club. She was the first woman elected to the Borough Council and was talked about as a mayoral candidate. "She would have sought the mayoralty and probably won, but for the fact that her friend Frank Durand was a candidate for the post," wrote Jack Little. "She had no desire to oppose him, so she shelved her political ambitions in deference to him."[122]

World War I ended on November 11, 1918. The Lighthouse Service resumed normal operations and expansion. A telephone party line was installed at the lighthouse in 1920 in the final stage of a program funded by Congress to upgrade communications at all lighthouses and their command centers.

As a precaution, the Lighthouse Service had the front porch steps at the lighthouse moved in 1920 from their original oceanfront location to the south side, putting them farther back from the property's east line and the beach.

That same year, Sea Girt became the first land-based station equipped with a radio beacon transmitter system. Two skeleton towers, taller than the lighthouse, were erected. An antenna was strung between them and connected to an automatic transmitter in the lighthouse. Similar rigs were installed on Ambrose Lightship and Fire Island Lightship. "Tests of these stations were made September 1920, and later, they were placed in regular operation on May 1, 1921. These were the first successful radiobeacons in the world," wrote lighthouse commissioner George Putnam in his book *Radiobeacons and Radiobeacon Navigation.*[123]

"These stations were selected so as to enable vessels approaching or leaving New York to locate themselves conveniently by cross bearings," noted Putnam in the *Annual Report of the Commissioner of Lighthouses to the Secretary of Commerce for the Fiscal Year Ended June 30, 1921.* Each station transmitted a unique signal. Sea Girt's was three dashes for sixty seconds followed by six minutes of silence.[124] When fog obscured the flashing beacons of light stations, mariners could fix their positions through triangulation—tracking the distinct radio signals of the three installations. This system was a forerunner of long-range navigation (LORAN), the terrestrial radio navigation system developed by the Allies during World War II when U.S. and other Allied lighthouses extinguished or dimmed their beacons so as not to give aid to the enemy. The success of the fog beacon transmitters at the first three installations prompted the Lighthouse Service to expand the system to other stations. (Sea Girt's transmitter operated until 1928, when it was moved to Barnegat Lightship.)

Electric service was brought to Sea Girt Lighthouse in late 1924 to illuminate the tower but not the living quarters. On the recommendation of district lighthouse superintendent J.T. Yates, a 300-watt PS 35 lamp with a C-7 filament was installed inside the Fresnel lens, replacing an oil-vapor lamp. The change increased the candlepower nearly tenfold from 11,000 to 100,000. The stated reason for the change was "to increase intensity of light and decrease labor of attendance."[125]

The weight that dropped down the tower shaft, driving gears that made the lens revolve, was replaced by an electric motor. No longer would the keeper have to crank the weight back to the top to start a new descent to keep the lens revolving and the light blinking.

Jack Little wrote the following about keeper Lake's long career and how it was before and after electrification:

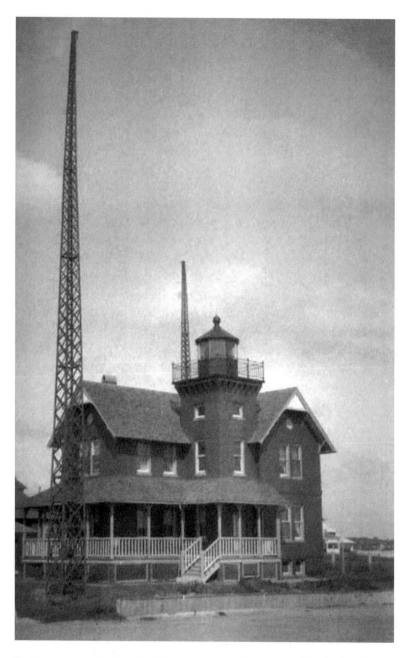

Skeleton towers, taller than the lighthouse, support the antenna of the first land-based radio fog transmitter, 1921. *Courtesy Kenrick A. Claflin & Son Nautical Antiques.*

*In early days, these lamps were operated with kerosene; then the switch was made to electricity in the early 20's...We recall Bill and Elvin winding the weight* [before electrification] *many a time throughout the night. It had to be wound every five hours, and if Bill or Elvin might have forgotten, which they never did, an automatic gong would ring to remind them. Even in Bill's latter days as a keeper, the service was, as he put it, "not what it used to be. It's far better. There's no oil and wicks to bother with. Now all we do is turn a switch and it starts.* "[126]

As the lighthouse was undergoing modernization, so too was the town around it. When Bill Lake came to Sea Girt, he said there were so few houses he could walk in a straight line from the lighthouse to the train station almost a mile distant. By the mid-1920s, he could not say that. Sleepy little Sea Girt was being discovered and becoming a popular resort town. Construction of jetties, groins, bulkheads and other remedial projects along the coast slowed erosion and enabled towns, including Sea Girt, to stabilize and rebuild their beachfronts.

Meanwhile, the sandy streets began to be paved one by one. With beach replenishment and careful engineering, a short road named Ocean Avenue extended from in front of the lighthouse south for several blocks. With paved streets came more and more beachgoers and their cars, which could often be seen parked by the lighthouse—although one of them might have belonged to Pappy Lake. He is believed to be the first Sea Girt keeper to own a car. He is the first one documented to have driven an automobile, evidenced by an application for eight-day leave in which he gave "motoring to Long Island" as his itinerary.[127]

Summer cottages began popping up around town, and in 1925, the Borough built a bathing pavilion on the beach by Chicago Boulevard, a block south of the lighthouse. The two-story, clapboard pavilion with a covered observation deck cost over $50,000, financed by a bond issue, according to *The Sea Girt History* (1926) by Cecil Butler.[128] Replacing the pavilion put up in the previous decade across the street from the lighthouse, the new, larger building offered lockers, changing rooms, showers and a sweet shop—but no boardwalk (not yet).

In early 1926, the color of Sea Girt Lighthouse—then painted red—became an international issue. An officer aboard the Dutch freighter *Hillegom*, likely the captain, after steaming past Sea Girt Lighthouse, wrote to the U.S. Navy to "politely suggest" the lighthouse be painted "another, more striking colour; because in hazy and snowy weather like we encountered

This 1926 photo of the Sea Girt beachfront shows the Tremont Hotel, the new pavilion and the lighthouse but no boardwalk. *A.H. Holthusen.*

as we passed it, the lighthouse is extremely difficult to make out, owing to its great similarity to the chimneys of oil plants or factories which abound in that vicinity." The U.S. Navy relayed the suggestion to Commissioner Putnam. The suggestion was rejected with a marginal note on the letter from the navy by Putnam or one of his deputies: "Sea Girt does not look like a chimney."[129]

Meanwhile, the Borough was trying to build a boardwalk, but the proposal proved controversial. "In the 1920s, the Borough made several attempts to build a boardwalk along the ocean, and these efforts were forcefully resisted by the [Elliston] Morris family and many of their neighbors with oceanfront property. These people felt that a boardwalk would change the nature of Sea Girt and lower property values not only along the ocean, but in the rest of the Borough as well," according to the Monmouth County Historical Association.[130]

On November 5, 1929, the Borough put its boardwalk plan on the ballot, which was supported by a majority of Sea Girt voters. Construction proceeded after the courts rejected a suit by opponents, who claimed a boardwalk would violate property rights and obstruct their ocean views and access to the sidewalk and street. Once finished, the wooden boardwalk—measuring sixteen feet wide—extended from Beacon Boulevard three-quarters of a mile south to Trenton Boulevard, stopping just short of the Stockton Hotel, which had its own boardwalk.

In July 1931, Edith Lake passed away. The *Asbury Park Press* called her "an able woman with keen business ability and political sagacity." The following month, Pappy took a two-week leave to recover and consider his future. The Lighthouse Service picked up the cost of the substitute keeper, which was not a change in policy but a bereavement benefit. Upon return, the keeper resumed his duties while preparing to retire from the Lighthouse Service.

Bill Lake, the youngest and longest-serving keeper to be posted at Sea Girt, retired on October 29, 1931, at fifty-two. He took over his late wife's real estate business and lived above the office on Washington Boulevard, where the Governor's Court condominiums are now located. He died on July 10, 1951, at the age of seventy-two.[131]

# CHAPTER 8
# FINAL YEARS UNDER THE LIGHTHOUSE SERVICE: KEEPER THOMAS

The Lighthouse Service, the civilian agency created in 1910 as the successor to the quasi-military Light-House Board, matured and grew under the capable leadership of lighthouse commissioner George Putnam. In 1910, the Light-House Board handed off 11,713 aids to navigation to the Lighthouse Service. By the mid-1930s, the service operated 24,000 along the coasts, rivers and inland waterways. Buoys and small, unmanned lights accounted for most of that total, according to "Lighthouses: An Administrative History," an online history found at the Maritime Heritage website of the National Park Service.[132]

Coast Guard historian Robert Browning notes, "One of the most frequently asked questions is how many lighthouses have been built. This is not a question that can be easily answered because almost every lighthouse has been rebuilt at one time or another." In New Jersey, the present Barnegat Lighthouse was preceded by two earlier lighthouses, while Navesink Twin Lights replaced an earlier, smaller lighthouse on the Navesink Highlands. Browning concludes, "I believe that nearly 1,500 lighthouse sites have existed in the United States at one time or another."[133]

The total of actual lighthouses in operation in the United States was never more than 850, a peak reached around 1910, while lightships peaked at 77 in 1915, according to the United States Lighthouse Society.[134] Technology inevitably led to a reduction in staffing. In 1936, the Lighthouse Service had some five thousand personnel,[135] a drop of eight hundred from the early days of the service.

Among the technological breakthroughs adapted by the Lighthouse Service were a bell alarm warning keepers of fluctuations in the burning efficiency of oil-vapor lamps, an automatic device for replacing burned-out electric lamps, a time clock that operated electric tower lamps and range lights, lightships operated by remote control and the further development of radio-beacon navigation. The last was a broader application of the radio-beacon system introduced at Sea Girt in 1921 that was later used effectively in ship and air navigation in all types of weather, according to "Lighthouses: An Administrative History." The article concludes:

> *Because of the technological improvements mentioned above, and in particular the radiobeacon direction finder, the United States rose from sixth in shipping safety in 1920 to second in 1935, with only the Netherlands holding a better safety record.*
>
> *Improvements in the road and highway systems provided better and more rapid means of transportation during the 1920s and 1930s. As a result of the improved roadways, the Bureau was able to better maintain aids to navigation, benefiting the service economically. The extension of electric lines into remote sections of the country provided a reliable power source for operating aids to navigation. By the 1920s and 1930s, the majority of light stations had electric service, reducing the number of staff necessary to operate the station. As ancillary buildings at many stations, especially shore stations, were rendered useless, the makeup of the light station began to change.[136]*

The decline in personnel accelerated as some stations, reclassified as obsolete, were discontinued to save costs. As early as 1932, Sea Girt faced that prospect. The station came under review for possible closure or automation but remained staffed for years to come.

The 1930s would prove a challenging time for the Lighthouse Service and its personnel as new technologies continued to be introduced against the backdrop and constraints of the Great Depression, the political instability in Europe and economic and social uncertainty at home.

The keeper assigned to Sea Girt during the 1930s was the right person for the job and the times. He was flexible, adaptable, unflappable, resourceful, conscientious and independent enough to take the initiative when an unexpected challenge confronted him.

# SIXTH KEEPER: GEORGE JOSEPH THOMAS

## (October 29, 1931–March 31, 1941)

George J. Thomas was the sixth and last keeper at Sea Girt to be appointed by the Lighthouse Service, which he would outlast. Sea Girt would be his last posting. He was a decorated keeper.

Born in Brooklyn in 1876, Thomas first worked for several years as a steam locomotive fireman for the Brooklyn–Rockaway Beach Railroad, surviving a train derailment. He next worked for more than a decade at a flour mill. He left briefly to join the Lighthouse Service in 1906, being assigned as second assistant keeper at Race Rock Light in Long Island Sound. After two months at the offshore light, he resigned and returned to the flour mill. He married Minnie DeBow in 1910. A year later, their first daughter, Lucy Caroline, was born.[137]

Thomas rejoined the Lighthouse Service in 1913 as second assistant keeper at Fire Island Lighthouse on the barrier island off Long Island's south coast and first assistant a year later. Mr. and Mrs. Thomas and daughter Lucy lived in an apartment in the stone house that connected to the tower. A second child, Alice May, was born in 1915.[138] On November 23, 1917, George was named head keeper.[139] A week later, the ever-vigilant keeper "rendered [assistance] in rescuing from a dangerous position two aviators whose hydroplane had plunged into Great South Bay and partly sunk," reads a Lighthouse Service commendation.[140]

During World War I, Fire Island Light and a few dozen other lighthouses were put under U.S. Navy command along with their keepers.[141] George Thomas continued as the keeper at Fire Island.[142] Several months after the war's end, he was reassigned to Point Au Roche Lighthouse, an offshore station on Lake Champlain in upstate New York. In her unpublished memoir, daughter Alice recalled the family's April 1919 arrival and George's reaction:

> *After an all day train trip one day, we arrived at Plattsburgh, N.Y. on the western shore of Lake Champlain. Had communications been better in those days, we wouldn't have gone on such a "wild goose chase." Mom and Pop discovered that the lighthouse was in the middle of Lake Champlain and keepers spent 2 weeks at a time at the light while families lived ashore. This was a worse situation than Fire Island, so we returned to Brooklyn*

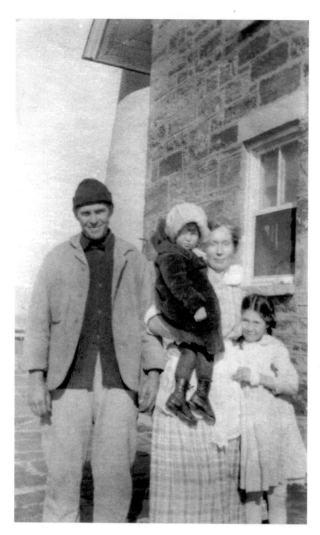

George Thomas and wife, Minnie, who holds baby Alice while Lucy stays close to mom, Fire Island Lighthouse, circa 1919. *Donated to Sea Girt Lighthouse Collection by Lucy Thomas.*

*the next day, wiser and a little poorer. Pop resigned, but within a week or so was offered the position of second assistant keeper at Shinnecock Bay Light Station with salary reduced.*[143]

Even though his resignation was short-lived, it would complicate matters when Thomas applied for retirement. But that discovery was decades away, and he was soon back with the Lighthouse Service. "You are advised you have been recommended for reinstatement as 2nd assistant keeper at Shinnecock Bay Light Station," wrote district lighthouse superintendent Y.T. Yates on

May 23, 1919.[144] The appointment took effect on May 27. The annual pay was $600.[145] As head keeper at Fire Island, Thomas had earned $900. Alice's narrative continues:

> *Pop took the job anyway, and in June 1919 we moved to Good Ground on Long Island, N.Y. Shinnecock Bay Lighthouse was on Ponquogue Point on the mainland of Good Ground…In 1922 the name of the village was changed from Good Ground to Hampton Bays (maybe that sounded classier). Life, as was usual with most families of the time, revolved around work, church, and school. Since Pop had been under the Navy during World War I, he joined the American Legion and Mom the Auxiliary. The first Legion building was not far from the lighthouse, between Foster Ave. and Lighthouse Road. Someone there ran programs for children, and I learned to play the ukulele (very popular then) and dance the Charleston.*[146]

While Shinnecock meant a pay cut for George Thomas, the family was able to stay together, get involved in the community and live normal lives, which would have been impossible if Thomas took the offshore Point Au Roche job. Shinnecock Lighthouse, with a first-order Fresnel lens that projected its beacon some twenty miles, was an important light on the south side of Long Island that required a keeper and two assistant keepers.

Attached to both sides of the brick tower were three-story white clapboard houses. The head keeper's family occupied the one on the west side. The other assistant keeper occupied the first floor of the eastside house. "Above him, we had a kitchen and living room on the second floor with two bedrooms above that," Alice remembered.[147] She and her sister Lucy befriended Hans and Fritz Aichele, whose father, William, was head keeper, as well as the daughters of assistant keeper Waldo Penny, Shirley and Hope. They all attended the village school a half mile away, noted Waldo Penny descendant Richard Casabianca in a March 27, 2013 e-mail to the author.

The children made the most of their free time, visiting friends or inviting them over to play on the spacious lighthouse grounds or the beach nearby. "All we had to use on the bay was a rowboat. Later, we were given a canoe, which was a lot more fun," wrote Alice. She also recalled the dread of the inspector: "After breakfast, beds had to be straightened and as much as possible left in order because you never knew when the inspector might come. Imagine Mom's consternation one morning as we were finishing breakfast when the town jitney drove up and out stepped the inspector. All Mom could do was try to straighten things a little in the kitchen while she

fixed breakfast for him. Apparently all went well because the station was rated excellent as usual."[148]

Shinnecock would prove a casualty of Commissioner George Putnam's modernization program. The light was scheduled for deactivation in mid-1931, to be replaced by an automatic light. In anticipation, keeper Thomas sought reassignment to a land-based station. He wrote to headquarters of his interest in two Connecticut lighthouses, as well as Sea Girt. Disregarding Thomas's request, district lighthouse superintendent J.T. Yates wrote in mid-May to inquire if he would consider an offshore position as second assistant keeper at New London Ledge Lighthouse in Connecticut in the event of a vacancy. The superintendent noted that "no family quarters are provided at this station." The salary would be $1,680, more than what he was making at Shinnecock. Before sending a formal reply indicating he had no interest in the offshore position, Thomas drafted his response a few times to get the wording just right and state again his preference for a station with family quarters. In the handwritten draft, Thomas states that he wishes to remain at his present station as long as possible until there is a keeper vacancy "where I can take my family."

On August 3, 1931, Thomas was offered a transfer to the offshore Bullock Point Lighthouse in Rhode Island. He responded, "Please be advised that I do not wish to be considered for this vacancy. As my wife passed away yesterday I would like to remain here as long as possible."[149] Minnie was forty-four years old at the time of her death, according to the family genealogy.

Ultimately, George Thomas's patience and respectful persistence paid off. On October 16, the lighthouse superintendent wrote him to report that he had been nominated for the opening at Sea Girt, succeeding retiring Bill Lake. "You are directed to hold yourself in readiness to report for duty as soon as definite orders are sent you." The start date was to be "on or about October 31st." Thomas responded immediately: "Please be advised that I am holding myself in readiness to report for duty." In fact, George Thomas took command of Sea Girt Light on October 29.[150]

The widowed Thomas was fifty-five at the beginning of his long tour of duty at Sea Girt, during which time he earned numerous commendations and Efficiency Stars. Daughters Alice and Lucy were fifteen and twenty, respectively. They settled in easily and made friends in the community. Alice enrolled in Manasquan High School. Lucy ran the household, with help from Alice, while their father kept the beacon burning bright, tended to paperwork, serviced the equipment and made repairs as needed.

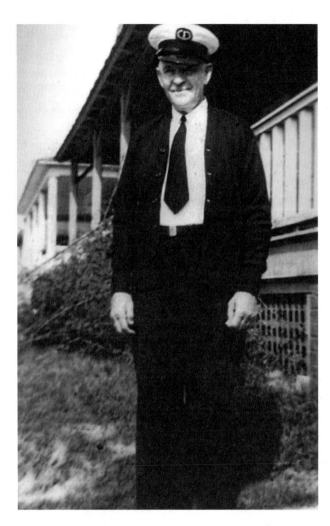

Widowed George Thomas and his daughters arrived at Sea Girt in 1931 after having declined offshore postings. *Courtesy Kenrick A. Claflin & Son Nautical Antiques.*

George Thomas's tenure at Sea Girt started with a bang. Headquarters ordered the removal of the towers of the radio fog beacon system deactivated in 1928. Bids for the job were solicited, and a local crew of ironworkers was hired. Dismantling the towers, which were taller than the lighthouse, was scheduled for December 5.

As Thomas reported that day in his letter to the superintendent, taking down the skeleton towers did not go according to plan. "They jacked it [the southeastern tower] off the foundation, and when they did it got away from them." Portions of the tower landed on the southwest corner of the porch roof and the oil house.[151] Then the ironworkers turned their attention to

the other tower, which "fell across the fence which is on the north of the reservation and damaged it badly."[152] Thomas sprang into action, initiating repairs. In a follow-up report, he wrote, "I wish to inform you that the roofs have been repaired with new material...The fence has been restored to its original condition with new material. The contractor finished this work on December 19th. The reservation has been left in good condition."[153]

During the winter of 1932, the keeper was busy overseeing electrification of the living quarters and installation of a boiler and pipes for a hot-water heating system, as authorized by the superintendent to "improve living conditions for keeper to compare with the adjacent residences."[154] The new heating system obviated the need for a fireplace in every room. Eventually, the fireplaces were removed, except the one left in the parlor. The southwest chimney also was later taken down.

On June 24 in Washington, Commissioner George Putnam wrote to Superintendent J.T. Yates in Staten Island seeking his assessment of a report by a committee of the American Steamship Owners Association that concluded Sea Girt Lighthouse could be discontinued without serious detriment to navigation.[155] Yates disputed the report, writing on June 27, "Sea Girt Light is the only light on the Jersey coast between Highlands and Barnegat...This light is extremely important, especially in the winter time when there are no other lights showing along the shore on the Jersey coast."[156]

Yates reviewed the option of automating the lighthouse, concluding, "This office is of the opinion that this light would be more expensive to maintain as an automatic light than as an attended light." Someone in the commissioner's office other than Putnam wrote in the margin of Yates's reply, "Not apparent if placed in charge of a caretaker at nominal salary."[157]

In addition to enabling mariners to fix their positions, lighthouse beacons also orient and give precious hope to passengers and crew in those horrible situations when the order is given to abandon ship, as happened off Sea Girt on September 8, 1934.

The night before the scheduled New York docking of the cruise ship *Morro Castle*, the captain died of a heart attack. In the early morning hours of September 8, just hours from port, fire was discovered in a closet in the Writing Room on B Deck. The acting captain navigated the ship at twenty knots through a raging nor'easter. The ship's lacquered wood paneling was fuel for the fire, which spread quickly, fed by strong winds racing through the ship's ventilation system. With a pump system designed to simultaneously deliver water at top pressure to six hydrants, water pressure dropped to a trickle as the crew opened almost two dozen hydrants.

The first SOS was sent thirty-nine minutes after the fire's discovery at 2:45 a.m., ship's time. The acting captain ordered lifeboats lowered; some could not be reached. He struggled to turn the ship out of the wind and toward the beach. Then the steering and engines quit. In less than an hour, all hope was lost. The ship was some three miles offshore. The acting captain gave orders to drop anchor and abandon ship, although he and several other officers stayed with the ship, moving to the forecastle.[158]

While *Instructions to Employees of the United States Lighthouse Service* stated that beacons were to be extinguished at sunrise, it also ordered keepers to "give or summon aid to vessels in distress, whether public or private, and to assist in saving life and property from perils of the sea whenever it is practicable to do so." George Thomas is believed to have kept the beacon lighted hours past sunrise to aid rescue ships in navigation and give people hope as they struggled to shore.

The acting captain reportedly could not see the lighthouse through smoke and heavy rain. But the light must have been seen by some crew members, for the ship's position was fixed as being east of Sea Girt and twenty miles south of Ambrose Lightship.[159]

In the book *Inferno at Sea*, by Gretchen F. Coyle and Deborah C. Whitcraft, a *Morro Castle* survivor recalled, "It was dark, and we didn't know where to go. And all of a sudden we saw a light. To this day, the only thing that saved us was the lighthouse…I thought we didn't have to worry, all we had to do was swim to that light." While 137 died in the *Morro Castle* disaster, over 400 survived.[160]

Several ships responded and lowered manned lifeboats to pick up survivors. The Coast Guard dispatched boats from Shark River and Staten Island.[161] Many who survived were saved by local people—fishermen, lifeguards and others. Among the rescuers, the Bogans and other volunteers aboard the Bogan fishing boat *Paramount* saved sixty-seven people. In Sea Girt, six lifeguards saved fifteen people.

The cause of the fire was never determined, yet there was and remains a suspicion of arson. There were other plausible causes advanced. Investigations uncovered flaws in the ship's design, as well as inadequate emergency equipment, procedures and crew training.[162] "The tragedy became the impetus for the Merchant Marine Act of 1936, stipulating more stringent fire regulations. Training for crew members became mandatory, fire drills were to be conducted for all passengers, along with complete ship fire alarms, and emergency generators," noted Coyle and Whitcraft in *Inferno at Sea*.[163]

In addition to minding the beacon and monitoring ship traffic, as prescribed in *Instructions to Employees of the United States Lighthouse Service*,

The burning cruise ship *Morro Castle* dropped anchor three miles offshore on September 8, 1934, and the order was given to abandon ship. *Library of Congress.*

Thomas, like his predecessors, kept a watchful eye on the coastline and Sea Girt Inlet to the north. The inlet was shoaling, getting shallower as storms and the normal tidal flow shifted the sands. The 1924 issue of *Coast Pilot* noted the inlet "is closed at low water, and is only occasionally used at high water and smooth sea by small fishing boats of 2 foot draft."[164]

But the shallowness and natural shoaling did not preclude flooding, especially in storm surges from the ocean. While sand dunes, groins and jetties built over the years offered some protection and mitigation, they did not prevent the inlet and Wreck Pond to the west from overflowing their banks in the worst ocean storms that also threatened the beachfront.

New strategies were investigated in the 1930s to better control Wreck Pond, including building a dam and water control system at the inlet. The federal government, through President Franklin Delano Roosevelt's New Deal programs, was creating loans and grants for public works projects. The Boroughs of Spring Lake and Sea Girt applied in the mid-1930s for federal

funds for a Wreck Pond dam project and were approved for grants and loans from the Public Works Administration.

Construction of the Wreck Pond dam, after some delays, was completed in mid-1938. The *Asbury Park Press* of May 24, 1938, reported on page two:

> *Built at a total cost of $61,000, the dam will maintain the water in the pond at a constant level, covering unsightly mud flats. Construction of the dam was a joint project of the two municipalities, with additional aid being furnished by the federal government.*
>
> *Spring Lake's share of the expense was approximately $35,100, with Sea Girt furnishing $11,700 and the federal government $14,200 through public work funds.*
>
> *The dam, with short "wings" extending on both sides, is about on a line with Ocean Avenue. It is equipped with a 180-foot pipe line running seaward to carry the outflow to sea and prevent the ocean from breaking through sand piled up along the beach.*

Wreck Pond dam was back in the news on June 2, this time on the front page. The *Press* reported that a nor'easter had breached the sand dunes on either side of Wreck Pond dam: "Temporary barriers had been erected with sand from the beach, but these gave way yesterday before the pounding of the sea. The pond was quickly emptied and the floodgate and control works were left high and dry."

The project engineer said the beach had not had enough time to build up a natural barrier and the temporary sand dunes had not sufficiently settled. The breach was closed up as workmen piled higher mounds of sand into the opening, while a permanent spillway was being considered.

Sand built up at the seaward end of the pipe, impeding Wreck Pond's tidal flow. As reported on the front page of the *Asbury Park Press* on August 9, 1938, "Several times since the project was finished [Spring Lake] borough employees have had to dig sand away from the other end of the pipe to allow the pond water to flow freely to the ocean."

Repairs were made to the dam and dredging completed, and this was repeated over the years. Shoaling, plus the dam, spillway and periodic rebuilding of dunes, caused the inlet to eventually disappear, except for temporary channels carved out by the strongest storms. While the south end of Spring Lake remained vulnerable to flooding, the lighthouse and other Sea Girt properties on higher ground along Wreck Pond were less vulnerable than before. Yet problems reoccurred at Wreck Pond, which,

without adequate flushing of the pond by tidal waters, became more polluted in coming years with increasing development, lawn fertilizer runoff and geese overpopulation.

Meanwhile, at the lighthouse, keeper Thomas remained vigilant and ran the lighthouse with peak efficiency, which was recorded by his superiors during the periodic inspections. When engineers and workmen were busy at Wreck Pond dam, Thomas was being notified he had been awarded the coveted Superintendent's Efficiency Star for the third year in a row and was therefore "entitled to wear, in lieu thereof, the Commissioner's Efficiency Star for the year 1938."[165]

Thomas had able but unofficial assistants at the lighthouse in his daughters, who ran the household, tended a vegetable garden and generally helped their dad. Once when Thomas requested a day off to visit family in Brooklyn, he proposed his daughter Alice, twenty, to be his substitute. The lighthouse district command judged her to be qualified and appointed her for twenty-four hours "with understanding substitute is to be furnished at your own expense."[166]

So infrequent were his absences that by March 31, 1939, Thomas had accrued sixty-two days of leave. The Superintendent's Office advised Thomas to take leave before a scheduled reorganization of all U.S. lighthouses.[167] Thomas took off the entire month of June. The approved substitute keeper was Lester M. Hurley, a U.S. Navy veteran and resident of Bradley Beach, who was paid by the government.[168]

# CHAPTER 9
# U.S. COAST GUARD ERA: IN WAR AND PEACE

August 7, 1939, was the 150th anniversary of President George Washington's signing of the Ninth Act of Congress in 1789, which created the United States Light-House Establishment, the grandfather of the Lighthouse Service.

President Roosevelt signed a joint resolution of Congress, Public Resolution No. 16, designating the week of August 7, 1939, as Lighthouse Week. Yet before the nation could observe the milestone, the venerable Lighthouse Service disappeared, and its keepers either retired or transferred to the Coast Guard, which took command of all lighthouses on direct orders of President Roosevelt.

The president's Reorganization Plan No. 2, which went into effect on July 1, provided:

> *The Bureau of Lighthouses in the Department of Commerce and its functions be transferred to and consolidated with and administered as a part of the Coast Guard. This consolidation, made in the interest of efficiency and economy, will result in the transfer to and consolidation with the Coast Guard of the system of approximately 30,000 aids to navigation (including light vessels and lighthouses) maintained by the Lighthouse Service on the sea and lake coasts of the United States, on the rivers of the United States, and on the coasts of all other territory under the jurisdiction of the United States with the exception of the Philippine Islands and Panama Canal proper.*[169]

The plan also implemented "a complete integration with the Coast Guard of the personnel of the Lighthouse Service numbering about 5,200, together with the auxiliary organization of 64 buoy tenders, 30 depots, and 17 district offices."[170]

Ray Jones, in *The Lighthouse Encyclopedia: The Definitive Reference*, writes, "President Roosevelt cited efficiency and economy as his rationale for dissolving the Bureau of Lighthouses and placing all maritime lights under the authority of the Coast Guard, but some historians recognize a broader strategic motive in the measure. With another war on the horizon, the president likely thought it prudent to place the nation's maritime lights in the hands of a military organization, just as President Wilson had done in 1917."

H.D. King, who succeeded George Putnam after he retired in 1935, moved into the Coast Guard headquarters but soon retired himself. "Lighthouse Service personnel were given three choices: retire, enlist in the Coast Guard, or transfer to the Coast Guard as a civilian employee. While some former Lighthouse Service employees resigned outright, most chose to stay, about half as civilians and half as newly enlisted members of the Coast Guard," reports Jones. "When members of the old Lighthouse Service retired or resigned and moved on to other jobs, their places were taken by young Coast Guard servicemen who had not necessarily signed up with lighthouse duty in mind."[171]

During World War I, George Thomas transferred to the U.S. Navy, where he served for almost two years. Now aiming to hang on a few more years, the sixty-three-year-old Thomas inquired about enlisting in the Coast Guard. But the Coast Guard district command, in a letter dated November 5, 1939, advised him that he did not meet enlistment requirements. "You will continue as a keeper in civilian capacity."[172] Thomas hung on, adjusting to the new command structure. His daughters, Alice and Lucy, continued to live at the lighthouse. No enlisted Coast Guard personnel were assigned to Sea Girt until late 1940.

Within two months of the Coast Guard taking over America's lighthouses, war erupted in Europe on September 1, 1939, with Germany's invasion of Poland. On September 8, President Roosevelt declared a limited national emergency in America "for the proper observance, safeguarding, and enforcing of the neutrality of the United States and the strengthening of our national defense within the limits of peace-time authorizations."[173]

On September 7, 1940, Germany launched the Blitz, the aerial bombardment campaign against London and other cities in Britain, which continued into early May 1941. In anticipation of America's going to war

and in response to the Blitz, the U.S. War Department and Coast Guard conducted secret studies and began devising plans to protect America against bombardment.

George Thomas advised the Coast Guard district command in a letter dated October 12, 1940, that he was applying for retirement, noting he would have twenty-eight years of continuous service on March 10, 1941. The Coast Guard responded on October 16, noting, "You were out of service from May 1, 1919 to June 4, 1919, so that you will not have 28 years of continuous service on date stated. You will not have 30 years service to your credit until April 13, 1943, at which time you will be eligible for retirement, as you will be over 65 years of age."

Thomas would then, in fact, be sixty-seven years old. The letter continued, "If, however, your health is such at this time that you are unable to perform your duties as keeper, and you wish to be considered for disability retirement, advise this office."[174] Thomas was evaluated by an Asbury Park physician, who reported that Thomas had two hernias and hemorrhoids. The Coast Guard sent Thomas to the U.S. Marine Hospital in Stapleton, Staten Island, for a second examination, which qualified him for a disability retirement.

His last day of active duty was November 29, 1940. At noon that day, he went on paid leave in anticipation of his official retirement in the new year.[175] Assuming command was thirty-seven-year-old Thurlow E. Jester, the first Coast Guardsman on duty at Sea Girt, sent on temporary duty from Coast Guard Station Point Pleasant. Indicating the changed organizational structure, he reported not to the Lighthouse Service but to USCG District Command in New York.[176]

After four months of leave, George Thomas officially retired on March 31, 1941, with an annual pension of $1,015.[177] His tenure at Sea Girt Lighthouse—nine and a half years—was the second longest, topped only by Bill Lake. He moved to Ocean Grove, New Jersey, where he lived until his death in 1963 at age eighty-six.[178]

Lucy remained in the area, while Alice traveled far and wide. Dan Herzog, who explored census and other genealogical records for information on Sea Girt's various keepers, discovered research done by relatives of George Thomas and his wife, Minnie DeBow Thomas, that offered rich detail on their daughters. Lucy worked as a secretary in Allenhurst, living first in Ocean Township and later in Ocean Grove. She was a parishioner at Trinity Episcopal Church in Asbury Park, where she was director of Christian education and was a member of the Monmouth College Alumni Association and the Union Theological Seminary Alumni Association.[179]

President Roosevelt signed the declaration of war on December 8, 1941, a day after the Pearl Harbor attack. *National Park Service, National Archives and Records Administration.*

Daughter Alice, who became a nurse, enlisted in the U.S. Army in October 1941. She served stateside and overseas in the Army Nurses Corps, rising to the rank of captain, and was awarded the Bronze Star.[180] During the war, Alice was stationed in Australia and, near the war's end, was a staff nurse with General Douglas MacArthur's forces in the Philippines, where she assisted in establishing a hospital. After the war, she was posted to the veterans' hospital in Washington, D.C., today known as the Walter Reed Army Medical Center.[181]

The attack on the U.S. Naval Base at Pearl Harbor on December 7, 1941, that plunged America into World War II began at 7:48 a.m. Hawaiian time as the first bombs fell on U.S. ships in the aerial assault by Japanese planes launched from aircraft carriers of the Imperial Japanese Navy. The following day, Congress approved a declaration of war on Japan. At 4:00 p.m. that same day, President Roosevelt signed the declaration of war.

Alerts from the top command of each U.S. military service were rocketed to all units stateside, including Sea Girt, and overseas, announcing the state of war, followed by updates throughout the day and night. Coast Guard alerts came from the Commandant's Office or the Intelligence Office.

Contingency plans were put into action, and all lighthouses immediately became watch stations. Beacons at 91 major light stations were eventually dimmed, including Sandy Hook and Navesink Twin Lights. In the coming months, beacons at over 1,200 light stations were extinguished, including Barnegat and Sea Girt. Approximately 16 lightships were removed from their stations, 155 lighted buoys were extinguished and 282 lighted buoys were replaced by unlighted buoys.[182] This was done so as not to give navigational aid to enemy planes and ships.

"Probably the most important reason for the dimming of seacoast lighthouses and lighted buoys was the fact that these lights silhouetted passing ships and made them clearly visible even when the ships themselves carried no lights. There is considerable evidence that German submarines took advantage of this silhouetting," according to the official service history *The Coast Guard at War: Aids to Navigation*.[183]

With U.S. lighthouses being dimmed or extinguished, Allied planes and ships needed alternative systems of navigation, which they found in newly developed technologies, including RADAR (radio detection and ranging), RACON (a radar beacon transponder that identifies navigational hazards) and LORAN (long-range navigation).

Some of the earliest armed beach patrols by Coast Guardsmen in the Third Naval District (New York), which extended from Rhode Island to Manasquan Inlet, were conducted along the beaches of Sea Girt, Montauk Point and Fire Island. The letter authorizing those patrols was dated December 5, 1941. With the U.S. declaration of war on December 8, the patrols were expanded up and down the coast.[184] The beach patrols were on the lookout for enemy planes and ships and landed saboteurs. They also were on the lookout for Allied planes, ships and crewmen in trouble.

By January 1942, ten Coast Guardsmen were at Sea Girt Station, which was reconfigured to their needs. The wall between the dining room and kitchen was removed to create the mess. The pantry became the galley. Upstairs, two north bedrooms became one big room where the men slept in bunk beds. The commanding officer slept in what was the keeper's bedroom on the south side and had his office below in the parlor, where there was a telephone and Teletype machine.

At the top of the tower, in the octagonal lantern room with its eight panes, every other pane was replaced with a double-sash window that could be opened for ventilation in the summer, when temperatures topped ninety degrees. An internal phone line was rigged to connect the watch detail in the lantern room with the commanding officer in the parlor.

For the first eight months of the war, the Fresnel lens remained in place and operating sunset to sunrise,[185] making the lantern room tight quarters in which to stand watch. Coasties were posted to the lantern room in four-hour shifts around the clock. The man or men on duty often went onto the railed gallery surrounding the lantern room for more room and an unobstructed view.

Sunset to sunrise, there were also patrols of the beach by two-man teams working in two-hour shifts. A team would split up, with one walking back and forth along the north beachfront and the other doing the same along the south beachfront. They covered the one-mile beachfront from Wreck Pond to the edge of the army camp. National Guardsmen patrolled the beachfront of the camp, while beach towns immediately to the north were covered by Coast Guard Stations Spring Lake and Shark River, according to a wartime planning map in the collection of Timothy Dring. German U-boats were known to be off the East Coast. U.S. Navy and Coast Guard offshore patrols and anti-submarine capabilities were inadequate in the early months of the war.

Sometime before midnight on February 26, 1942, oil tanker RP *Resor* was torpedoed by U-boat *578* off Sea Girt. The war diary of the U.S. Navy's Eastern Sea Frontier for 0035 hours, February 27, reads, "Great light and explosion 095°T and about 5 miles from Sea Girt. Vessel torpedoed and afire. Some survivors taken aboard ship's boat to Bradley Beach. Others in PC-507 and Coast Guard. VAL-PARAISO?"[186] The 12:40 a.m. entry in the Sea Girt logbook reads, "Men on watch reported ship's fire seven miles east of station."[187] Rescue craft responded from the Coast Guard stations at Manasquan Inlet and Shark River.[188]

*Opposite, top*: American oil tanker RP *Resor* was torpedoed on February 26, 1942, by a German U-boat several miles off Sea Girt. *New Jersey Maritime Museum.*

*Opposite, bottom*: By July 1942, eighteen Coast Guardsmen were at Sea Girt. *Donated to Sea Girt Lighthouse Collection by Richard Smith.*

Only two crewmen survived, picked up by submarine chaser *PC-507*. Forty-seven men perished in the fire that engulfed the ship and surrounding waters. The stricken ship drifted southward. On March 1, the U.S. Navy tugboat *Sagamore* attempted to tow the *Resor*. The attempt failed. The *Resor* sank thirty-one miles east of Barnegat, according to the "Official Chronology of the United States Navy in World War II."[189]

By the spring of 1942, there were as many as eighteen Coast Guard troops at Sea Girt. The commanding officer was Chief Boatswain's Mate Irvie Camburn, from nearby Waretown in Ocean County. Additional troops arrived in the wake of two teams of saboteurs off-loaded from German U-boats reaching Long Island and Florida in June. While all the saboteurs were eventually captured, their reaching U.S. soil was a rude awakening that triggered a swift buildup in U.S. coastal patrols and expansion of the dim-out and blackout of light stations.

In his daily log entry for July 22, 1942, CBM Camburn wrote, "11:00 a.m. Received orders from the commanding officer to discontinue the operation of the light." Not only was Sea Girt's beacon finally extinguished, but also the Fresnel lens was removed to make more room for men on watch duty. A team of electricians was sent to the lighthouse to disconnect and remove the lens. The lens was likely put into Coast Guard storage, although it could have been thrown out.[190]

Meanwhile, many light stations and other strategic assets were being painted or disguised in some other ways to make them less obvious daymarks for enemy ships to navigate by and targets to fire on. Sandy Hook Lighthouse, for example, was painted in camouflage. Sea Girt Lighthouse, described as "red brick" in the widely available reference book *U.S. Coast Guard Light List*, was painted a dark brown at least once and possibly twice during the war.

Despite the war, local residents and visitors in summertime would go to the beach to sunbathe, swim and fish. "Oil came in on the tide occasionally as a reminder of how close the war really was," recalled a Sea Girt resident years later.[191] At night, homes and buildings along America's coastlines drew blackout curtains across windows to block any light from lamps or light fixtures getting out. In the lighthouse tower, the men stood watch in darkness.

"From dusk to dawn, the Coast Guard would also patrol the beach," remembers Donald Ferry, a longtime lighthouse trustee who spent his childhood summers in the family house just north of the lighthouse.[192] Troops on patrol carried flare pistols and side arms or rifles. If suspected saboteurs or other suspicious people were encountered, the troops would

Sandy Hook, an octagonal tower of white rubblestone, narrows as it rises and is topped by a red lantern room. *Bill Dunn.*

Navesink Twin Lights is a brownstone fortress with a north-side octagonal tower and a south-side square tower. *Bill Dunn.*

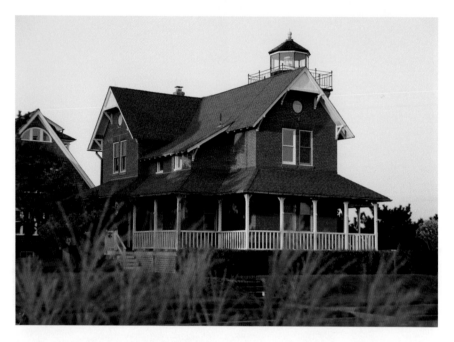

Smaller than its neighbors, Sea Girt Lighthouse stands out with the tower rising out of the redbrick house. *Robert S. Varcoe.*

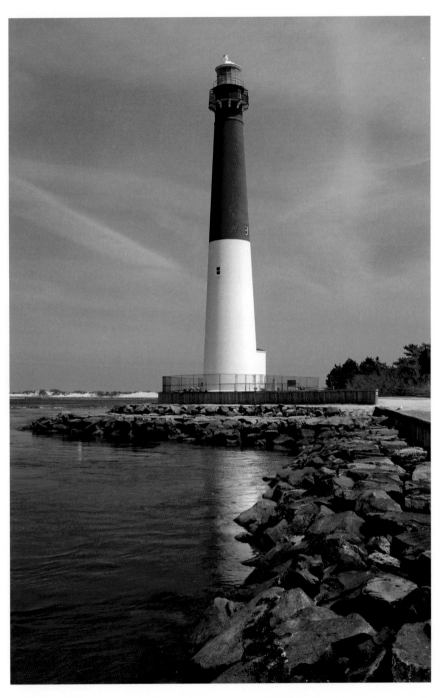

The red and white stripes of Old Barney distinguish it from the yellow-black-yellow striped Absecon in Atlantic City. *Jonathan Carlucci, NJDEP, Division of Parks and Forestry.*

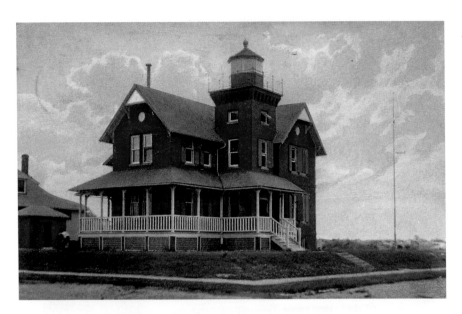

This circa 1917 postcard is the earliest known color photo of Sea Girt Lighthouse. *Donated to Sea Girt Lighthouse Collection by Ryan Wade.*

This postcard captures 1921 changes—the fog beacon transmitter towers and the relocation of steps to the south side. *Donated to Sea Girt Lighthouse Collection by Robert G. McKelvey.*

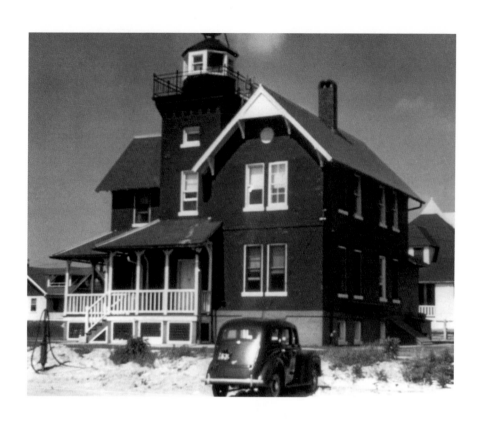

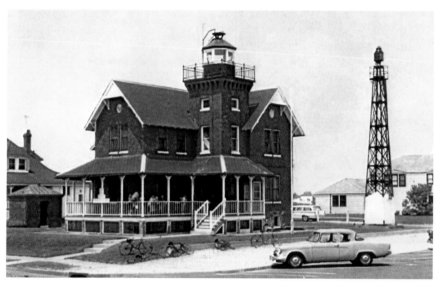

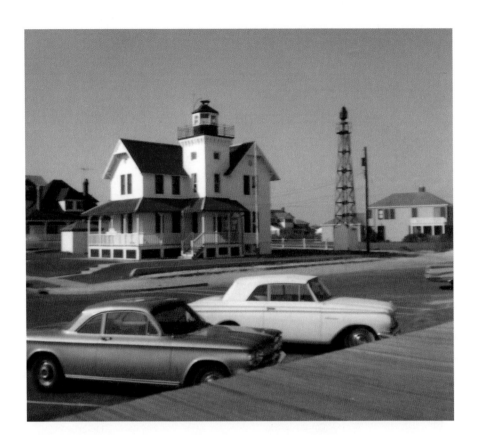

*Above*: A mother sent this 1963 snapshot to her soldier son overseas. It settles a debate over when the lighthouse was painted white. *Frederika Beckmann.*

*Opposite, top*: During World War II, the Coast Guard painted the lighthouse brown to disguise it, making it less of a target for enemy ships. *Sea Girt Borough.*

*Opposite, bottom*: This circa 1958 postcard shows the lighthouse again painted red. The aerobeacon now sits atop the skeleton tower, built in 1954. *Donated to Sea Girt Lighthouse Collection by Henry Bossett.*

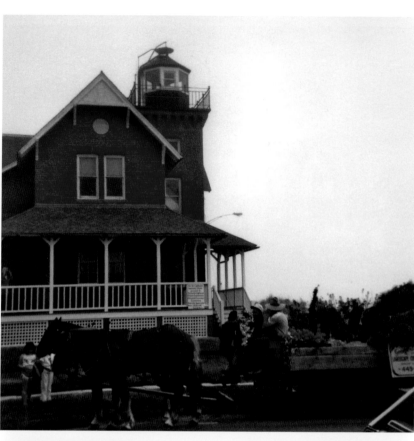

*Above*: Local tradesmen and materials kept construction costs low, yet pride and flare are evident in the machine-tooled banister, spindles and carved end posts. *Bill Dunn.*

*Opposite, top*: The Holly Club's plantings are delivered by horse-drawn wagon, June 1983. The lighthouse once again shows its natural brick color. *Sea Girt Lighthouse Collection.*

*Opposite, bottom*: The practical soapstone fireplace surround, which absorbs and projects the fire's heat, also reveals artistry in the floral carvings. *Bill Dunn.*

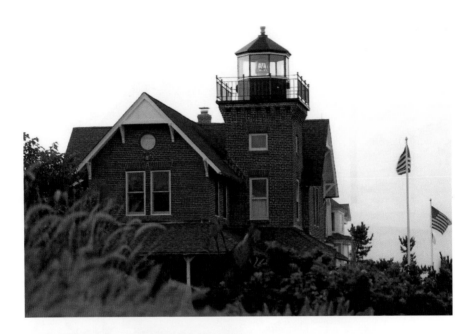

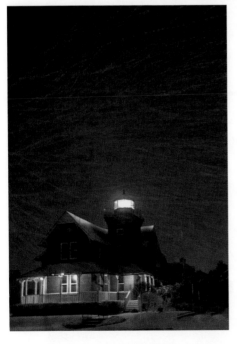

*Above*: Brickwork over the windows and at the top of the tower add flourish to the building's simple design. *Henry Bossett.*

*Left*: No matter the weather, the memorial light shines every night, a beacon to the community and a reminder of the lighthouse's past as a guiding light to mariners. *Henry Bossett.*

*Opposite*: These shutters—discovered in the attic and rehung by volunteers—are fine examples of craftsmanship. *Bill Dunn.*

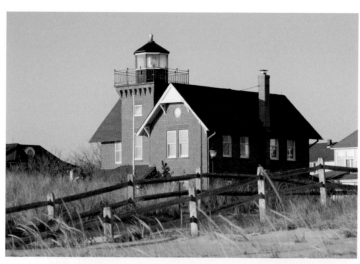

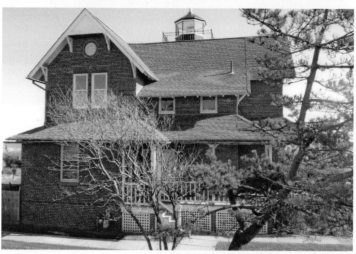

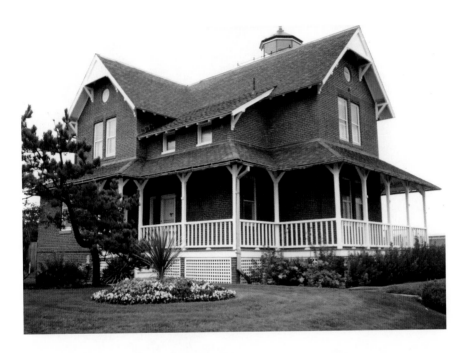

*Above*: Come springtime, the garden blooms (thanks to the efforts of the Holly Club) and docents resume tours after a winter of fine-tuning the exhibits. *Sea Girt Lighthouse Collection.*

*Opposite, top*: Seasons change, and the lighthouse remains. Here it is seen in springtime looking westward from the beach dunes. *Robert S. Varcoe.*

*Opposite, middle*: View of the lighthouse looking seaward through the scrub pines from the porch of the house next door, built by first keeper Abraham Wolf. *Bill Dunn.*

*Opposite, bottom*: In 2012, Hurricane Sandy tore up boardwalks and damaged many homes. Sea Girt Lighthouse sustained only minor damage and was repaired. *Robert S. Varcoe.*

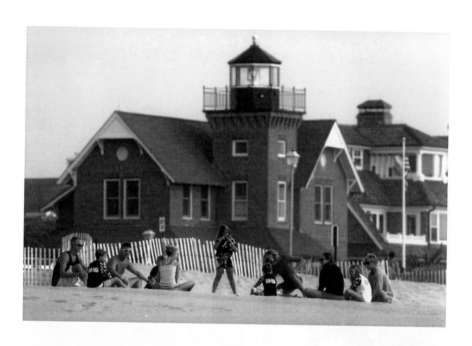

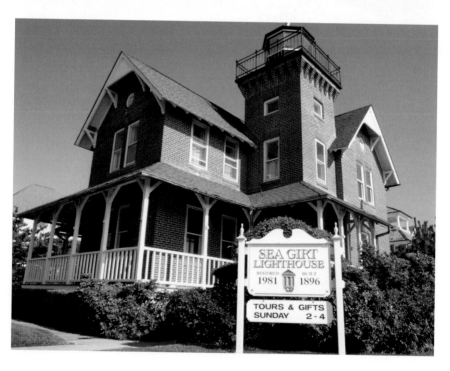

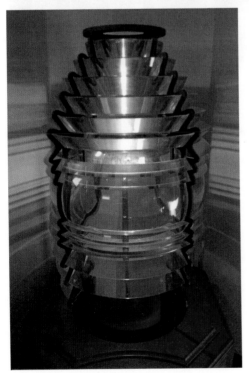

*Above*: Sunrise at the beach reveals the lighthouse—seen here through the beach grass that covers the sand dunes to the east—as the daymark it has been since 1896. *Henry Bossett.*

*Left*: The jewel of the lighthouse collection, the fourth-order Fresnel lens from Australia is the same size and beehive shape as the original Sea Girt lens. *Bill Dunn.*

*Opposite, top*: In the summertime, Sea Girt hits high gear, and the lighthouse comes alive with activity as people flock to the beach. *Henry Bossett.*

*Opposite, bottom*: Guided tours by knowledgeable and friendly docents are conducted from mid-April through mid-November (except on holiday weekends). *Bill Dunn.*

The boardwalk railings nicely frame the lighthouse in the view from Beacon Beach near the pavilion. *Henry Bossett.*

draw their weapons and hold suspects under armed guard. The flare pistols would be fired to signal for reinforcements or to alert to something else amiss, including Allied ships in trouble.

Also joining beach patrols by late fall in 1942 were K9 units—infantry troops from Camp Edison, as the U.S. Army National Guard encampment in Sea Girt was then called, patrolling with guard dogs that were trained and kenneled at the camp. The beach patrol troops were known as sand pounders. The war dogs, as they were called, tended to be German shepherds or Dobermans. They were fearless and loyal coast defenders.

Donald Ferry, in his early teens during the war, befriended the Coast Guardsmen at Sea Girt Lighthouse. A funny ritual developed. When Don would visit, the trooper on sentry duty would stop him and demand, "Halt! What's the password?" The password, which changed daily, was often the name of a cigarette brand. Don would rattle off a succession of brand names until he got it right. He remembers with a laugh that he was allowed on the grounds because he was a "non-combatant."[193] By October, there were twenty-one Coast Guardsmen at Sea Girt Lighthouse.

In the log for January 18, 1943, CBM Camburn wrote, "1 p.m. Electrician from Coast Guard Depot St. George at this unit installing radio beacon." Two related entries on February 4 record its activation and the temporary assignment of a radio operator.[194] The radio beacon system is not explained in the log entries, but Coast Guard photos show a dipole antenna strung between two poles.

Historian Tim Dring, who has inspected the photos, notes:

> The dipole antenna arrangement in the photos, although the dipole antenna is a bit small to be a navigational radio beacon, may actually be for a voice radio installation...The other possibility, though, is that the dipole installation is for a temporary wartime RACON [abbreviation for radar beacon], which is a beacon that, when hit with a radar beam from a ship, transmits back a dot-dash signal that shows up on the ship's radar scope and which can be plotted as a line of bearing with distance measurement. I remember reading that a number of these RACON beacons were installed along the East Coast during the war, and that may be the reason for the dipole installation. That would be why the logbook states it as a radio beacon type of outfit.[195]

On February 27, 1943, Sea Girt Station received two telephone handsets, issued by Coast Guard Station Manasquan Inlet, for use on beach patrols.

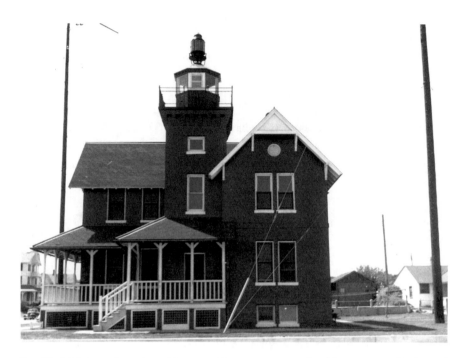

Sea Girt Lighthouse is equipped for war with an antenna overhead between two dipoles and an aero-beacon atop the lantern room. *U.S. Coast Guard.*

By March 1, patrols kept two men together instead of splitting up to go in opposite directions.

On May 8, Sergeant Richard S. Tucker, U.S. Army, was killed in action in North Africa. He was twenty-seven. Tuck, who had summered in Sea Girt in the 1930s, was a local legend and a popular fellow with an easy smile. He was one of six Sea Girt lifeguards credited with saving fifteen people who had jumped off the burning cruise ship *Morro Castle* on September 8, 1934.

"Elizabeth Hero Killed in Africa," read the headline of the *Newark Evening News* obituary, which had been clipped and saved by his friend Jack Holthusen, head lifeguard in the *Morro Castle* rescue. Decades later, in memory of Dick Tucker and her late husband, Dorothy Holthusen donated the yellowed and brittle clipping to the lighthouse archives.

By June 1943, there were twenty-eight Coast Guardsmen at Sea Girt. The June 16 log entry reads, "Crew painting the lighthouse."[196] A 1943 color photo shows the lighthouse a dark brown, while the foundation is gray. It is one of the earliest wartime lighthouse photos so far uncovered. Either the painting was a rush job, missing small areas on the front where red brick can

still be detected, or Coasties repainted the lighthouse after an initial brown coat from 1942 began wearing off, exposing the color beneath.

Historian Tim Dring, a U.S. Navy veteran who has written extensively about the Coast Guard, notes, "The paint job was performed by the wartime staff and not the USLHS." Mr. Dring notes that the gray paint at the base of the lighthouse was "typical for a wartime USN or USCG building." Painting the lighthouse brown was intended to "make it a little less visible and therefore less useful as a visual navigation landmark for the U-boats offshore."[197]

By August 1943, four soldiers were detailed to the lighthouse, listed in the log as "Army Liaison Unit." Don Ferry recalls soldiers "camped on the northwest corner of the lawn. They had quite a big tent there."[198] The soldiers, too, patrolled the beaches and ate in the lighthouse mess.

Sea Girt Lighthouse remained dark, although an aero-beacon was mounted by the Coast Guard on top of the lantern room's conical roof in early 1943. The navigation reference book *Light List*, published in mid-1943, noted that the new lens was "temporarily extinguished."[199] The stationary lens, which sat on a pedestal, had an electric light inside. While unused for over a year, the automatic beacon was installed as a replacement for the original Fresnel lens, ready to go as soon as conditions permitted and the Department of War lifted blackout/dim-out restrictions.

By 1944, the tide of war had shifted in favor of the Allies. The U.S. Navy and Coast Guard effectively patrolled the shipping channels and provided escorts for merchant ships bound for England. On June 6, D-Day, the Allies launched the Normandy Invasion, the beginning of the end of the war in Europe. Stateside by July, only the West Coast still had an active beach patrol, which totaled only eight hundred men.[200]

By the late summer of 1944, aids to navigation—lighted buoys, lightships and lighthouses—that had been dimmed or extinguished early in the war were being reactivated in phases. "As the war progressed, aids temporarily darkened or reduced in power were restored, and a condition of normal operation again approached," notes the service history *The Coast Guard at War: Aids to Navigation.*[201] Sea Girt Station received orders on September 23, 1944, to test the aero-beacon. The bottom entry in the log reads, "4:00 p.m. to mid. Tested beacon light and found it to be in good operating condition."[202] Soon thereafter, it was activated.

Historian Dring has studied photos of the Sea Girt aero-beacon and found it was a "quasi-Fresnel lens." Instead of the hand-cut glass prisms of the early Fresnel lens, the aero-beacon was a "375mm-sized, pressed-glass" lens with the angled, horizontal, curved bands of prisms held in a metal cylindrical frame.[203]

The automatic electric light flashed from sunset to sunrise. Sea Girt Lighthouse was once again providing a navigational beacon to mariners but one that did not require a keeper to tend. In the coming peacetime, the lighthouse would no longer require staffing.

After V-E Day, the Allied victory in Europe on April 7, 1945, with Germany's unconditional surrender, the Coast Guard accelerated reactivation of navigational aids along the East Coast. "Light ships which had been removed during the war were returned to their former stations on the Atlantic coast. The blackout and dim-out of aids on the Atlantic coast was discontinued and they were restored to fully lighted conditions as fast as practicable," notes the history *The Coast Guard at War: Aids to Navigation.*[204] And with Japan's surrender on September 2, V-J Day, blackout/dim-out restrictions on the West Coast were lifted.

With the war won and the automatic aero-beacon activated at Sea Girt, the lighthouse was officially decommissioned. The Coast Guardsmen still there were reassigned to other posts. The Coast Guard sent in a construction crew from one of the larger Coast Guard installations nearby to remove the wartime dipoles. Over the next several years, the Coast Guard periodically sent an enlisted man or a civilian to mind the station, either living there or coming on daytrips.

John Chilly, a civilian employee of the Coast Guard, arrived for duty at Sea Girt Lighthouse on July 12, 1951, taking up the post of keeper. But with an automatic beacon running on a timer, Chilly was there for several months principally to maintain the building and the grounds. He was also responsible for Shark River Station and Manasquan Inlet.

Chilly's log entries reveal that he spent much of his time painting—interior rooms, exterior wood trim, the porch, the metal lantern room and the building's brickwork. Unlike handwritten entries in the logs of previous keepers and Coast Guardsmen at Sea Girt, keeper Chilly typed his daily reports on a manual typewriter on a single log sheet with two punch holes, enabling him to add the completed sheet to the double-ring logbook binder.

Chilly did not specify the paint colors he was applying to the lighthouse in the log entry, but a black-and-white aerial Coast Guard photo from the period, taken as part of a postwar inventory of decommissioned stations, shows that most of the brickwork was a dark color, probably brown, while the lower portion appears to be gray. The photo is also revealing for what it does not show: beach erosion. In contrast to some earlier photos, this one shows land reclaimed and Ocean Avenue paved and intact, even after the Great Atlantic Hurricane of 1944. The cumulative effect of remedial projects saved the lighthouse from advancing beach erosion and reclaimed

Seaman First Class Henry Wapelhorst (right), who was at Sea Girt in 1954 to supervise a project and then close down the lighthouse, receives a visit from his dad. *Donated to Sea Girt Lighthouse Collection by Henry Wapelhorst.*

land to the east of the property so it could be repaved, even as periodic severe storms still posed risks.

The last Coast Guard detail at Sea Girt Lighthouse—an old salt with lighthouse experience and a young recruit—were assigned to the station in 1954 to oversee a construction project that would make the building superfluous. They were then to secure the building and close it down.

"I spent a year and a half at Sandy Hook tending the buoys. Then I got a temporary assignment to Sea Girt. It was only supposed to be a month or two," recalls Henry Wapelhorst, who was then a seaman first class from Union City, New Jersey. "But there was a steel strike that prolonged my time down there from March until October. That was a blessing."

His commanding officer was a boatswain's mate "who had long been on a lighthouse off Sandy Hook, Romer Shoal. He was used to cooking. We'd

use our food allowance to shop in local markets. Sometimes I'd go across the street and catch fluke and flounder." When off duty, Wapelhorst went to the beach. "I made a lot of friends."[205]

Hank has returned to Sea Girt Lighthouse many times. He recalls that the lighthouse was still painted brown when he arrived in the winter of 1954 and when he left eight months later. He and his commanding officer were there to receive delivery of construction materials and then oversee a team of four local ironworkers, hired by the Coast Guard, to erect a freestanding metal tower on the northeast corner of the property. According to the plan, upon the tower's completion, the automatic aero-beacon would be moved from the top of the lighthouse to the new tower.[206]

The first phase of the project was the pouring of the concrete foundation on which the tower would stand. The concrete work was completed without a hitch, but then the project stalled for weeks because of a temporary shortage of steel, due to a strike. Once the steel was delivered, the ironworkers set about building the tower, which, according to the Coast Guard design, had a wide base and narrowed as it rose with cross-strapping for added strength, a distinctive feature that classified the structure as a truss or lattice tower.

With the work completed by early October, the workers then detached the aero-beacon from the pedestal on top of the lighthouse lantern room. "They had a crane there. They then swung the beacon right over to the new tower and mounted it right on the platform at the top of that structure," said Hank. The new tower was taller than the lighthouse by several feet. The added height made the beacon more visible than when it was atop the lantern room. The electric light, controlled by a timer, flashed from dusk until dawn.

The landward half of the aero-beacon had a shield inside to block projection of the light inland, just as the lantern room had curtains on the west side. The job done, the last Coasties at Sea Girt Light conducted a final inspection, secured the building, locked it up tight and departed.[207] Sea Girt Lighthouse was empty and tired, and its fate was uncertain.

Reclassified as surplus property, the lighthouse was put up for sale by the General Services Administration, the federal government's landlord. The State of New Jersey, not interested "because of the small size of the area," alerted Sea Girt in early February 1955. On April 12, 1955, after several meetings to investigate possibilities, the Borough Council passed a resolution to apply to purchase the property "for recreational purposes and youth organizations."[208]

# BOROUGH LIBRARY AND RECREATION CENTER

S ea Girt Lighthouse, in addition to its distinguished role in federal service, had become a beloved shore landmark appreciated by people across the shore region and beyond. Sea Girt residents also appreciated the lighthouse as a venerable building that still had life in it and as a symbol of hope, spirit and the town itself.

By the mid-1950s, Sea Girt was booming. The population swelled in the summer as families returned to their vacation homes. The year-round population was growing, too, as more and more summer residents retired to Sea Girt. The Borough struggled to keep up with the growth. Sea Girt Lighthouse was viewed by town officials and residents as an attractive building that could be put to good use.

A year after Sea Girt applied to buy the lighthouse, on March 23, 1956, the General Services Administration's regional director wrote to the mayor: "We are pleased to inform you we have received authorization to execute the transfer of this property. In this connection, the Borough of Sea Girt shall be required to pay 50% of the established fair value of $22,000 or $11,000, payable in cash at closing." Also due was $372.60 for the appraisal and survey.[209]

The closing was on August 10. Not included in the sale was the twenty-two- by twenty-four-foot plot on which stood the skeleton tower with the automatic light, which remained federal property and continued to operate. There followed months of repairs and cleanup before the lighthouse was ready for its new community role "for recreational purposes and youth organizations," in the phraseology of the council resolution.

In the first half of 1957, repairs were made to the chimney, roof, floorboards, ceilings and sidewalk. The building was cleaned from top to bottom. When the work was done, a new sign was secured to the porch railing: "Sea Girt Recreation Center." A color photo postcard—taken around 1958, based on the cars in the photo—shows that the lighthouse is no longer World War II/Coast Guard brown but red.

As part of the purchase agreement, the Borough was required to submit to the federal government a biennial report on the lighthouse, including accomplishments, repairs, usage, finances and future plans. The first biennial report, dated August 10, 1958, noted that the lighthouse was in use year-round, attracting some fifty visitors a week in wintertime and fifty per day in the summer.[210]

While the sign on the porch railing read, "Sea Girt Recreation Center," the lighthouse also now housed the Sea Girt Library, which had moved from Borough Hall, where it had occupied a small upstairs room next to a conference room that then served as the kindergarten classroom. At the lighthouse, the library was set up on the first floor in the thirteen-and-a-half- by fifteen-and-a-half-foot parlor.

The parlor fireplace, on the west side, was covered up, as were built-in bookcases on either side of it. Tall, freestanding bookcases were placed against the west and north walls. On the south side, which has two windows, low bookcases were used. The librarian's desk extended out from the east wall, facing the parlor doorway. The library, which was open a few afternoons a week, had some three thousand volumes. Being a part of the Monmouth County Library Association, it also received a shipment of books on loan every few weeks and could get specific titles requested by patrons.[211]

Across from the parlor—in what originally was the dining room and kitchen in the Lighthouse Service era and then the Coast Guard mess hall—was now the main activity room for Scout meetings, recreation programs, monthly teen canteen dances and the gathering place for community groups.

Against the west wall was an upright Lauter & Co. piano, which had been donated to the lighthouse. Anita Rafter Riley, who attended Brownie meetings and dances at the lighthouse, remembers playing chopsticks on the piano. And countless other children took their turns at the keyboard over the next four decades.[212]

The original pantry, which became the galley for the Coast Guardsmen, was now a kitchen, equipped with donated appliances. The large room upstairs was now the game room, where youngsters could play ping-pong and board games or do crafts. Most everything used at the center had been donated, including

Befitting its new role as a community center, the lighthouse was equipped with a donated upright piano. *Sea Girt Lighthouse Collection.*

the ping-pong table, sports equipment, card tables and folding chairs, games, magazines and books. Operating costs were running around $3,600 a year. There were also a live-in caretaker and two part-time summer recreation directors. In the section of the 1958 biennial report labeled "Contemplated Improvement," there was one project listed: "Painting."[213]

In 1962, a nor'easter that became known as the Great March Storm battered the New Jersey shore, including Sea Girt, and much of the mid-Atlantic, causing extensive damage. The lighthouse survived, but other local landmarks did not. The Sea Girt boardwalk was ripped up. The pavilion built on the beach at Chicago Boulevard in 1925 listed dangerously toward the washed-out Ocean Avenue. The Borough had the pavilion demolished, Ocean Avenue rebuilt and a temporary one-story wooden pavilion erected on the beach in front of the lighthouse.

While withstanding the storm, the lighthouse was scheduled for work in 1963. At its meeting of April 9, 1963, the Borough Council unanimously passed a motion approving "the sanding and refinishing of the exterior of the lighthouse, approximate cost—$1,800.00 as provided for in the 1963 budget."[214] Sanding the exterior would have removed the paint but also the fired protective surface layer of the brick. The council minutes do not indicate how the brick was refinished. But a casual snapshot taken months later shows that the lighthouse, which was painted brown during the war and then red sometime in the 1950s, was now white.

In 1963, Bruce Beckmann, a lifelong Sea Girt resident and future lighthouse docent, was a twenty-six-year-old U.S. Army helicopter mechanic serving in Wertheim, West Germany. To remind him of home, his mother, Frederika, sent him photos of local landmarks she had taken, including the train station, St. Uriel's Church, the new pavilion and the lighthouse, recently painted white.[215]

At the other end of town, the once-elegant Stockton Hotel, battered by the Great March Storm of 1962, had stood empty since then. The owners wanted to take it down and replace it with a new hotel. The proposal was eventually approved. An auction of the contents was held in mid-September 1965, to be followed by demolition.

The demolition never occurred. The building went up in flames on September 23. A southwest breeze, fueling the fire, came through windows left open from the auction when people lowered purchased items to the ground. The Sea Girt Volunteer Fire Department was quickly on the scene and called in reinforcements. "Over sixty pieces of firefighting equipment were deployed by forty-three companies drawing water from Wreck Pond, Stockton Lake and even the ocean to contain the inferno," writes Joseph G. Bilby in *Sea Girt, New Jersey: A Brief History*.[216]

Other landmarks in town faced uncertainty. The train station, built a year before the lighthouse in 1895 and once a busy mainline stop and an important junction for branch-line service to Trenton and Philadelphia, was owned by the struggling Pennsylvania Railroad and New York & Long Branch Railroad. Service was being cut. One of the last trains over the branch line was a self-propelled single coach nicknamed the Doodlebug, making its last Sea Girt stop on May 29, 1962. There were rumors of cutbacks on the main line to New York. In 1967, the Borough bought the train station for $20,000, with an eye to converting it to municipal use down the road but in the meantime leasing it back to the railroads, which continued using it as a stop.[217]

This one-car Doodlebug makes its last southbound stop at Sea Girt, once a very busy junction, in 1962. The towerman hands a clearance slip to the conductor to proceed onto the western spur en route to Trenton. *Jeff Asay.*

Meanwhile, usage of the lighthouse increased, and so did the wear and tear. In addition to library patrons, other lighthouse regulars were Scouts and youngsters participating in the recreation programs and teen canteens. Several community groups held meetings there, including the Holly Club, the Surf Kings fishing club and the Sea Girt Women's Club.

The Sea Girt Community Club, which also met at the lighthouse, wrote to the Borough Council in April 1969 to inquire if the building were for sale. At the council meeting of April 18, the clerk read the Community Club letter, which stated that if the lighthouse were for sale, the club wished to go on record as being interested as a possible purchaser.

In 1956, the Borough bought the lighthouse for $11,000 from the federal General Services Administration, which sold it as surplus property with a twenty-year restriction that it would be used for "park and recreational purposes or historical monument purposes." Mayor Thomas Black explained that the Borough was credited $1,000 for each year of operation as a recreation center. According to the meeting minutes, the mayor indicated there were "no plans for selling it at the present time."[218] But the news raised concern among some about the future of the lighthouse.

The New Jersey exhibit at the St. Louis World's Fair—a replica of General Washington's 1779–80 winter headquarters—was moved to Camp Sea Girt to serve as the Governor's Summer Cottage, nicknamed the "Little White House." *National Guard Militia Museum, Sea Girt.*

In 1971, the Governor's Summer Cottage at the army camp fell to the wrecking ball.[219] The handsome Colonial cottage, inspired by the Ford Mansion in Morristown, where General Washington spent the winter of 1779–80, was the New Jersey exhibit at the 1904 St. Louis World's Fair. After the fair, it was disassembled and sent by train to the National Guard Camp at Sea Girt, where it became the comfortable beach house for a succession of New Jersey governors. Governor Woodrow Wilson was there when he learned he had been nominated by the Democrat Party to be its 1912 presidential candidate.[220] The last governor to use the cottage was Charles Edison in 1941. By the 1960s, the Governor's Summer Cottage was being used as classrooms for the instruction of officer candidates. There were various proposals on what to do with the building, including turning it into a museum. Funds were available, but in a cost-saving move, the state ordered the building demolished.[221]

In 1972, a minor landmark in town, the oil house on the lighthouse property, was taken down on orders of the Borough Council, which had received complaints it had become a nuisance. The oil house—the brick shed behind the lighthouse where keepers stored fuel—got a new assignment in the 1950s under Borough ownership, becoming the place where Boy Scouts stored old newspapers collected for recycling. But after more than

a few decades, the shed was shut down because the newspapers awaiting storage inside too often wound up being scattered about the neighborhood by the wind. The announcement that the shed would be taken down came at the council meeting of December 22, 1971.

Another sign of the changing times and priorities, the Sea Girt train station was dropped as a stop on the Jersey Coast Line in 1976. Local commuters would have to catch the train from either Manasquan or Spring Lake. The change was a small piece of the larger reorganization of several bankrupt Northeast rail lines, including the Central Railroad of New Jersey and the Pennsylvania Railroad, into the Consolidated Rail Corporation (Conrail), which began commuter and freight operations on April 1, 1976. The Sea Girt station was shuttered and remained empty for several years while the Borough Council decided what to do with it.

The fate of the Governor's Summer Cottage was a cautionary tale to people who were growing concerned about the future of the lighthouse and the expense to taxpayers of running it. The Borough Council, at its meeting on July 25, 1972, authorized "$1,600 be expended for refurbishing the lighthouse."[222] On November 27, the council unanimously approved an amendment of the July 25 motion "to authorize an expenditure of $3,100 for Lighthouse improvement."[223]

Less than a year later, at its meeting of March 20, 1973, the council approved a motion to "expend up to $1,500 for exterior painting of the Lighthouse."[224] The color the lighthouse was to be painted was not indicated in the minutes. But a black-and-white photo appearing in the *Asbury Park Press* of June 21, 1975, shows the lighthouse once again a dark color. The story that accompanied the photo noted, "The lighthouse remains today as it was then except that a new coat of paint has changed it from white to red."[225]

Neither the article nor council meeting minutes indicate the reason for the color change. But the problem in painting a brick building, first done by the Lighthouse Service and then the Coast Guard, is that the paint inevitably peels and the brick must be repainted again and again, becoming a recurring expense. The Borough probably concluded that white was the wrong color because once it started peeling, it would reveal the previous paint color or the natural brick underneath.

The automatic aero-beacon, activated atop the lighthouse in 1944 and then moved in 1954 to the metal tower built on the northeast corner of the property, was scheduled to be turned off in mid-1977. The Coast Guard notified the Borough that it planned to replace the flashing light by upgrading the existing breakwater light at Manasquan Inlet.

Sea Girt's automatic beacon (Light List Number 100) was extinguished in June after the upgrading and activation of the brighter Manasquan Inlet South Breakwater Light (Light List Number 2046). The skeleton tower was removed by the Coast Guard, as Mayor Black had requested, but the twenty-two- by twenty-four-foot parcel on which the tower stood remains federal property to this day.

With the skeleton tower gone, attention refocused on the lighthouse. After decades of heavy use, the lighthouse was in need of extensive repairs. The Borough explored options. At the council meeting of October 14, 1980, a letter from the Sea Girt–Spring Lake Junior Women's Club was read. The organization expressed interest in refurbishing the lighthouse.

During the public comment period of the meeting, longtime Sea Girt resident Susan Brennan addressed the council, stating that the Holly Club, the Sea Girt Elementary School PTO, the Sea Girt Fire Company Women's Auxiliary, the Sea Girt Real Estate Owners Association and the Sea Girt Women's Club were prepared to donate time and money to revitalize the lighthouse to serve as a meeting place and to be used as a possible archive for Borough artifacts.

Mayor Tom Black frankly discussed the status of the lighthouse. He noted that the Borough must operate under the state's 5 percent cap on expenditures. As a result of the tight budget and state constraints, lighthouse repairs and maintenance were a low priority, and the needed funds for the continued maintenance of the building were not available, according to the meeting minutes. He explained the Borough's ownership and operation of the lighthouse, noting that it had been purchased in 1956 from the federal government for the stipulated purposes of being a public park and recreation center. The agreement required the Borough to continue using the lighthouse in that manner for twenty years. It was already four years past the requirement. The mayor instructed that a budget be prepared on projected repairs and maintenance costs. The fate of the lighthouse would be revisited at a future council meeting. All options were on the table.[226]

At the council meeting two weeks later, Mayor Black presented a report by engineer William Birdsall, who had inspected the lighthouse and estimated it would cost $80,530 to repair it. While acknowledging the building needed repairs, the mayor noted that the state's 5 percent budget cap made it impossible to include funds for repair in the regular budget. A lively and wide-ranging discussion ensued on what to do with the lighthouse. After one resident proposed a poll of all residents to better gauge the level of support for the lighthouse and its restoration or sale, Councilman Robert Caspersen suggested the matter be put on the next ballot.[227]

# CHAPTER 11
# LIGHTHOUSE SAVED, TOWER RELIGHTED

As the Borough investigated whether to restore the lighthouse or sell it, a survey of Sea Girt residents found overwhelming support for restoration. Results, presented at the council meeting on November 25, 1981, by Susan Brennan, found that of more than 1,200 residents surveyed, 91 percent of respondents favored renovating the lighthouse, 5 percent supported selling the property and 4 percent had no opinion. Of those in favor of restoration, 77 percent backed municipal funding, while 20 percent volunteered personal contributions.

Mayor Black said the matter would be put to a town-wide referendum. Among the six council members, there was general interest in restoring the lighthouse but differing views on how to proceed. Councilman Frederick McKnight favored restoration, supported a referendum and recommended exploring all avenues of financing, with a bond issue being the last alternative.[228]

Meanwhile, concerned residents were meeting to explore options. Early in 1981, they formulated a plan to "Save Our Lighthouse." Two representatives from each community group—the Holly Club, the Sea Girt–Spring Lake Junior Women's Club, the Sea Girt Fire Company Women's Auxiliary, the Sea Girt PTO, the Sea Girt Real Estate Owners Associations and Sea Girt Women's Club—formed the Sea Girt Lighthouse Citizens Committee Inc. (SGLCC) "as a non-profit agency for educational, historical and charitable purposes." SGLCC is a tax-exempt organization under Section 501(c)(3) of the U.S. Internal Revenue Code, registered with the state of New Jersey.

On July 11, 1981, Save the Lighthouse Day brought together supporters of lighthouse restoration in their first gathering. *Sea Girt Lighthouse Collection.*

The committee met on April 1, electing Nancy MacInnes as president. The minutes record: "Mrs. MacInnes then presided and stated the purpose for being as follows: To restore and preserve our lighthouse and keep it as an historical landmark to be used by community groups." After discussing whether to pursue buying or leasing the building, the committee passed a resolution in support of SGLCC's leasing and restoring the lighthouse for submission to the Borough.[229]

The resolution was presented to the mayor and council on April 7. SGLCC then wrote on April 20 to "urge prompt action on our resolution." The letter noted that the Junior Women's Club had raised $2,500 and the Women's Club pledged $2,500.[230] The committee planned to solicit additional contributions and was hosting Save the Lighthouse Day on July 11 at the army camp.

The council's position was that it could not recognize SGLCC's resolution. Instead, the proposal needed to go to a referendum. SGLCC meeting minutes for June 1981 contain the following comment: "They [the council] probably want an outright sale for $125,000." The council also sought more details on how SGLCC would operate and use the building.

In addition to Mrs. MacInnes, the other founding trustees of the Sea Girt Lighthouse Citizens Committee Inc., drawn from the founding groups, were Susan Brennan, Joan Calhoun, John DeCastro, Linda Deignan, Eve Gilbert, William W. Graham, Joan Hall, Charles G. Hoffman, E. Dayton Jones, William MacInnes, Robert McKelvey, James Mulvihill, Carol Oberhauser, Frank A. Prettyman, Liz Sherman, Barbara Walsh and Sally Whitman. They and other volunteers were preparing to go door to door to enlist others to the cause to save the lighthouse.

The Lighthouse Citizens Committee named a negotiating team headed by Mrs. MacInnes to have direct discussions with Councilman Raymond Harter, the council's lighthouse liaison. SGLCC hoped to reach a mutually acceptable agreement without going to a referendum, which would be costly and delay action. One sticking point in discussions was the question of who would be responsible for maintenance. Each side wanted the other to cover maintenance costs.

Finally, after numerous meetings, and without the need to go to a referendum, a twenty-five-year agreement was reached in August. The Borough would lease the lighthouse to the Sea Girt Lighthouse Citizens Committee Inc. for one dollar a year "to be used and occupied only and for no other purposes than educational, historical, community and charitable which shall include the restoration and preservation of the historical building."

The Borough, as landlord, agreed to pay $4,000 of the maintenance and utility costs for each of the first three years, dropping to $3,000 for the fourth year, $2,000 in the fifth year and $1,000 in each of the remaining years of the agreement. Maintenance and utilities above those amounts would be borne by SGLCC. The Lighthouse Citizens Committee agreed to permit existing tenants—Borough Recreation Department programs, the Library and Civil Defense—to continue activities there. SGLCC also agreed to provide insurance coverage for liability and property.[231]

On August 31, the Lighthouse Citizens Committee held its first Signing of the Lease Party, bringing together friends and supporters to celebrate the lease agreement and the historic treasure that had been saved. The reception was attended by 306 people. Over $2,000 was raised, including special contributions. The committee pledged to raise $80,000 for the total restoration of the building.

The lighthouse, when the committee took it over, was already back to its natural red brick. A study of the lighthouse brickwork, done years later by two architectural firms, noted, "The brick at the Lighthouse was sandblasted by the Borough to remove peeling paint in the 1970s."[232]

Lighthouse restoration begins in late 1981 with the rebuilding of the porch by carpenter Richard Hankins. *Sea Girt Lighthouse Collection.*

While the committee would address brickwork in mid-1983, one of the first restoration projects undertaken was the rebuilding of the porch. SGLCC member and architect Richard Graham, who was recruited and volunteered to advise on and oversee restoration efforts, prepared a plan detailing the restoration work needed and assigning a priority to each project according to the policy of safety first. Carpenter Richard Hankins was selected by

trustees at the November 1981 meeting to rebuild the porch and front and back steps.

Trustees were eager to alert the community that restoration was finally underway. A hand-painted sign was secured to the porch post at the top of the front steps announcing to all: "SEA GIRT LIGHTHOUSE / RESTORATION IN PROGRESS / PLEASE USE CAUTION WHEN ENTERING / SGLCC."

Throughout much of the restoration, which would take several years to complete, the lighthouse remained open, with only a few temporary closings. While the porch was being rebuilt, the front door was initially boarded up, so visitors entered through the back door. When Mr. Hankins finished rebuilding the east side of the porch and moved to the west side, the front door was reopened and the back door boarded up. Carpenter Hankins worked throughout the winter of 1982, spending much of his time in the basement cutting and milling lumber to make replacement banisters, railings, spindles and tongue-in-grove floorboards. He spent almost a year on the eighty-foot-long porch.

Other projects in the safety-first phase of the restoration included replacing the roof, repairing the one remaining chimney and installing a new metal railing on the gallery that surrounded the lantern room. Window restoration would extend over several years with the focus on repairing or replacing leaky windows first, including the lantern room's double-hung windows, which were removed in favor of going back to the original style. The wiring and electrical service were upgraded, and the plumbing repairs were underway. Inside the lighthouse, volunteers removed layers of Coast Guard paint from the fireplace, the wooden doors and trim.

In April 1982, at the first annual membership meeting, tours of the building were conducted by docents, who worked from a script written by trustees based on information gleaned from many sources, including the Historian's Office of the Coast Guard, the National Archives, the Borough's archives, descendants of keepers and other sources. In the coming years, the script would be revised and expanded numerous times as new facts were uncovered.

Fundraising efforts continued. On April 28, the Sea Girt Women's Club and the Holly Club, two founding members of the Sea Girt Lighthouse Citizens Committee, co-hosted a lighthouse benefit luncheon, fashion show and bridge party at the Manasquan Elks Lodge that was well attended. All of the proceeds—$2,081—went to the restoration effort.

Meanwhile, the kitchen, with a new electric stove, and the two bathrooms with new sinks and toilets were ready in time for the second annual Signing

of the Lease Party. Throughout the restoration, the Scouts and community groups, such as the Holly Club and the Lighthouse Bridge Club, continued to meet in the first-floor meeting room, with only a few meetings cancelled when work was underway in that room or the adjoining kitchen.

At the October 1982 trustees meeting, there was a guest speaker, Elvin (Toots) Lake, who returned to discuss his childhood at the lighthouse as the son of keeper Bill Lake. He recalled that there was a fireplace in every room and a chicken coop on the property. Supplies were delivered to the lighthouse by tender until 1928, when a tender capsized and supplies were lost. Thereafter, supplies were delivered by truck. (The chicken coop recollection would seem to suggest that the previous keeper, John Hawkey, did get the approval he sought in 1912 to build a henhouse.)

The year 1983 was a busy one for the Sea Girt Lighthouse Citizens Committee. Trustees gathered on January 11 at a special meeting to discuss a Borough Council request that SGLCC submit a bid to manage the pavilion across the street. Running the pavilion had some appeal as a possible source of revenue, which could help SGLCC cover lighthouse maintenance and operational expenses.

But the pavilion, built in 1962 as a temporary structure to replace the pavilion destroyed in that year's Great March Storm, needed repair and new equipment for the snack bar. Mrs. MacInnes appointed a feasibility committee to investigate. At the February board meeting, the feasibility committee reported that the minimum cost, if the Lighthouse Committee were to bid, would be between $15,000 and $20,000, with little income realized the first year. The feasibility committee advised against bidding. SGLCC did not pursue the matter.

By the spring of 1983, the gardeners of the Holly Club were transforming the lighthouse grounds. One of the founding members of the Sea Girt Lighthouse Citizens Committee, the Holly Club had pledged to re-landscape the property and to raise the $5,000 to do it.

The landscaping would be done in three stages. Phase I: Plantings around porch. Phase II: Plantings in the northeast corner where the aero-beacon once stood. Phase III: Plantings in remaining areas, including by the railed steps. In preparation, the Holly Club weeded the long-neglected grounds, tilled selected areas and then prepared flower beds with topsoil.

With the grounds ready, Holly Club members gathered one Saturday in May to receive delivery of carefully selected evergreens and perennials that came in an old wagon pulled by a team of horses. On hand were Dorothy Holthusen, Dalia Binnie, Elizabeth McKelvey, Joan Calhoun, Eve Gilbert

and Eileen Salzmann. Plantings included bayberries, black pines, junipers and yuccas, as well as lacecap hydrangeas and *Rosa rugosa*. Landscape designer George Borab's vision would re-create a shore landscape in keeping with the building's age and history, as was the delivery method.

The Holly Club faced a tight deadline. On June 21, the members were hosting Over the Garden Wall, a full day of tours of the lighthouse grounds and nine other gardens, with a box lunch at the lighthouse. The Holly Club met the deadline, sold 684 tour tickets and raised $3,420 for the next landscape phases.

The next big project undertaken was the brickwork. By early July, scaffolding was up to allow masons to repoint the bricks as needed. Where deteriorated, the original mortar was removed and filled with fresh mortar to secure the bricks and eliminate voids. Then a silicone sealant was applied. The project was completed and scaffolding removed before the third annual Signing of the Lease Party on Sunday, August 21. Also completed were roof repairs and the rebuilding of the porch.

The 1983 Signing of the Lease Party brought together some three hundred lighthouse supporters to celebrate and witness an unveiling and the relighting of the tower. In just two years, SGLCC had raised more than $80,000 toward the restoration, which was progressing on schedule. The committee used the opportunity of the party to thank its many benefactors.

SGLCC president Joan Calhoun unveiled a donors plaque that "commemorates with gratitude the special contributions that helped preserve this historic landmark." The plaque, which today hangs in the first-floor hallway through which all visitors pass, lists more than seventy people—benefactors or those who had donations made in their memory—as well as five community groups.

At 8:00 p.m., the conclusion of celebrations, Mayor Tom Black pushed a switch, turning on a newly installed antique Coast Guard lantern in the octagonal lens room at the top of the tower, where the original Fresnel lens had been. For the first time in forty-one years, this room was lighted.

It was most appropriate that Mayor Black did the honors. In 1977, when the Coast Guard turned off and removed the aero-beacon, Mayor Black and the council came up with the idea of putting a "commemorative light" in the tower. The intriguing proposal was discussed with the Coast Guard in the hopes the service might provide a lens and install it, but discussions stalled until 1982, when lighthouse trustees revived the proposal.

Trustee William MacInnes was alerted to the availability of a decommissioned lantern in storage at a Coast Guard depot on Staten Island. The Coast Guard

*Above*: Relighting the lighthouse tower after forty-one years proved big news. This photo accompanied an article in the *Asbury Park Press*. *Mike Vuocolo*.

*Opposite*: The Coast Guard lantern, installed where the original lens was once located, projects a memorial light recalling the Fresnel lens. *Robert S. Varcoe*.

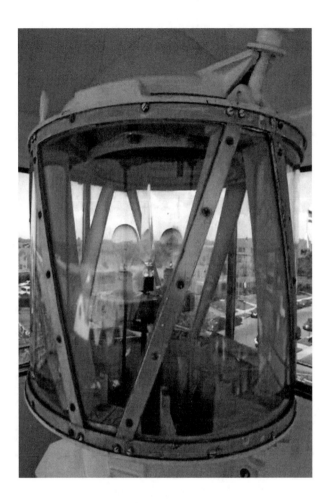

offered it to the lighthouse on permanent loan. Bill MacInnes retrieved the lens and brought it back to the lighthouse, where it was stored until work in the lens room was completed and the lantern installed.[233]

The lantern is a clear glass cylindrical enclosure that was used to surround and protect the light source on a large ocean buoy or a small fixed shore light or beacon. Timothy Dring, an authority on Coast Guard vessels and equipment, dates the lantern from the late 1930s to the early 1950s.[234]

Coast Guard permission was required to relight the lantern. Approval was given on the condition that the light would be of low intensity so it would not be mistaken by mariners for an aid to navigation. SGLCC readily agreed, wanting simply to re-create for visitors and passersby the bygone atmosphere when the tower was illuminated, as it is now dusk until dawn.

# CHAPTER 12
# UNCOVERING BURIED TREASURE AND A FORGOTTEN FIREPLACE

As tradesmen made their repairs at the lighthouse, trustees and other volunteers were cleaning up and painting inside.

As the restoration and cleanup progressed room by room, startling and exciting discoveries of artifacts were made by contractors and volunteers. The Lighthouse Service left behind several boxes filled with official documents related to its operation of Sea Girt Lighthouse, including original letters from the district lighthouse superintendent in Staten Island and the lighthouse commissioner in Washington, D.C., to a succession of keepers.

Also uncovered were the carefully written drafts of the keepers' responses to their superiors, as well as carbons of the letters they eventually sent. In addition, there were advisories, alerts, manuals and the monthly Lighthouse Service Bulletin, as well as requisitions, inventories and leave request forms—some of them filled out by keepers.

Trustees also unearthed more than one thousand pages of Coast Guard documents dating from mid-1939, when President Roosevelt dissolved the Lighthouse Service and put the Coast Guard in charge of America's light stations. The documents trace organizational changes, the U.S. defense buildup and events overseas.

Left behind by the Coast Guard were not only routine communiqués, advisories and manuals but also the riveting "Alerts to All Units" from the Coast Guard commandant and from the Intelligence Office, including some detailing developments in World War II. Among the discoveries was the December 8, 1941 alert announcing that America was at war.

Historic documents left by the Lighthouse Service and Coast Guard provide clues to the lighthouse's history and are displayed as artifacts. *Sea Girt Lighthouse Collection.*

In the days long before e-mail, urgent Lighthouse Service letters came by messenger or, during the Coast Guard era, by Teletype. Routine communiqués came in the mail. These valuable artifacts are the foundation of the lighthouse archives that would grow in the coming decades with more discoveries, as well as donated and purchased artifacts.

Lighthouse trustees focused increasing attention on the lighthouse archives, reviewing what was already in the collection that deserved display. Some trustees became detectives, tracking items down. Trustees Bill MacInnes and Sam Franklin ventured to the National Archives in Washington, D.C., where they found important and revealing Sea Girt Lighthouse documents and photos that they had photocopied. These official reproductions, along with original documents discovered at the lighthouse, were arranged chronologically in binders available to visitors and researchers.

As news of the discoveries and the continuing hunt got around, SGLCC began hearing from people who had items of interest or knew people who did. Leads were pursued. People were encouraged to donate appropriate material to the lighthouse for safekeeping, proper display and to share with visitors.

People with personal or family connections to the lighthouse, including the descendants of keepers Abram and Harriet Yates, Bill Lake and George Thomas, donated important photos and other artifacts. Coast Guard veterans Richard Smith, who served at Sea Girt during World War II, and Hank Wapelhorst, who was on the last detail in 1954, gave photos that went up on the walls.

Collectors contacted the lighthouse to donate all manner of artifacts directly related to the lighthouse, as well as maritime items of general interest such as navigational tools used by mariners to find lighthouse beacons and daymarks, including chart books, maps, lamps, a binnacle compass, a telescope, a long lens and binoculars, all of which went on display. Members have also been generous with gifts of important artifacts.

These discoveries and gifts greatly enhanced the trustees' knowledge of the lighthouse story and provided historic facts that went into the tour narrative, which began being revised and expanded as more details came to light with subsequent discoveries and gifts of artifacts.

Meanwhile, the lighthouse was being furnished with antique tables, chairs, desks and rugs and was lighted with period and nautical lamps and light fixtures that were also donated.

By mid-1985, renovations were nearing completion. Trustees decided that the lighthouse needed a new sign to proclaim its rebirth and new mission. Unlike the small painted signs the Coast Guard and the Borough had put

on the porch railing or the homemade sign the carpenter had nailed to a porch column during the early days of the restoration, the trustees wanted a professionally designed sign prominently but tastefully displayed as an invitation to visitors.

The resulting three- by four-foot white wooden sign, installed beside the walkway, had "Sea Girt Lighthouse" above a stylized image of a lens, both in gold leaf. While the restoration actually took years, space limitations and symmetry prompted the trustees to put "Built 1896" to the left of the centered lens image and "Restored 1981" to the right in black. Beneath hung a message board to announce tours and special events.

The lighthouse parlor became the next focus of attention and discovery. The parlor, which might have been the busiest room in the building as the town library for the last three decades, loaned its last book. The Borough Council closed the lighthouse library in late 1988 in anticipation of the Borough's plan to convert the train station, acquired in 1967, into the library. A benefactor gave the Borough the funds to renovate the train station and convert it to the library, which finally opened on May 13, 1992.

Peg Krauss, the lighthouse librarian since the early 1970s and who was there when it closed, recalled, "It was a wonderful library—when Sea Girt was Sea Girt…It was not a large room. So with all the bookcases and my desk, there was just enough room to wander and check the books on the shelves."[235]

In preparation for restoring the parlor, lighthouse volunteers removed the freestanding bookcases, thereby uncovering the one remaining fireplace on the west side and the built-in bookcases to either side of it. The trustees decided that "the old fireplace will be opened for view," according to the minutes of their November 1988 meeting. The built-in floor-to-ceiling bookcases to either side of the fireplace would be kept. The plan was to furnish the room in period furniture and display appropriate historic artifacts.

Lighthouse trustees announced a dinner dance cruise on the Manasquan River on June 28, 1990, with proceeds to fund the redecorating and furnishing of the parlor, a project directed by trustee Eve Gilbert. The cruise was a sell-out, and the former library was returned to a Victorian parlor. In keeping with the building's rich maritime past, an impressive oil painting of a tall ship, its four sails capturing a strong wind, was hung above the fireplace mantel. The painting was donated by Mrs. Gilbert and her husband, James. Their daughter Janine Cook would herself become involved at the lighthouse. They were one of several families in which two generations have volunteered.

Ten years into its twenty-five-year lease with the Borough, SGLCC sought to extend into the middle of the twenty-first century for the security

and stability that would provide and to reassure potential benefactors the preservation effort was ongoing and the commitment secure. The matter was discussed at the council meeting of April 24, 1990.

Bill MacInnes, a founding trustee of the Lighthouse Citizens Committee who was president in the mid-1980s, was now the mayor of Sea Girt. While no longer on the SGLCC board, he remained a lighthouse supporter, as evident in the council minutes of April 24:

> *It is felt that the time frame of 15 years (remaining on the original lease) is not all that attractive to those people who may wish to leave funds in a trust or will. The committee is requesting an extension of 50 years which is allowed by State law for public property. The Mayor stated that the Lighthouse program has been successful, the building is just about completely renovated and all costs have been paid by collection of donated funds and activities sponsored by the Lighthouse. Mayor MacInnes stated the request would extend the time frame and also delete the small amount of funds for maintenance costs that the town had agreed to pay in the original lease. Mayor MacInnes asked if there were any comments; Mr. Ahern stated he could not think of any reason we would not want to take this action. Mayor MacInnes introduced the current president of the Lighthouse Committee, Mr. Samuel Franklin, who states this action would help the finance committee and would help to build the endowment.* [236]

At the meeting of August 25, 1990, the council agreed to extend SGLCC's lease to August 30, 2056, with a few amendments. No longer would the Borough contribute $1,000 annually to lighthouse maintenance, which would be covered by the committee. Rent remained $1 a year. [237]

In his audit of the Sea Girt Lighthouse Citizens Committee for the year ending April 30, 1991, Robert L. Doremus, CPA, reported, "Since the inception of the organization, approximately $103,000 has been expended on the restoration and preservation of the lighthouse building." [238] The operating expenses in the previous twelve months topped $7,000. [239] The restoration and preservation investment and annual operating costs have grown since then.

The organization is able to meet those sizable obligations because of the continuing generosity of many people who support the mission to not only preserve the building and its history but also keep it in good condition and open to the public. Benefactors, including those who have left bequests to the lighthouse, coupled with the ongoing support of members through their dues, donations by visitors and proceeds from the annual Signing of the

Lease Party have enabled the committee to build a sufficient endowment to fund the restoration, make needed repairs and meet operating expenses.

The lighthouse funds are carefully managed by SGLCC's financial advisor, Robert McKelvey, one of the founding trustees. The aim is to use only a small percentage of the endowment in any given year for restoration, preservation and repairs in an effort to retain enough principal in the lighthouse account so that it will continue to grow and ensure that there are sufficient funds for future projects.

Hanging beside the plaque in the lighthouse hallway commemorating the original benefactors is the Sea Girt Lighthouse Keepers plaque with the names of those who have followed in their footsteps. Above the columns of nameplates, the text reads, "Lighthouse keepers provided the beacon that guided countless mariners in their voyages. This plaque honors a New Generation of Lighthouse Keepers for their generous support of the preservation of Sea Girt Lighthouse."

Sea Girt Lighthouse turned one hundred at the end of 1996. In anticipation, the trustees hosted a full week of summer fun events, including guided tours, an exhibition of lighthouse paintings by the student artists from the Sea Girt Elementary School, presentations, performances and evening concerts. There was something for everyone, attracting several hundred members and guests. Given that the lighthouse was built and activated in 1896, in a decade known as the Gay Nineties, the colorful era was reflected in several of the events, including the Dixieland Band and barbershop quartet performances and high tea for the ladies, to which many wore wide-brimmed Victorian bonnets decorated with colorful flowers and ribbons. Many gentlemen sported boaters to the other events.

Instead of the usual Sunday tours, the lighthouse was open every afternoon Sunday through Friday. Among those dropping by for a guided tour was Governor Christie Todd Whitman. She was greeted by Andy Flanagan, SGLCC president. Andy then guided the governor through the building. They followed in the footsteps of the keepers and countless Coast Guardsmen in making the climb up the forty-two steps to the lantern room, where they ventured onto the gallery to take in the view.

For the evening concerts, Ocean Avenue by the pavilion served as the bandstand for Bill Starr's Dixieland Band and Harry Hurley's Big Band. The best seats were folding beach chairs people set up in front of the lighthouse. At the concluding event, the Signing of the Lease Party, barbershop was back in style as a quartet serenaded guests. Over three hundred lighthouse friends gathered.

Governor Christie Todd Whitman and SGLCC president Andy Flanagan take in the view from the top. *Sea Girt Lighthouse Collection.*

While lighthouse restoration was complete, maintenance continued according to schedule, and repairs were made as needed. In the summer of 1998, SGLCC brought in a Manhattan architectural preservation firm in collaboration with a Princeton firm of architects to assess matters after interior wall damage was discovered. Moisture was evident inside around some windows and on the second floor by the chimney, where plaster was failing. Outside gaps were observed in areas between masonry and the edge of the wooden window frames, and the brick was found to be porous, results of the sandblasting done decades before to remove paint.[240] The inevitable saltwater spray and strong winds would also affect the brickwork and masonry.[241]

A firm specializing in historic brick restoration was hired. Repairs were made in November and December of 1998. Hot water at low pressure was used to remove old sealant from the exterior brickwork and areas of efflorescence or salt deposits. The brickwork was then repointed with a soft mortar mixture appropriate for one-hundred-year-old bricks. Caulk was removed from around windows and doors and new caulk applied. A fresh coat of sealant was then applied to the building's exterior.[242] Eventually, the

windows throughout the first and second floors were replaced with double-paned storm windows set in new frames.

Ever vigilant in maintaining the building, trustees also remained on the lookout for appropriate items to add to the collection. And the discoveries and acquisitions continued. Even after acquiring the Coast Guard lantern that went in the tower in 1983, the lighthouse trustees still hope to one day locate the original Fresnel lens. To this day, its fate remains unknown.

But the fate of another Fresnel lens was brought to the attention of SGLCC in late 2001 by a member who spotted a fourth-order Fresnel lens being offered on the online auction site eBay. The trustees decided to make a bid for it and wound up submitting the winning bid of $20,000. The New Jersey Lighthouse Society helped in the acquisition with a generous grant.

But there was one complication: the lens was 10,000 miles away in Australia. The beehive-shaped lens, with three center bull's-eye prisms, had been in service at least from 1920 to 1970 at Crowdy Head Lighthouse in New South Wales, some 240 miles north of Sydney. A conservator who inspected the lens believes it is much older and could be the original lens at Crowdy Head, which was built in 1878.

Before shipment by ocean freighter, the 180-pound lens, with more than two dozen prisms, was wrapped in several layers of bubble wrap and then put in a wooden crate built to the specifications of insurer Lloyd's of London. The lens was bolted to the bottom of the box. The crate was almost as heavy as the lens. The precious cargo took six weeks to reach New York City, at which point it was trucked to Sea Girt and required five trustees to carry it inside.

The board considered putting the lens in the lantern room where the original lens was. But the Coast Guard lantern was already there. Swapping them would have been a risky ordeal. Instead, trustees opted to display the Fresnel lens on the second floor as the centerpiece of a Fresnel exhibit where people could get a close-up look at the lens.

The lens from Down Under is probably the most photographed artifact in the lighthouse collection and something that visitors like to be photographed beside.

The octagonal lantern room underwent repairs in 2006. The unheated metal room, with a conical roof and a copper cap that used to vent the fumes of the oil-burning lamp, is the room most exposed to the elements and high winds. In heavy rains, some water was able to seep through the gallery hatchway, the top vent despite a plug for it and possibly through cracks or gaps in the window caulk, common problems in lighthouse towers.

The Fresnel lens is frequently photographed by visitors, many of whom also like to have their pictures taken beside it. *Bill Dunn.*

The current pavilion, at the north end of the boardwalk, opened in 2006 across Ocean Avenue from the lighthouse. *Bob Dunn.*

The heavy metal double doors that open to the gallery were rusting, and one of its hinges had separated from the door. There was corrosion evident at the bottom of three interior wall plates. There were small cracks in some of the windows, which could have been caused by bird strikes, high winds and/or pressure from the expansion and contraction of the metal during seasonal swings in temperatures. The exterior metal was inspected and found to be in good condition, just needing a new coat of paint.

Metalworkers and glaziers with experience in lighthouse work were brought in. The corroded panels of the hatch doors were replaced, the hinge repaired and gaskets installed to keep out rainwater. The corroded wall panels were replaced, and new laminated glass was installed in all eight windows, which were caulked with silicone. The lantern room was then painted inside and out and the top vent plugged.

Elsewhere in the community that year and following years were projects that recalled lighthouse history from decades ago. The temporary pavilion, built in 1962 in front of the lighthouse as an interim pavilion to replace the one on Chicago destroyed by the Great March Storm of '62, was finally torn down and replaced by an attractive new pavilion with offices, a refreshment stand, lockers and showers.[243]

Also in 2006, the New Jersey Department of Environmental Protection plan for a three-hundred-foot extension of the Wreck Pond outflow pipe to the ocean was completed (the original pipe was built in 1938). This was the latest but not the last engineering project designed to better control the tidal water between the ocean and pond and minimize, if not eliminate, storm flooding.[244]

In 2014, six sluice gates are to be built at the west end of the outflow pipe in a project funded by the Borough of Spring Lake and the Federal Emergency Management Agency. The manually operated sluice gates, by design, are intended to regulate tidal water and can be closed during storms to stop ocean surges from flooding Wreck Pond.[245]

# CHAPTER 13
# BEACON TO THE COMMUNITY

S ea Girt Lighthouse has withstood countless hurricanes and nor'easters since it was built in 1896, including Hurricane Sandy, which slammed the New Jersey coast on October 29, 2012, causing havoc in coastal communities. In Sea Girt and neighboring towns, the boardwalks were torn up, and some homes and public buildings were damaged. Remarkably, the lighthouse sustained only minor damage.

Sandy carved a channel from the ocean to Wreck Pond, just north of the 1938 dam. The channel was eventually filled in. There was some local flooding but no flooding of the lighthouse basement or erosion of the property. Activities at the lighthouse were cancelled during the local cleanup and lighthouse repairs. The tower was dark for days during an area-wide blackout. When power returned, the relighted tower was a reassuring sight to all. In less than four weeks, as a result of a coordinated response, the lighthouse was back on its normal schedule.

In addition to preserving the lighthouse and its history, the Sea Girt Lighthouse Citizens Committee has also pledged to keep the building open to the community. And so far, the committee has been successful in fulfilling the three interrelated missions.

A review of the lighthouse calendar reveals that the lighthouse is in use most years some two hundred days, attracting three thousand to four thousand people. The lighthouse is the regular meeting place for the Holly Club and other community groups. Alcoholics Anonymous holds gatherings every Friday night. The Manasquan River Group of Artists, one of the first

Manasquan River Group of Artists, one of the first groups to meet regularly at the lighthouse, hosts an annual summer art show on the lawn. *Sea Girt Lighthouse Collection.*

community groups ever to meet regularly at the lighthouse, continues to hold painting and drawing classes. And every July, there is an art exhibition and sale of the work of its members.

There are other groups that, while not regulars, return periodically to the lighthouse, including the historic preservation groups known as the Questers and the New Jersey Lighthouse Society, both of which have given grants to the lighthouse to support SGLCC's own preservation effort. The lighthouse is also available to Sea Girt property owners for private parties and has been the setting for weddings, family reunions and graduation parties.

Sunday tours run April through November. In preparation for the new season of tours, trustees spend every winter going through the lighthouse archives, mining for overlooked treasure. Other archives are also explored, including the National Archives, in search of Sea Girt photos and documents worth copying. In addition to uncovered items being added to exhibits, some artifacts already on view have been given more prominent display.

Group tours, held year round, have proven popular with teachers and students. Every fall, Maureen Masto, a third-grade teacher at Sea Girt Elementary School, has her class tour as part of a town appreciation project. And one day in May, eighteen children from a dozen countries, exchange

Exchange students from Millburn public schools in Essex County visit the lighthouse. *Bill Dunn.*

students at Millburn Middle School and High School in Essex County, ventured fifty-five miles south with their teachers to see the lighthouse as part of their New Jersey history studies.

People from down the block and around the world find their way to Sea Girt Lighthouse. It amazes and gratifies the docents. Youngsters, at the conclusion of tours, are issued SGLCC Junior Membership cards. They're encouraged to tell family and friends about what they've seen and learned, to come back with them and to help the docents give the tour. Visitors of all ages help spread the story of Sea Girt Lighthouse far and wide.

Scouts from Sea Girt and surrounding towns come through the lighthouse on group tours with some regularity. A den of Cub Scouts, their den mothers and some family members visited one spring afternoon. Among the visitors were Charles Harrison Height, then seven years old; his mother, Lori Lake Height; and Charlie's grandfather and Lori's father, William Lake. They are descendants of William Lake, Sea Girt keeper from 1917 to 1931. "It was amazing that my great-great-grandfather was so cool," said Charlie after his

Visitors return home telling the lighthouse story, including these London youngsters who are the great-grandchildren of the late Harry Tower, whose lighthouse paintings are displayed. *Elizabeth Whelan.*

tour. "It surprised me that my family lived in the lighthouse with no TV or lights," he admitted. He wants to return. "I would like to live there when I grow up."

In addition to tours, there are special events and programs featuring topical speakers such as the late Marjorie Yates Irving, who in 1999 delivered an informative and insightful presentation on her great-grandparents, Abram and Harriet Yates, the second and third keepers at Sea Girt Lighthouse, based on her own family research.

A program held every five years remembers the 1934 *Morro Castle* ship fire and rescue effort. Thomas Torresson Jr., a retired U.S. Air Force colonel who had been the seventeen-year-old third assistant purser on that final, fateful voyage, was one of the speakers at the seventieth anniversary program on September 8, 2004, which attracted a capacity crowd to the first-floor

Keeper Lake's grandson, great-granddaughter and great-great-grandson visit their ancestral home. *Bill Dunn.*

meeting room. Attending the program was Brian Hicks, a South Carolina newspaper reporter who had driven through the night to be there to meet Colonel Torresson, whom he interviewed that day and subsequently. Brian went on to write the book *When the Dancing Stopped: The Real Story of the Morro Castle Disaster and Its Deadly Wake*, in which Tom features prominently.

For several years, local amateur radio operators broadcast from Sea Girt Lighthouse to lighthouses and home-based hams around the world in the annual International Lighthouse/Lightship Weekend in August. "CQ, CQ [seeking you]. Calling CQ. This is special event radio station WR2DX—whiskey Romeo 2 delta x-ray—calling from Sea Girt Lighthouse, New Jersey, on International Lighthouse/Lightship Weekend. Calling CQ." Hams at Sea Girt have made contact with scores of light stations in the United States, Canada and overseas and with home-based

hams in most every state, as well as Germany, Northern Ireland and Russia. As hams speak into their microphones or tap their keys to transmit Morse code, passersby inevitably are drawn to the lighthouse porch to listen and observe.

The Coast Guard era was celebrated at a 2007 program. The featured speaker was Henry Wapelhorst, who in 1954 was nineteen years old and one of the last two Coast Guardsmen assigned to Sea Girt. Hank spoke of his tour and related stories passed down by Coasties who served at shore stations in World War II. At the conclusion of the program, the lighthouse was presented with a Coast Guard ensign, which went on display to commemorate its years as a Coast Guard installation.

The third weekend of every October is the Lighthouse Challenge, which started in 2000. The challenge is for participants to visit eleven New Jersey lighthouses in just two days, with the option of also visiting two related museums and two lifesaving stations. The challenge attracts a wide range of participants, including many families, couples of all ages and some solo folks. At each stop, challenge takers collect the stamp of that lighthouse in their challenge passports. If they collect every stamp, they earn a gold seal that proclaims, "Congratulations! Challenge Completed!"

A familiar face at the Sea Girt stop in the Lighthouse Challenge has long been Greg Fitzgerald, who started volunteering at Sea Girt during an early challenge weekend when he was in junior high school. From northern New Jersey, he would swing by the lighthouse during visits with his grandparents in Spring Lake. He's been back most every challenge since. A knowledgeable volunteer, Greg typically would be on duty in the lantern room. A well-traveled young man, Greg qualifies as a lighthouse authority, having visited over four hundred lighthouses around the world.

And his favorite lighthouse? Sea Girt! "There's something about Sea Girt Light I can't quite explain—something about it that feels so homey. I see this special thing in our challenge visitors," said Greg. "They'll come, sit in the parlor on the sofa and just decompress. And they'll say, after visiting the ancient Sandy Hook or the majestic tall towers of Absecon and Barnegat and Cape May, that our beautiful little lighthouse was their favorite. Sea Girt Light feels like home. And for me, it is a home—a literal and figurative refuge from the storm and my favorite lighthouse as well."

Greg invariably has his camera with him to photograph every lighthouse visited. He's taken excellent photos of Sea Girt inside and out. Whether on a tour, attending a special event or just coming by when the lighthouse is closed, visitors to Sea Girt Lighthouse can often be seen photographing the landmark from different angles night and day across the seasons. The

*Above*: A young lighthouse enthusiast proudly displays her lighthouse passport with the stamps of lighthouses she has visited, including Sea Girt. *Bill Dunn.*

*Opposite*: Trustee Jude Meehan re-creates lighthouse history by pitching an army tent on the lawn and hanging signal flags from the porch. *Sea Girt Lighthouse Collection.*

lighthouse interior and displays of artifacts also inspire photographers, as does the view from the top of the tower.

In the 2013 challenge, 1,341 people visited Sea Girt Light, coming from fifteen states; Washington, D.C.; Germany; and the Czech Republic. One family drove twenty-four hours straight from Wichita, Kansas, to participate in their third challenge in five years. In addition to permanent exhibits, Sea Girt offered added displays of artifacts from the personal collection of trustee Jude Meehan that recalled events from lighthouse history. Hanging from the porch were signal flags of the type the Light-House Board issued to the station in 1899 for shore-to-ship communications. On the west lawn, Mr. Meehan pitched an army tent, as did a small detachment of soldiers who camped on the lawn in mid-1943 and joined the Coast Guard in beach patrols.

Giving tours and running special events at the lighthouses requires volunteers—many of them—who traditionally have come from the

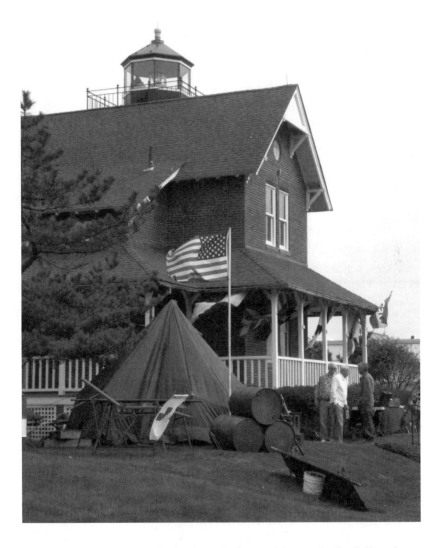

membership. Conrad Yauch, in charge of recruiting and scheduling docents, has a roster of capable and enthusiastic docents. Quite a few have an affinity for the lighthouse, such as Bruce Beckmann, who grew up in Sea Girt and remembers the lighthouse from its days as the community center; lighthouse trustee Jude Meehan, who collects lighthouse and military artifacts; and Walt Emery, who served in the Coast Guard in World War II.

Realizing the importance of getting young people involved with the enthusiasm and interest of someone like Greg Fitzgerald, trustees a few years ago launched an ongoing drive to recruit students. History teachers

and Key Club moderators at area high schools were alerted and asked to encourage students to volunteer. The response was encouraging. Several students volunteered the first year and seemed to enjoy the experience, which fulfilled school requirements to do community service and made for an impressive activity on college applications. It also helped develop their confidence, poise and public-speaking ability. The lighthouse benefitted from their energy and efforts.

In addition to individual students, there have been groups of youngsters who have pitched in at the lighthouse. Some two dozen children of military servicemen and servicewomen took time out of a fun week of swimming, games and barbecues at summer camp at the National Guard Training Center in Sea Girt to provide selfless service, undertaking a cleanup project at the lighthouse. The campers dusted, cleaned and polished artifacts, including a ship signal lantern, a Life-Saving Service oil lamp, a doorknocker, a coalscuttle and several lamps and trays. Within an hour, they had everything gleaming. The trustees marveled at the transformation and thanked them for their initiative, willingness to help and hard work. The children were pleased to know that the items would go back on display. Having successfully completed their mission, the campers earned some R and R. They and their counselors were given tours of the lighthouse.

On one special summer Sunday of expanded tours a few years ago, lighthouse docents had assistants—Girl Scouts. Working in pairs, one pair to a room, they gave tours to drop-in visitors and Girl Scout families. The Scout guides, ages ten through fourteen, worked in two shifts of ninety minutes each. They prepared for their assignment by studying the tour script and by taking their own tour earlier the same day. They then chose the rooms in which they were posted. Conrad Yauch noted, "Our docents had an easy day of it. Our Scout teammates did an excellent job. They were well prepared, enthusiastic and informative."

Trustee Meehan, possibly the docent most often on duty and usually in the tower, has recruited his sons, Julian, ten, and Harlan, fifteen. Julian is often greeting visitors or at the Fresnel lens display. Harlan has been on duty in the lantern room. The brothers were interviewed by the *Philadelphia Inquirer*. In the resulting front-page article, the boys explained what attracts them to the lighthouse. "I like going up into the tower and looking at all the ships," said Harlan. "I like how old it is here, the history of it," added Julian.[246]

Just as the Lighthouse Citizens Committee is always looking for new members and volunteers, the trustees are also looking for new trustees with the right stuff. They found it in William Mountford, who is himself living

lighthouse history as the great-grandson of William (Pappy) Lake, Sea Girt's longest-serving keeper and grandson of Elvin (Toots) Lake, one of the lifeguard rescuers in the 1934 *Morro Castle* disaster.

Bill Mountford joined the board and was sworn in at the 2009 annual membership meeting. He quickly proved himself a strong addition because of his knowledge of his forebears and the unique perspective he brings to ongoing research and when giving tours. A commodities trader with website design experience, Bill launched the lighthouse into cyberspace, creating SGLCC's very own website (www.seagirtlighthouse.org), which went live in February 2010. The site has become "the virtual historic record" of the lighthouse, featuring the latest news, historic and contemporary photos, articles, profiles, fun facts, technical details and a calendar of upcoming events.

The annual meeting, held the third Tuesday in May and always well attended, begins with a brief business meeting. At the 2013 meeting, President Virginia Zientek delivered the traditional State of the Lighthouse Report, reviewing the past year and the challenges ahead. She began by warmly remembering Colette Casey, who died on January 6, 2013, at age sixty-two. A trustee since 2005, Colette was corresponding secretary and in charge of membership and ticket sales for the summer party. "Colette was a dedicated trustee and a tireless worker. Her cheerful enthusiasm was infectious and her buoyant humor a joy. She will be missed," said Mrs. Zientek in announcing a grant made to the lighthouse in Colette's memory.

In celebration of Colette's contributions and to inspire others to become members, an anonymous benefactor made a $1,000 donation in a pledge to match the initial $25 annual dues of new members who joined in 2013 or until the grant total is reached. The drive was named the Colette Casey Memorial Membership Challenge. "This is a most fitting way to remember our friend," said Mrs. Zientek. "We thank our benefactor for this creative expression of support."[247] Ms. Zientek asked attendees to extend the challenge to family and friends. "Our mission to maintain this landmark is a collaborative effort, made possible by our many members, volunteers and benefactors. I thank you all." There are currently some four hundred members.

After the business was concluded, there followed a speaker, Tim Dring, who gave an excellent talk and slide presentation titled "The U.S. Life-Saving Service: New Jersey Origins of the Coast Guard's Predecessor." Topics of presentation at previous annual meetings have included New Jersey lighthouses, Jersey Shore lifeguards and Sea Girt Light keepers. After the speaker's presentation, the annual meeting is adjourned, followed by a reception where members and the speaker gather for refreshments and lively conversation.

The lighthouse, decorated for the season, is illuminated by a full moon for the first-ever night climb in mid-December 2013. *Henry Bossett.*

In addition to the annual meeting, members and non-members alike have the opportunity to gather socially at the Signing of the Lease Party every August on the lawn and then the first Sunday of December in the first-floor meeting room for the holiday reception.

There was an added treat to which the community was invited in mid-December 2013. In what might become an annual event, the lighthouse was open for the first-ever night climb on December 15. The lighthouse, beautifully decorated for the season by trustees and the Holly Club, was bathed in the light of a full moon that also illuminated the beach and ocean, making for spectacular views and the opportunity to take dramatic photos. Little children had a table to themselves where they were given coloring sheets of the lighthouse and crayons. Hot chocolate was served, and young carolers filled the lighthouse with seasonal music. The night climb, the idea of trustee Meehan, attracted more than three hundred people.

All these gatherings are celebrations of the landmark and provide an opportunity to reflect on what's been accomplished and to recommit to meet the challenges to come.

# CHAPTER 14
# ROOM-BY-ROOM TOUR

Now let's take a room-by-room tour of Sea Girt Lighthouse to learn more about how the keepers and their families and, later, the Coast Guardsmen lived, worked and relaxed while assigned here.

## KEEPER'S OFFICE

We begin our tour, as we do our Sunday and group tours, in the keeper's office, just inside the front door at the base of the tower. It is a most appropriate place to begin, for it is through this door that a succession of reassigned keepers and Coast Guardsmen walked to take up their new duties. And through the door came Lighthouse Service inspectors and, later, Coast Guard district commanders to assess operations.

In these cramped quarters, the keeper sat at a desk to write daily entries in the Light Station Journal and kept up with official communications. And here the keeper monitored the weight in the channel in the northeast corner as it dropped and propelled gears that turned the Fresnel lens at the top of the tower in the days before the tower was electrified in 1924.

On the west side of the office are double doors that open to the living quarters. Above the doors is a horizontal window, a transom that can be

The front door opens to the keeper's office. In the northeast corner is the channel down which dropped the weight that powered the revolving lens up top. *Bill Dunn.*

lowered forty-five degrees inward. On hot days, the transom was opened, allowing ocean breezes to enter the home through the screened front door. This provided air-conditioning before there was air-conditioning.

# PARLOR

Enter the double doors into the living quarters, and to the left is the parlor, which would be referred to today as the living room. This is where the keeper and family often gathered in their spare time in an era long before the

After the Borough closed the lighthouse library, the fireplace was uncovered and the parlor restored. On the mantle are keeper family photos. *Bill Dunn.*

Internet, computers, TV or even radio. The family often came together here to do what families did long ago during their quiet time—chat, read, write letters, play parlor games, sing and/or play instruments. Keeper George Thomas played a guitar, and his daughter Alice played the ukulele. During World War II, the Coast Guard commanding officer had his office here.

The parlor fireplace, the only one surviving, has a surround made of soapstone, a soft, dense rock then favored for fireplaces because it absorbed, held and projected heat from the fire. On the mantelpiece are photos of some of the people who called the Sea Girt Lighthouse home, including Harriet Yates, wife of second keeper Abram and herself the third keeper, gathered with her children. On the walls are oil paintings of sailing ships. Into the early twentieth century, sailing ships still carried passengers and cargo in local waters, and their crews relied on the lighthouse beacon to guide them, as did mariners who followed in powered vessels.

The furnishings are not original. However, they are appropriate to the Victorian era. Most of the wood molding, flooring and shutters in the building are original.

# FIRST-FLOOR MEETING ROOM (ORIGINALLY DINING ROOM AND KITCHEN)

Across from the parlor is the room where lighthouse trustees and community groups meet. Originally, there were two rooms: a dining room on the east side and a kitchen on the west. A chimney ran up the center of the common wall, venting the dining room fireplace and the kitchen's cookstove. When the Coast Guard took command of Sea Girt on July 1, 1939, the building was reconfigured to better serve its needs. The wall was removed to make one big room—the mess hall where the men ate. The west-side pantry became the galley where meals were prepared. The room now houses some of our most important artifacts.

In the northeast cabinet are artifacts of the early keepers. On the bottom shelf, left, is the 1903–06 Light Station Journal of Sea Girt's second keeper, Abram Lewis Yates. Recorded on November 25, 1903: "Inspected. Excellent order." All light stations were inspected quarterly. Keepers would be graded on the efficiency of the station's operation and its condition. Displayed are commendation letters received by Sea Girt keepers, as well as replicas of Efficiency Stars, the medals given to top-rated keepers to be worn on their dress uniforms.

On the second shelf, right, is a circa 1917 brass oil lamp that belonged to Bill Lake, Sea Girt's longest-serving keeper (1917–31). He used it in the house and tower to find his way at night. More than a few youngsters have been puzzled by the need for an oil lamp and have asked why Lake didn't just turn on the light switches on the wall—but that would require electricity. They are surprised to learn that the Fresnel lens was not electrified until 1924 and the living quarters not until 1932.

In the southeast cabinet are tools on which mariners relied to navigate and find beacons and landmarks, including a post–World War I U.S. Navy quartermaster long lens. This type of spyglass was still being used in World War II aboard ship to scan the waters to ensure a safe course, search for enemy ships and aircraft and track incoming and outgoing fire. Despite excellent optics, the long lens was awkward and heavy and ultimately was replaced by binoculars. The telescope displayed came off the bridge of an early Coast Guard cutter.

On the second shelf are regional volumes of the annual series *U.S. Coast Pilot*, the essential reference guides listing all aids to navigation, as well as their flash sequence and appearance, that have enabled generations of mariners to figure out where they were.

*Left*: Among the artifacts donated was the oil lamp of keeper Bill Lake, held here by his great-great-grandson, Charlie Height. *Bill Dunn.*

*Below*: Mariners relied on these tools to find beacons and daymarks. *Sea Girt Lighthouse Collection.*

Just as light stations projected beacons to identify themselves and enable mariners to fix their positions, so too the mariners relied on lamps of different colors and placement to let other ships know their position and whether they were at anchor or underway. The exhibit includes a fourteen-inch oil lantern, circa 1900, which was displayed to indicate a ship at anchor, and an eight-and-half-inch-high brass bow lantern (mid-twentieth century) that was mounted at the forward-most point of a ship.

# MORRO CASTLE

An important chapter in the lighthouse history is the fire aboard the cruise ship *Morro Castle* and the ensuing rescue efforts. Fire was discovered early on September 8, 1934. It spread quickly, fed by the high winds of a nor'easter. The anchor was dropped and the abandon-ship order given. The ship was three miles offshore. Most people were struggling in the water in bulky cork-filled canvas lifejackets. The lighthouse beacon gave them hope as they fought for their lives. In all, 137 people died, but over 400 survived due in large part to the efforts of local people.

The *Morro Castle* exhibit begins on the south wall with dramatic photos and reports on the front pages of newspapers across the nation and around the world. At the top of the display is a *Morro Castle* lifeboat oar, measuring fourteen feet long, with the ship's name stenciled on the paddle. The oar was retrieved from the beach by Tom Black, a Sea Girt lifeguard who became a hero that day.

On the countertop are poignant reminders of what was and what had been lost: a photo of the sleek cruise ship peacefully at anchor in 1931 by the Brooklyn Bridge, the sailing schedule and a colorful invitation to the *Morro Castle*'s masked ball. Despite the Depression, the *Morro Castle*, described by a crewman as "a party boat," attracted passengers with low fares and the expectation of fun. Also displayed is a souvenir life preserver purchased in the ship's gift shop during the 1934 Easter cruise by a boy from Spring Lake.

Captain John Bogan Sr., his sons John Jr. and Jim and other volunteers disregarded Coast Guard orders for small boats not to leave their docks because of storm conditions and sailed to the disaster area. The Bogans and others, aboard their fishing boat *Paramount*, saved sixty-seven people, including Agnes and Ruth Prince.

Captain John Bogan Sr. (under "MO"), sons John and Jim (fourth and fifth from left, respectively) and other volunteers aboard the Bogans' *Paramount* saved sixty-seven people. *Donated to Sea Girt Lighthouse Collection by the Bogan family.*

Sea Girt lifeguards (left to right) Jack Holthusen, Tom Black, Toots Lake, Dick Tucker, George Braender and Jack Little rescued fifteen people. *Donated to Sea Girt Lighthouse Collection by Dorothy Holthusen.*

Two *Morro Castle* lifejackets are powerful reminders of the 1934 disaster and inspiring rescues. *Sea Girt Lighthouse Collection.*

On the beach, lifeguards had difficulty launching lifeboats. Six Sea Girt lifeguards couldn't get their lifeboat past the breakers. They devised an alternative plan. The strongest swimmers among the lifeguards took turns. The designated guard attached a lifeline to his leather-over-canvas belt. The other end of the line was connected to a wooden barrel with a hand-crank, which worked like a fishing reel. When someone was spotted in the water, the guard attached to the lifeline swam out to the person, got control and then flashed a signal. At that point, the other lifeguards reeled them back to shore. In all, fifteen people were saved that way.

By afternoon, a Coast Guard cutter secured a towline to the ship, cut the anchor chain and began towing the wreck to New York, but the towline broke. Strong winds, storm swells and currents pushed the ship to shore, where the *Morro Castle* beached in Asbury Park, narrowly missing Convention Hall. The burned-out wreck remained there for six months, becoming a macabre tourist attraction.

In 1994, on the sixtieth anniversary of the *Morro Castle* tragedy, a memorial program at the lighthouse reunited Captain Jim Bogan and Agnes Prince Margolis. A dramatic photo, now hanging on the wall, shows them together, joined by Agnes's two children, who would not have been there but for Captain Bogan's heroism. In early 1935, Senate Bill 1874 was introduced in the U.S. Senate to authorize the awarding of medals to the *Morro Castle* rescuers. The campaign stalled. In the end, Congress never awarded medals.

Dorothy Holthusen donated an original copy of the bill in memory of her late husband, Jack, the head Sea Girt lifeguard. When the framed document, now displayed at the lighthouse, was unveiled at a *Morro Castle* memorial, Mrs. Holthusen said, "I'm very happy. I feel that Jack and the other rescuers finally got their medals."[248]

The human drama of the *Morro Castle* fire and the struggles of passengers and crew to survive are vividly captured in two lifejackets on display beneath a wall of *Morro Castle* photos that follows the ship from earlier days as a sleek, fast ship to its destruction.

# COLLABORATION OF HISTORIC PRESERVATION

The lifejackets also demonstrate the collaborative and serendipitous nature of historic preservation. After touring the lighthouse in 2007 and seeing the *Morro Castle* display, retired teacher Robert Bossett of Brielle alerted trustees that he had witnessed one of the *Morro Castle* lifeboats coming ashore just off the lighthouse. Thirteen years old then, Bobby Bossett went home that day with a discarded lifejacket, which he kept for seventy years.

He offered it to the lighthouse. Brittle with age and torn, the lifejacket nevertheless was an important artifact trustees readily accepted with gratitude. A photo of the lifejacket and an article about the donation appeared in the *Asbury Park Press*,[249] prompting a phone call to the lighthouse from a second gentleman, Grover Donnelly, who noted that he, too, had a *Morro Castle* lifejacket and that his was in better condition. Mr. Donnelly was asked if he would like to donate his lifejacket to the collection. He responded in the affirmative.[250]

Soon after, New Jersey Questers, the state chapter of an international group promoting historic preservation, met at the lighthouse and learned of the lifejackets. Virginia Cutaio, chapter president, encouraged lighthouse trustees to apply for a restoration grant. SGLCC did. The grant was approved, enabling the cleaning of both lifejackets and the full restoration of Mr. Bossett's lifejacket.[251]

Dr. Bill Sciarappa, an entomologist and zoologist at Rutgers Cooperative Research & Extension in Monmouth County, volunteered to first examine the damaged lifejacket. He did and reported no evidence of fabric pests or insects.[252] Next, the lighthouse committee chose Katherine Francis, a leading textile conservator, to do the restoration. Among her previous

Robert Bossett (right) presents the *Morro Castle* lifejacket to lighthouse trustees.
Representatives of New Jersey Questers, which funded the lifejacket's restoration, are to the
left of the artifact. *Henry Bossett.*

assignments, Ms. Francis had restored the vest that John Adams, future second president of the United States, wore on October 25, 1764, when he married Abigail Smith.

Ms. Francis mended tears, strengthened weak sections of fabric, replaced missing sections and straps with similar canvas dyed to look aged and carved new floats to replace the four missing ones. She then reassembled the Bossett lifejacket.[253] Her mends are hard to detect. After completing the lifejacket restoration in December 2007, the conservator set to work making a fleece-lined linen cover for the display case, into which the *Morro Castle* lifejackets were placed for viewing. She donated the cover that is put over the display case when the lighthouse is closed to protect the artifacts from sunlight.

# U.S. COAST GUARD AND ITS NEW JERSEY ORIGINS

The U.S. Coast Guard features prominently in the lighthouse's history because the lighthouse was, from 1939 to 1956, a Coast Guard station and because one of the sea rescue agencies that preceded the Coast Guard originated in New Jersey.

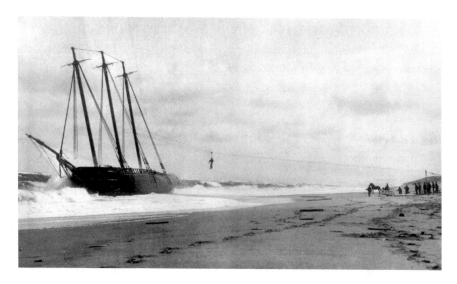

U.S. Life-Saving Service volunteers rescue a crewman from his ship using the breeches buoy envisioned by Dr. William Newell. *Courtesy Timothy R. Dring.*

Before there was the modern Coast Guard, there was the Revenue Cutter Service (organized in 1790 to enforce maritime laws and collect duties) and the U.S. Life-Saving Service (established in New Jersey and New York in 1848 to assist ships in trouble). The Life-Saving Service grew out of humanitarian efforts of volunteers in seafaring towns along the East Coast who attempted—often unsuccessfully—to help shipwrecked mariners.

In 1839, Dr. William Newell, a physician and a volunteer rescuer, watched helplessly as the Austrian sailing ship *Terasto* wrecked off Long Beach Island, New Jersey, claiming all thirteen lives aboard. Newell began thinking about how they could have been saved. He envisioned shooting lifelines to ships in trouble and then pulling people to shore.

Over a decade later, Dr. Newell was elected to Congress, where he sponsored legislation that organized and funded a coastal rescue service that became known as the U.S. Life-Saving Service. The first stations were built in New Jersey and New York and were equipped with lifeboats, life preservers, hooks and lines for volunteers to use when responding to ships in trouble.[254]

The lifesaving stations were eventually equipped with portable cannons that could shoot a lifeline with a grappling hook into the mast of a wrecked ship. The other end of the line would be secured to a tripod on shore. Attached to the line was a breeches buoy—basically a cutoff pair of sturdy

pants attached to a life preserver—into which one person at a time from the ship would climb and then slide to shore along the lifeline. This was the realization of Dr. Newell's brainstorm.

# UNITED, STRONGER, ALWAYS READY

In 1915, Congress passed the Act to Create the Coast Guard. The act merged the Life-Saving Service with the Revenue Cutter Service, thereby launching the U.S. Coast Guard. The Latin motto of the new service, *Semper Paratus* (Always Ready), captures the mission and spirit of the officers and enlisted personnel who are always ready to help others. From two overlapping services, a single, integrated and stronger maritime service emerged to save life at sea and enforce the nation's maritime laws.

On display in the meeting room are photos of daring Life-Saving Service rescues, a circa 1890 Life-Saving Service hand-held brass lamp and a circa 1925 portable Coast Guard binnacle compass with an attached oil lamp that would have been placed on the helm of a lifeboat to navigate.

The Coast Guard mission was significantly expanded on July 1, 1939, by President Roosevelt's Reorganization Plan No. 2 (also on display), which ordered "that the Bureau of Lighthouses in the Department of Commerce and its functions be transferred to and consolidated with and administered as a part of the Coast Guard." While the plan stated that the reorganization was in the "interest of efficiency and economy," the prospect of America's going to war and need to strengthen the nation's defenses were clearly the primary motivating factors.

With Germany's invasion of Poland on September 1, 1940, World War II erupted in Europe. All Units alerts that arrived at Sea Girt Lighthouse from the Intelligence Office of the Coast Guard commandant in Washington, D.C., contained sensitive information—for service use only—and provide a timeline for the spreading war in Europe and the U.S. military buildup. They make for chilling reading today. On the south wall hang a dozen alerts reporting the worsening situation and the need for increased vigilance and discipline. The subject lines are sobering, e.g.: "Proclamation of a State of War Between Germany and Italy, on the One Hand, and Yugoslavia, on the Other Hand" and "Presidential Proclamation 2487 dated May 2, 1941—Unlimited National Emergency."

# AMERICA ATTACKED, ENTERS WARS

And then came the alert from Coast Guard command in Washington, D.C., to all units on December 8, 1941—the day after Pearl Harbor—advising, "Effective this date a state of war between the United States of America and Japan now existing…"

Earlier that day, President Roosevelt had appeared before a joint session of Congress to deliver his "date which will live in infamy" speech. "I ask that Congress declare, that since the unprovoked and dastardly attack by Japan on Sunday, December 7, 1941, a state of war has existed between the United States and the Empire of Japan." Within an hour, both houses of Congress passed a declaration of war against Japan by a margin of 80–0 in the Senate and 388–1 in the House. The declaration of war was flashed to all U.S. military commanders and down the chain of command.

On December 11, Germany and Italy declared war on the United States, which that same day declared war on Germany and Italy. With America's entry into World War II, Sea Girt Lighthouse went on a war footing.

The Coast Guard detail began increasing steadily. There were ten Coast Guardsmen at Sea Girt Lighthouse by January 1942. By spring, there were as many as eighteen Coasties. And more were coming, along with a detail

```
              SENIOR COAST GUARD OFFICER
                 THIRD NAVAL DISTRICT
                  411 CUSTOMHOUSE
                  NEW YORK, N.Y.

                              December 8, 1941.

From:          Senior Coast Guard Officer, Third Naval District.
To:            All units under my command.

Subject:       Discipline, Administration of.

Reference:     (a)  Naval Courts & Boards, Section 44.
               (b)  Naval Courts & Boards, Section 451.
               (c)  Articles for the Government of the Navy.
               (d)  U. S. Navy Regulations 1920, Article 830.
               (e)  ComTHREE ltr. to All Activities, of
                    September 2, 1941.

        1.        Effective this date, a state of war between the
United States of America and Japan now existing, specifica-
tions for military offenses committed by personnel of the
Navy, Marine Corps and Coast Guard, and in accordance with
reference (a), will contain the averment, "The United States
then being in the state of war."
```

On December 8, 1941, Coast Guard command issued the following alert to all units: "Effective this date, a state of war…now existing." *Sea Girt Lighthouse Collection.*

of U.S. Army soldiers. Troops stood watch in the tower and patrolled the beaches looking for enemy aircraft and ships and landed saboteurs, as well as Allied ships in trouble. The beach patrols also enforced curfews and blackouts, which were phased in. Early in the war, Sea Girt's Fresnel lens was still lighted at night. But eventually orders came down from Coast Guard command to extinguish the light.

In the National Archives in Washington, D.C., which holds the U.S. Constitution and countless other historic American documents, are also Sea Girt Light Station's Coast Guard Logs for World War II, containing daily handwritten entries by the commanding officer. The notations record the troop strength and the activity at the station and in the area they patrolled. The entries record the routine as well as the extraordinary, including "ship's fire seven miles east of station." That was the oil tanker RP *Resor*, torpedoed on February 26, 1942. The log entries of July 22, 1942, include:

> *9:00—11:00 a.m.: Drilled crew in use of Thompson submachine gun.*
> *11 a.m.: Received orders from the Commanding Officer to discontinue the operation of the light.*

# SECOND-FLOOR CHILDREN'S BEDROOMS (CONVERTED TO BARRACKS)

The Coast Guard reconfigured the second floor to its needs just as it had the first. The wall between the two children's bedrooms on the north side was removed to create one big room where the enlisted men slept in bunk beds. It is now a meeting room, where many of our displays of bygone Sea Girt hang on the walls.

At the west end of the room are six upholstered chairs around a table. The chairs were found in the lighthouse attic by volunteers during the building's restoration and are believed to have belonged to the first keeper, Abraham Wolf, who married a wealthy widow. Given a keeper's modest salary, Mr. and Mrs. Wolf were likely the only ones at Sea Girt Lighthouse who could have afforded such luxury items.

Atop the tables in the room are binders containing official documents produced or received by Sea Girt's keepers and Coast Guardsmen, spanning more than a half century in peace and in war and then peace again when

the lighthouse was an active station. Available for viewing by visitors, the letters, alerts and other communiqués offer an inside view of the changing mission of the lighthouse and the people who ran it.

On the west wall is the announcement of an 1892 auction of 50- by 150-foot lots in Sea Girt and an accompanying street map identifying the available properties. "Stages in attendance between 2 and 4 o'clock, on day of sale to convey visitors from Sea Girt station to see the lots." An auction the week before saw Sea Girt lots sell for $195.00 to $1,425.00, with the average price realized $442.50.

The Philadelphia land company selling the properties, envisioning a booming city by the sea, asserted, "There is no better site for a large and populous sea-side city on the New Jersey coast. It is the nearest fixed and fertile shore land to Philadelphia. Railroad fares from Philadelphia, Trenton, New Brunswick, etc. to Sea Girt are lower than to any other spot on the Monmouth coast."

Sea Girt in bygone days was actually a busy transportation hub, with Philadelphia trains traveling a spur line through Trenton and Freehold and mainline trains going to and from Manhattan. There was also a trolley that ran between Long Branch and Sea Girt, according to trolley historian Steve Dunham.[255] For alternative transportation, there was horseback riding. People would saddle their horses at the Dubois Stables on Chicago Boulevard, west of Route 71,[256] and ride about town into the 1920s. Still, most people came to Sea Girt for fun and relaxation at the beach. Campers pitched tents in wooded areas by the beach.

And in a tradition going back to the local Indian tribes, Big Sea Day attracted farmers to shore towns for an end-of-summer celebration. The *New York Times* of August 28, 1885, reported:

*A week ago Saturday the beach was crowded by the Monmouth County farmers and their families. They came in vehicles of every sort. The old-time chaise was there, the rockaway, the mill wagon and the hay wagon. In bright calico and gingham the farmers' wives and daughters were dressed, while some of the men wore brass buttoned blue coats that they don only on festal days and on Presidential election day, when they go to the polls to vote for Andrew Jackson. It was "Big Sea Day." Men and women, girls and boys, horses and dogs all came down for a dip in the sea. Bathing houses were improvised in the wagons or under them, and after the bath the clothes were hung out to dry them while the picnickers ate the provender they had brought and had a good time after the fashion that most suited them. "No*

Several blocks west of the lighthouse was the trolley, which ran from Long Branch to Sea Girt. *Donated to Sea Girt Lighthouse Collection by William Joule.*

A mile inland, DuBois Stables (pictured here circa 1926) offered alternate transportation. *Donated to Sea Girt Lighthouse Collection by Mary Height Black.*

Big Sea Day 1896 attracted fun-seekers to the beach in an annual end-of-summer fest. *Courtesy Mark J.H. Hannah.*

*sea folks admitted" was the sign displayed over the door of many Sea Girt hotels; the farmers don't go to the sea to spend money and they are apt to make themselves very at home wherever they are admitted.*

# KEEPER'S BEDROOM

Across the second-floor hallway we enter what had been the keeper's bedroom and, later, the Coast Guard commanding officer's bedroom. It is now known now as the Willetts Room, named for the late Edmund and Virginia Willetts of Spring Lake, who were lighthouse benefactors.

The room holds the rarest artifacts in the collection, including the fourth-order Fresnel lens from Australia that trustees bought on eBay in 2001 after years of unsuccessfully searching for Sea Girt's original lens. This lens was made by Chance Brothers & Co. of Birmingham, England, leading manufacturers of Fresnel lenses. This is a stationary lens with three center

bull's-eye prisms, whereas the original Sea Girt lens had twelve bull's-eye prisms and revolved. Despite these differences, the Australian lens is the same size, order and beehive shape as the original Sea Girt lens, with a similar arrangement of prisms, producing a beam that projected fifteen miles, same as Sea Girt. The Australian lens illuminates a portrait print of the French inventor, a young Augustin-Jean Fresnel.

*Top*: The jewel of the lighthouse collection, the Fresnel lens from Australia, encourages close-up viewing. The principles of refraction and reflection are explained. *Sea Girt Lighthouse Collection*.

*Left*: Julian Meehan, age ten, is the youngest docent at Sea Girt Lighthouse. When not greeting visitors at the front door or helping at the merchandise desk, Julian can often be found at the Fresnel lens display. *Bill Dunn*.

# KEEPERS PHOTO GALLERY

On the south wall is the Keepers Photo Gallery, from which came the keeper portraits found throughout this book. Also on display are candid photos of the keepers and their families that capture them off-duty in relaxed moments.

An intriguing photo shows the second and third keepers, Abram and Harriet Yates, together on the porch, while off by herself at the other end of the porch stands an independent young Lizzie Yates.

The children of keepers pitched in and learned a lot about lighthouse operations and the new technologies, as captured in the photo of Lucy Thomas with her father, George, at a Marconi wireless station on Long Island while he was keeper at Fire Island Lighthouse in World War I. Years later, Lucy's sister Alice would serve as acting keeper at Sea Girt for twenty-four hours while their father was visiting family in Brooklyn. Girls who aspired to be keepers had a role model in Ida Lewis.

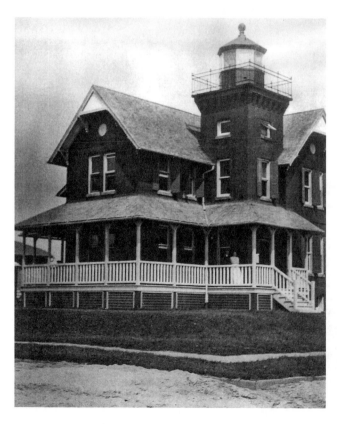

Abram Yates and wife, Harriet, pause on the porch while daughter Lizzie, an independent girl, stands by herself at the far left. *Donated to Sea Girt Lighthouse Collection by Marjorie Yates Irving.*

*Left*: George Thomas and daughter Lucy visit a wireless Marconi station on Fire Island, circa 1918. *Donated to Sea Girt Lighthouse Collection by Lucy Thomas.*

*Below*: Ida Lewis, legendary keeper at Lime Rock Light, Rhode Island, saved many lives and was known as the "bravest woman in America." *Newport Historical Society.*

On the east wall hangs a photo of Ida Lewis next to her official Lighthouse Service obituary. Ida, who died on October 25, 1911, at age sixty-nine, was a celebrated heroine, once called the "bravest woman in America" for her lifesaving exploits.[257] Her father was keeper of the offshore Lime Rock Light in Newport Harbor, Rhode Island, but fell ill in 1857. Her mother took over, and Ida helped her.

An expert rower from rowing to shore for supplies and to deliver her younger siblings to school, Ida was just sixteen when, in 1858, she rowed to the rescue of four young men whose sailboat capsized. Ida assumed ever-greater responsibility for the lighthouse and was running it by 1877, when her mother died, five years after her father passed away.[258]

The obituary credits Ida with thirteen saves; other sources report she saved three times that number. The obituary notes that she saved people "from imminent peril of drowning under circumstances requiring the highest courage and in most cases great exertion and skill." The notice praised her as "an excellent Keeper...a brave and noble woman." John Hawkey, keeper at Sea Girt, would have posted this notice as instructed: "In respect to Ida Lewis this circular will be posted at all light stations for a period of five days after receipt."[259]

# TOWER REENTRY AND UPWARD

And now we go back into the tower on the east side of the second-floor hallway. This is a supply room with closets north and south.

Lamp fuel and other essentials arrived at Sea Girt once or twice a year, delivered by a U.S. Lighthouse Service supply ship. Supplies for Sea Girt were offloaded from the USLHS tender *Tulip* onto a longboat by crewmen, who rowed to shore and delivered the cargo to the redbrick storage building on the west lawn.

On the southeast side of the room are the spiral steps leading to the tower's third-floor landing, known as the watch room, with a window on the east side and another on the west side. Against the watch room's north wall are double doors that open to a supply closet with seven shelves where the keeper stored supplies needed for the Fresnel lens in the room above. This is where the keeper put wicks, replacement parts, tools and cleaning cloths.

USLHS tender *Tulip* drops anchor off Sea Girt, circa 1910. Crewmen rowed to shore with lighthouse supplies. *Sea Girt Lighthouse Collection.*

In the northeast corner of this closet and the closet directly below are several hinged wooden hatches the keeper would open to gain access to the channel and the weight and cable to make adjustments and repairs. At the top of the channel, accessed from the top hatch in this floor's closet, are hooks on which the channel weight was put in the daytime, when the lamp above was turned off and the Fresnel lens was not in use. Putting the weight on the hooks relieved tension on the cable. At dusk, the keeper relighted the lamp and took the weight off the hooks to descend, driving gears to make the lens revolve, creating the pulsing light beam. (This ingenious mechanical system was retired in late 1924, when the tower was electrified.)

# LADDER TO THE TOP

From the sidewalk, there are fifty-one steps to the lantern room at the top of the tower. From the keeper's office on the first floor, there are forty-two steps to the lantern room, including the eight rungs up the ladder from the watch room.

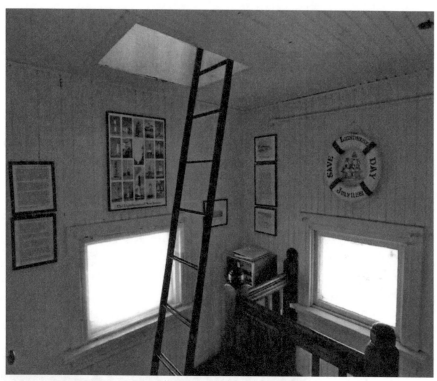

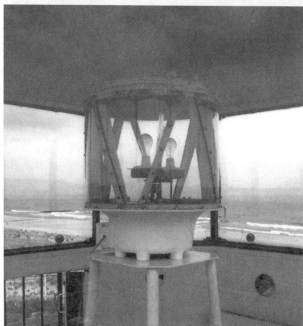

*Above*: The near-vertical ladder from the watch room leads to the lantern room at the top of the tower. *Robert S. Varcoe.*

*Left*: View from the lantern room looking seaward. The Coast Guard lantern sits on the center pedestal. The hatchway (lower left) leads to the gallery. *Bill Dunn.*

At the top of the ladder is a hinged metal trapdoor that, when closed, lies flat on the hatchway to the lantern room. On the first trip of the day, the keeper went halfway up the ladder and then, with the left forearm, pushed the closed trapdoor fully up and kept it in that position by hooking it to the east interior wall. Once that was secured, the keeper climbed through the hatch, pulling him/herself into the lantern room by grabbing the brass bar at the top. When it was time to clean the lens or make repairs, the keeper might be climbing the ladder with one hand holding a tool and the free hand reaching up for the next rung.

The lantern room is octagonal and measures six and a half feet across. The floor is steel. There are eight metal panels that serve as the interior walls. Atop each one is a pane of glass measuring two and three-quarters feet wide and three feet tall. The lantern room has a conical roof with a copper vent, through which the fumes from the lantern escaped.

At the center of the lantern room is where the original revolving fourth-order Fresnel lens sat atop a pedestal from December 1896 to July 1942, when early in World War II the orders came from Coast Guard command to extinguish the lens and remove it. In its place now is the protective glass lantern that was used to surround the light source on a large ocean buoy or a smaller fixed shore light or beacon. On permanent loan from the Coast Guard, the Lighthouse Committee decided to install it as a memorial light in 1983. It is the approximate size of Sea Girt's original Fresnel lens and is turned on at night to give visitors the experience of seeing the tower lighted.

# GALLERY

On the north side of the lantern room beneath the window is a double door that opens onto the gallery—the railed exterior steel walkway surrounding the lantern room. While the lantern room is octagonal, the exterior gallery is square, measuring twelve feet by twelve feet and with enough room to enable one to walk completely around the gallery for a 360-degree view of the water and inland.

The keeper would periodically be on the gallery to assess weather and water conditions and ship traffic, particularly in storms. The keeper was always on the lookout for ships in need of assistance. During World War II, Coast Guardsmen stood watch in the lantern room around the clock in four-

The square gallery surrounding the octagonal lantern room afforded keepers and Coasties unobstructed views of the sea. *Bill Dunn.*

hour shifts. Working in pairs, the men were often out on the gallery, looking for enemy ships and aircraft as well as Allied ships or planes in trouble.

With the lifting of the Coast Guard blackout in September 1944, Sea Girt Lighthouse was again illuminated from dusk until dawn. But it was then an automatic light—an aero-beacon—on top of the lantern room (not inside it) that flashed the beacon. The automatic light, which was moved in 1954 to a newly built skeleton tower on the northeast corner of the property, operated until 1977, when it was extinguished in favor of a more powerful automatic beacon at Manasquan Inlet.

# NOW AND THEN

Today, the Coast Guard is responsible for a few hundred active lighthouses, including New Jersey's Cape May and Sandy Hook. All the Coast Guard lights but one are automated. Only Boston Light, on the site of America's

very first lighthouse, still has a keeper. Lighthouses represent a small fraction of the active lights. Most are automatic light buoys.

Long ago deactivated as an aid to navigation, Sea Girt Lighthouse remains a beacon—to what was. From dusk until dawn, the memorial light illuminates the lantern room for visitors and passersby.

At sunrise, a timer turns off the memorial light. But in daylight, the lighthouse remains what it has been since 1896—a daymark, a distinctive landmark that people on land and at sea look for and recognize.

# PRESERVING HISTORY TOGETHER

Our tour of Sea Girt Lighthouse is complete. But the mission of the volunteers of the Sea Girt Lighthouse Citizens Committee is never ending. We are inspired by our keepers and Coast Guardsmen and strive to be constant and faithful in our mission to preserve the building and its rich history.

We encourage you to be in touch. It's easy. Here's how:

WEBSITE: Check www.seagirtlighthouse.org regularly for the latest news and photos.

E-MAIL: Write us from the contact page (www.seagirtlighthouse.com/contact.aspx).

MAIL: Send a letter to SGLCC, P.O. Box 83, Sea Girt, NJ 08750.

PHONE: Call the lighthouse at (732) 974-0514 and leave a message, which will be promptly returned.

If you haven't visited, please do. Directions are available on our website. We're located at 9 Ocean Avenue, by Beacon Boulevard. You can't miss us. We're the redbrick house facing the beach, with the tower coming out of the roof. If you have visited, why not make a return visit with family and neighbors? We're always adding to our exhibits.

Visitors, volunteers and members are always welcome. Join the fun, meet other lighthouse enthusiasts and experience the thrill and gratification of historic preservation.

We hope to see you soon at the lighthouse.

# NOTES

Numerous books and reports cited can be found online. For example, the *Annual Report of the Light-House Board* and its successor, the Lighthouse Service, can be accessed at the HathiTrust Digital Library (www.hathitrust. org), the Internet Archive (http://archive.org) or simply by using a search engine such as Google. Many Coast Guard and Lighthouse Service documents cited are accessible from the Coast Guard Historian's Office (www.uscg.mil/history). For space considerations, URLs of documents accessible at these sites are not listed below. But URLs of other referenced items are given.

Light-House Board and Lighthouse Service reports and manuals were published by the Government Printing Office (GPO) in Washington, D.C. Original Light-House Board, Lighthouse Service and Coast Guard documents referenced, including official correspondence, are in the Sea Girt Lighthouse Collection unless otherwise noted. When material in the collection has been reproduced at the National Archives and Records Administration, that is indicated with the notation "NARA photocopy in SGL Collection." Minutes of the Sea Girt Lighthouse Citizens Committee are in the lighthouse archives. Minutes of the Sea Girt Borough Council are in the Borough Administrator's Office.

# Chapter 1

1. Jenny Linford, *Lighthouses* (Bath, UK: Parragon Books Ltd., 2006), 6.
2. F. Ross Holland, *Lighthouses* (New York: Barnes & Noble Books, 1997), 8–9.
3. Ibid., 9–10, 14.
4. Thomas J. Hoffman, *Sandy Hook Lighthouse*, undated National Park Service pamphlet, 1–2.
5. Ibid., 2.
6. Al Mitchell, *Historic American Lighthouses* (New York: Barnes & Noble Books, 2003), 21, 25.
7. Robert Browning, "Lighthouse Evolution & Typology," U.S. Coast Guard Historian's Office, last modified January 26, 2012.
8. Ibid.
9. *Acts Passed at the First Session of the Congress of the United States of America: Begun and Held at the City of New-York* (Philadelphia: Francis Childs and John Swaine, 1791), 79–80.
10. New Jersey Lighthouse Society, "Historic Documents Collection." http://www.njlhs.org/historicdocs/letter6211790.htm.
11. George R. Putnam, *Lighthouses and Lightships of the United States* (Boston: Houghton Mifflin Co., 1917), 20, 22.
12. Robert Browning, "Lighthouses Then and Now," USCG Historian's Office, last modified January 26, 2012.
13. Browning, "Lighthouse Evolution & Typology."
14. Putnam, *Lighthouses and Lightships*, 42–44.

# Chapter 2

15. Margaret Thomas Bucholz, *New Jersey Shipwrecks: 350 Years in the Graveyard of the Atlantic* (West Creek, NJ: Down the Shore Publishing, 2004), 32.
16. Hoffman, "Sandy Hook Lighthouse," 1–2.
17. Diane Hackney, "Sandy Hook Light." Entry in "Historic Light Station Information & Photography: New Jersey," USCG Historian's Office, accessed December 9, 2013.
18. Hoffman, "Sandy Hook Lighthouse," 1, 3.
19. New Jersey State Park Service, *Twin Lights: Historic Site*, May 2000 pamphlet, 2.
20. New Jersey Division of Parks and Forestry, *Barnegat Lighthouse State Park*, undated pamphlet.

21. *Annual Report of the Light-House Board of the United States to the Secretary of the Treasury for the Fiscal Year Ended June 30, 1886*, 39.

22. Ibid.

23. *The Reports of the Committees of the House of Representatives for the First Session of the Fiftieth Congress 1887–88*, 161.

24. *Annual Report of the Light-House Board…for the Fiscal Year Ended June 30, 1893*, 76.

## Chapter 3

25. Ibid., 79.

26. *Annual Report of the Light-House Board…for the Fiscal Year Ended June 30, 1894*, 80.

27. *Annual Report of the Light-House Board…for the Fiscal Year Ended June 30, 1895*, 83.

28. *Annual Report of the Light-House Board…for the Fiscal Year Ended June 30, 1896*, 75.

29. Elvin Lake, as recounted at the SGLCC trustees meeting of October 5, 1982, and recorded in the meeting minutes by Elin Jones.

30. Lieutenant Colonel W.A. Jones, U.S. Army Corps of Engineers, signed letter to Light-House Board, April 5, 1898. NARA photocopy in SGL Collection.

31. Timothy R. Dring, e-mail exchange with the author, January 25, 2014.

32. "List of General Correspondence, 1791–1900," file card abstracts of letters received by the Light-House Board. National Archives.

## Chapter 4

33. Thomas Tag, "The Early Development of the Fresnel Lens, Part I," The Keeper's Log, Spring 2005. http://www.uslhs.org/assets/resources/articles/fresnel_lens_1.pdf.

34. Michigan Lighthouse Conservancy, "Fresnel Lenses." http://www.michiganlights.com/fresnel.htm.

35. Bruce Watson, "Science Makes a Better Lighthouse Lens," *Smithsonian*, August 1999. http://www.smithsonianmag.com/science-nature/object_aug99.html.

36. Tag, "Early Development of the Fresnel Lens."

37. Margaret Carlsen, historian at the Twin Lights Historic Site, e-mail exchange with the author, January 21–24, 2014.

38. H. Bamber, "Description of Light-House Tower, Buildings, and Premises," U.S. Army Corps of Engineers report and inventory for Sea Girt Light Station, November 12, 1907, 7. NARA photocopy in SGL Collection.

39. "Recommendation as to Aids of Navigation, Form 70, U.S. Lighthouse Service, May 8, 1912. NARA photocopy in SGL Collection.

40. *United States Coast Pilot: Atlantic Coast. Section C: Sandy Hook to Cape Henry* (Washington, D.C.: GPO, 1916), 42.

## Chapter 5

41. *Compilation of Public Documents and Extracts from Reports and Papers Relating to Light-Houses, Light-Vessels, and Illuminating Apparatus and to Beacons, Buoys and Fog Signals, 1789–1871* (Light-House Board, 1871), 370.

42. "Women & the U.S. Coast Guard: Moments in History," USCG Historian's Office, last modified July 16, 2013.

43. "Women Lighthouse Keepers: Breaking the Barrier: Women Lighthouse Keepers & Other Female Employees of the U.S. Lighthouse Board/Service," USCG Historian's Office, last modified January 26, 1912.

44. *Instructions to Employees of the United States Lighthouse Service*, 1927, 2, 52.

45. Ibid., 11.

46. *Annual Report of the Light-House Board…for the Fiscal Year Ended June 30, 1885*, 12.

47. *Regulations for Uniforms*, 1928, 10.

48. George Worthylake, "The Keeper's New Clothes," The Keeper's Log, Fall 2001, 3, 6. http://www.uslhs.org/assets/resources/articles/keepers_new_clothes.pdf.

49. Personnel records and correspondence of the U.S. Lighthouse Service and Sea Girt keepers. NARA photocopies in SGL Collection.

50. Arnold Burgess Johnson, *Modern Light-House Service* (GPO, 1890), 103. https://archive.org/stream/modernlighthous00boargoog#page/n6/mode/2up.

51. Truman R. Strobridge, "Chronology of Aids to Navigation and the United States Lighthouse Service, 1716–1939," USCG Historian's Office, last modified January 26, 2012.

52. USCG correspondence with keeper George Thomas. In SGL Collection.

## Chapter 6

53. Putnam, *Lighthouses and Lightships*, 51.

54. American Presidency Project, "Executive Order—Civil Service Rules, May 6, 1896." http://www.presidency.ucsb.edu/ws/?pid=70805.

55. *U.S. Light-House Board, Personnel Lists for Absecon, Barnegat, Reedy Island and Sea Girt Light-Stations*. NARA photocopies in SGL Collection.

56. Commander Charles J. Train, U.S. Navy, Fourth Light-House District inspector, signed letter on Light-House Establishment letterhead, September 8, 1896. NARA photocopy in SGL Collection.

57. Ibid.

58. Samuel Penniman Bates, *History of Pennsylvania Volunteers, 1861–65: Prepared in Compliance with Acts of the Legislature*, vol. 5 (Harrisburg, PA: B. Singerly, 1871), 900–01.

59. W. Emerson Wilson, *Fort Delaware in the Civil War* (Delaware City: Fort Delaware Society, 1961).

60. Randolph Abbott Shotwell, *The Papers of Randolph Abbott Shotwell*, vol. 2 (Raleigh: North Carolina Historical Commission, 1931), 159. http://archive.org/stream/ papersofrandolph02shot#page/n7/mode/2up.

61. Ibid.

62. *Personnel List for Reedy Island Light-Station*. NARA photocopies in SGL Collection.

63. Decennial Census 1900, Schedule No. 1—Population, Enumerator District No. 140, Sheet No. 13, Lines 14–16, p. 106.

64. *Personnel List for Reedy Island Light-Station*. NARA photocopies in SGL Collection.

65. *Personnel Lists for Absecon and Reedy Island Light-Stations*. NARA photocopies in SGL Collection.

66. *Personnel List for Absecon Light-Station*. NARA photocopies in SGL Collection.

67. Abraham Wolf, two signed letters, July 8 and 9, 1874; Lighthouse Inspector G.B. White, two signed letters, July 9 and 10, 1874. NARA photocopies in SGL Collection.

68. Death certificate of Kate Walker Bonner Wolf, July 29, 1888, Atlantic City, NJ.

69. *Personnel List for Barnegat Light-Station*. NARA photocopies in SGL Collection.

70. *Annual Report of the Light-House Board…for the Fiscal Year Ended June 30, 1897*, 13.

71. Affidavit of Applicant for Marriage License, signed by Abraham G. Wolf and Lidie H. Reiter, certified and issued May 3, 1897, by the clerk of the Orphans' Court, Philadelphia.

72. Application for an Invalid Pension, under the Act of June 27, 1890, by Abraham G. Wolf, submitted June 6, 1898, and rejected July 15, 1898. NARA photocopy in the SGL Collection.

73. *Annual Report of the Light-House Board…for the Fiscal Year Ended June 30, 1900*, 85.

74. Decennial Census 1900, Schedule No. 1—Population, Enumerator District No. 140, Sheet No. 13, Lines 14–16, p. 106.

75. "Wolf, A.G. Keeper, Sea Girt L.S., N.J. Resigned Sept. 30, 1902," abstract (1220) of resignation letter. NARA photocopy in the SGL Collection.

76. Abraham Wolf, Invalid Pension, under the Act of June 27, 1890, submitted November 17, 1902. NARA photocopy in SGL Collection.

77. Decennial Census 1910, p. 10A, Enumeration District 0116, Wall, Monmouth, New Jersey. (Note: While the name is recorded as Eliza Wolfe, the entry is almost certainly for Mrs. Wolf because of birth year and place, marital status and residence. It was not uncommon for enumerators to misspell names.)

78. BPO Elks National Home Medical Record for Abraham G. Wolf, November 2, 1906, Bedford City, Virginia.

79. Decennial Census 1910, Schedule No. 1—Population, Enumerator District No. 465, Pittsburgh City, Sheet No. 6, Line 90.

80. Certificate of Death, Commonwealth of Virginia, State Board of Health, Division of Vital Statistics, December 9, 1912. Certified copy issued March 25, 2003. In SGL Collection.

81. Declaration for Widow's Pension, as completed by Eliza H. Reiter Wolf, October 2, 1916. NARA photocopy in SGL Collection.

82. Certificate of marriage between Abram Lewis Yates and Harriet Wood Yates, October 13, 1880. In SGL Collection.

83. New Jersey Lighthouse Society, "Egg Island Point Lighthouse—Mouth of Maurice River." http://www.njlhs.org/njlight/eggisland.html.

84. Marjorie Yates Irving, "Abram Lewis Yates: 31 Years in the United Lighthouse Service," unpublished typewritten manuscript, 1–2. In SGL Collection.

85. Strobridge, "Chronology of Aids to Navigation."

86. *Annual Report of the Light-House Board...for the Fiscal Year Ended June 30, 1904*, 65.

87. Keeper's entry in Light-Station Journal, May 25, 1905. In SGL Collection.

88. *Annual Report of the Light-House Board...for the Fiscal Year Ended June 30, 1906*, 60.

89. *Annual Report of the Light-House Board...for the Fiscal Year Ended June 30, 1907*, 65.

90. Bamber, "Description of Light-House Tower, Buildings, and Premises," 4, 16.

91. Irving, "Abram Lewis Yates," 1.

92. Commander H.A. Bispham, U.S. Navy, Fourth Lighthouse District inspector, typed letter signed to the Light-House Board, June 7, 1910. NARA photocopy in SGL Collection.

93. *Asbury Park Evening Press*, "Woman Wants to Keep Light House: Petition of Mrs. A.L. Yates of Sea Girt Signed by Many Prominent Persons," June 9, 1910.

94. Bispham, typed letter signed to the Light-House Board, June 9, 1910. NARA photocopy in SGL Collection.

95. *Asbury Park Evening Press*, "Regulations Bar Her as Keeper of Sea Girt," June 11, 1910.

96. Arthur L. Yates, typed and signed letter, November 26, 1917. Photocopy in SGL Collection.

97. Irving, "Abram Lewis Yates," 1–2.

## Chapter 7

98. Putnam, *Lighthouses and Lightships*, 46–48.

99. Captain Jean Butler, "George Putnam: Pioneer Commissioner of the Lighthouse Service," *Coast Guard*, March 2005, 38–39.

100. Ibid.

101. *New York Times*, "Lonely Life of Lightship Sailors," November 22, 1903.

102. Decennial Census 1900, Schedule No. 1—Population, Enumerator District No. 109, Sheet No. 17, Lines 34–36, p. 106.

103. J. Parsons Smith, Office of the Inspector of the Fourth Light-House District, typed letter to keeper John L. Hawkey signed on Light-House Establishment letterhead, September 2, 1910. In SGL Collection.

104. "Recommendation as to Aids of Navigation" (USLHS Form 70), May 8, 1912. NARA photocopy in SGL Collection.

105. J.T. Yates, superintendent of the Fourth Lighthouse District, typed letter signed on Lighthouse Service letterhead, June 11, 1912. In SGL Collection.

106. Ibid., September 13, 1912.

107. Elvin Lake, as recounted at the SGLCC trustees meeting of October 5, 1982, and recorded in the meeting minutes by Elin Jones.

108. *Reports of the Department of Commerce and Labor 1912*, 551.

109. George Weiss, *The Lighthouse Service: Its History, Activities and Organization* (Baltimore, MD: Johns Hopkins University Press, 1926), 22.

110. Hopkins, typed letter signed on Lighthouse Service letterhead, January 6, 1914. In SGL Collection.

111. J.T. Yates, "Recommendations for Repairing" (USLHS Form 80), Sea Girt Light Station and repair projects typed in, July 14, 1914, with typed approval, dated July 16 and initialed by two individuals in the Commissioner's Office, Washington, D.C. NARA photocopy in SGL Collection.

112. J.T. Yates, typed letter signed on Lighthouse Service letterhead and headed "Returned to Commissioner," March 27, 1915. NARA photocopy in the SGL Collection.

113. Ibid.

114. H.B. Bowerman, chief construction engineer, typewritten letter to lighthouse commissioner signed on Bureau of Lighthouses letterhead, March 31, 1915. NARA photocopy in the SGL Collection.

115. Putnam, *Annual Report of the Commissioner of Lighthouses to the Secretary of Commerce for the Fiscal Year Ended June 30, 1915*, 92.

116. Decennial Census 1930, Schedule No. 1—Population, Enumerator District No. 109, Sheet No. 17, Lines 34–36, p. 106.

117. "Building Patents: 274,765, Automatically-Operating Door—John L. Hawkey, Cape May, N.J.," *American Architect & Building News* 13, no. 380 (April 7, 1883): 167. http://archive.org/stream/americanarchitec13newyuoft#page/n5/mode/2up.

118. Weiss, *Lighthouse Service*, 25–27.

119. *Asbury Park Sunday Press*, "How Sea Girt Light Guards Shipping," December 6, 1931.

120. Ibid.

121. Jack Little, "Bill Lake Broke Seven-Year Jinx as Keeper of Sea Girt Lighthouse," *South Monmouth News*, September 28, 1950.

122. Ibid.

123. Putnam, *Radiobeacons and Radiobeacon Navigation*, 35.

124. *Annual Report of the Commissioner of Lighthouses to the Secretary of Commerce for the Fiscal Year Ended June 30, 1921*, 26.

125. J.T. Yates, "Recommendation as to Aids to Navigation" (USLHS Form 80), typed entries, November 1, 1924. NARA photocopy in SGL Collection.

126. Little, "Bill Lake Broke Seven-Year Jinx."

127. "Shore Liberty or Leave of Absence of Keepers: Request" (USLHS Form 76), completed in ink by William Lake, July 8, 1929; typed response on the same form by J.T. Yates, July 10, 1929. In SGL Collection.

128. Cecil F. Butler, *The Sea Girt History* (Freehold, NJ: Transcript Printing House, 1926), 27.

129. Captain W.S. Crosley, head of the U.S. Navy's Hydrographic Office, typed letter signed on Hydrographic Office letterhead, February 26, 1926. NARA photocopy in the SGL Collection.

130. "Morris Family Papers, 1875–1968: Description of the Collection," Collection 31, Library & Archives Collection, Monmouth County Historical Association. http://www.monmouthhistory.org/Sections-read-45.html.

131. *Asbury Park Press*, obituary, July 12, 1951, 2.

## Chapter 8

132. National Park Service, "Lighthouses: An Administrative History." http://www.nps.gov/maritime/light/admin.htm.

133. Browning, "Lighthouse Evolution & Typology."

134. United States Lighthouse Society, "Lighthouse Facts." http://www.uslhs.org/resources_materials.php.

135. *Twenty-Fourth Annual Report of the Secretary of Commerce 1936*, 109.

136. National Park Service, "Lighthouses: An Administrative History."

137. George Thomas and family genealogy and notes by daughter Alice May Thomas McKenzie; digitized copy in the collection of Angelica Thomas Wallace, grandniece of George Thomas.

138. Ibid.

139. Untitled, handwritten chart of U.S. Lighthouse Service assignments of George Thomas, 1906–31 (likely written by Thomas himself). Photocopy in SGL Collection.

140. District Circular No. 203, Keepers and Assistant Keepers, notice of commendations, Office of the District Lighthouse Inspector, January 21, 1918.

141. Weiss, *Lighthouse Service*, 24–27.

142. Untitled, handwritten chart of Thomas assignments, 1906–31.

143. Alice May Thomas (McKenzie), daughter of keeper George Thomas, untitled and unpublished typewritten manuscript of reminiscences of family life at Shinnecock Lighthouse, 1. In SGL Collection.

144. J.T. Yates, typed letter signed on USLHS letterhead and addressed to Thomas, May 23, 1919. NARA photocopy in SGL Collection.

145. Clifford Hasting, chief of Appointment Division, Commerce Department. General Appointment form on which are typed the particulars of George Thomas's appointment, May 27, 1919, signed by Hasting. NARA photocopy in SGL Collection.

146. Alice Thomas, untitled and unpublished Shinnecock manuscript, 1–2.

147. Ibid., 1–3.

148. Ibid., 1–6

149. George Thomas and J.T. Yates, exchange of handwritten letters regarding Thomas's transfer from Shinnecock, 1931. NARA photocopies in SGL Collection.

150. Ibid.

151. George Thomas, handwritten letter in ink, signed on USLHS letterhead, December 5, 1931. In SGL Collection.

152. Ibid., handwritten notes in pencil on lined paper, undated and unsigned. In SGL Collection.

153. Ibid., draft letter in pencil on lined paper, undated and unsigned, "in reply to your letter of the 23rd" regarding completion of repairs. In SGL Collection.

154. J.T. Yates, collection of four original typed letters signed by Yates and one photocopy of specifications by the assistant lighthouse superintendent. In SGL Collection.

155. Putnam, typed, unsigned letter on top half of a sheet of Bureau of Lighthouses letterhead to Superintendent J.T. Yates, June 24, 1932. NARA photocopy in SGL Collection.

156. J.T. Yates, typed response signed on the bottom half of the aforementioned Putnam letter, June 27, 1932.

157. Ibid.

158. Brian Hicks, *When the Dancing Stopped: The Real Story of the* Morro Castle *Disaster and Its Deadly Wake* (New York: Free Press, 2006), 74–75, 88–89, 99, 103, 109–10, 114–16, 123.

159. Ibid., 109–10, 115.

160. Gretchen F. Coyle and Deborah C. Whitcraft, *Inferno at Sea: Stories of Death and Survival Aboard the* Morro Castle (West Creek, NJ: Down the Shore Publishing, 2012), 8, 65, 128.

161. Hicks, *When the Dancing Stopped*, 137–40, 147–51.

162. Sea Girt Lighthouse website, "Fateful, Final Cruise of the Morro Castle: Shore Tragedy, Inspiring Rescue Remembered." http://www.seagirtlighthouse.com/page/The-Morro-Castle.aspx.

163. Coyle and Whitcraft, *Inferno at Sea*, 141.

164. *U.S. Coast Pilot: Atlantic Coast. Section C*, 31.

165. Announcement of winners of Efficiency Stars, October 9, 1937, issued by J.T. Yates. In SGL Collection.

166. "Shore Liberty or Leave of Absence of Keepers: Request" (USLHS Form 76), completed in ink by keeper George Thomas, March 27, 1936; typed response by J.T. Yates, March 28, 1936. In SGL Collection.

167. J.T. Yates, superintendent of the Fourth Lighthouse District, USLHS HR leave form, April 27, 1939, with George Thomas's name, title, station and accrued annual leave typed in. In SGL Collection.

168. "Shore Liberty or Leave of Absence of Keepers: Request" (USLHS Form 76), completed in ink by keeper George Thomas, April 28, 1939; typed response by J.T. Yates, May 9 1939. In SGL Collection.

## *Chapter 9*

169. *Annual Report of the Secretary of the Treasury on the State of the Finances for the Fiscal Year Ended June 30, 1939*, 107.

170. Ibid.

171. Ray Jones, *The Lighthouse Encyclopedia: The Definitive Reference* (Guilford, CT: Globe Pequot Press, 2004), 44–45.

172. George Thomas and J.T. Yates, correspondence regarding Coast Guard enlistment, including: Thomas handwritten-undated draft letter of inquiry, typed

letter signed by Yates, dated September 25, 1939 requesting Personal History Statement, and typed letter signed by Yates assistant W. J. Lawton, November 5, 1939. In SGL Collection.

173. Presidential Proclamation No. 2352. (USCG Intelligence Office, June 2, 1941, Circular No. 87). In SGL Collection.

174. P.E. Shaw, typed letter signed to George Thomas on USCG letterhead, October 16, 1940. NARA photocopy in SGL Collection.

175. Ibid., typed letter signed on USCG letterhead, regarding Thomas disability retirement, November 6, 1940. NARA photocopy in SGL Collection.

176. Surfman Thurlow Jester, handwritten letter signed on the letterhead of the disbanded Lighthouse Service to USCG commander, New York District, November 30, 1940; "Monthly Report of Light Station, Depot, or Lightship" (USCG Form 65), completed and signed by Jester, December 1, 1940. NARA photocopy in SGL Collection.

177. P.E. Shaw, typed letter signed on USCG letterhead, March 28, 1941. NARA photocopy in SGL Collection.

178. *Asbury Park Press*, George Thomas obituary, January 28, 1963.

179. Linda Peloquin, e-mail exchange with the author, February 11, 2014; *Asbury Park Press*, obituary of Lucy Caroline Thomas, November 11, 1993.

180. Angelica Thomas Wallace, e-mail exchange with the author regarding research by her brother, W. Benjamin Thomas, on Alice Thomas's military service, February 8, 2014.

181. Peloquin, e-mail, February 11, 2014.

182. *The Coast Guard at War: Aids to Navigation*, vol. 15 (Washington, D.C.: USCG Historian's Office, July 1, 1949), 10.

183. Ibid.

184. Ibid., 22.

185. USCG Log: Sea Girt Light-Station, notes for 11:00 a.m. under "Miscellaneous Events of the Day," July 22, 1942. Photographed at NARA, in SGL Collection.

186. Commander S.S. Bunting, U.S. Navy, "Eastern Sea Frontier: Enemy Action Diary, February 27, 1942." http://www.uboatarchive.net/ESFWarDiaryFeb42APP4.htm.

187. USCG Log: Sea Girt Station, notes for 12:40 a.m. under "Miscellaneous Events of the Day," February 27, 1942. Photographed at NARA, in SGL Collection.

188. Dring, e-mail exchange with the author, April 24, 2013.

189. Robert J. Cressman, Official Chronology of the U.S. Navy in World War II, "Chapter IV: 1942: February." http://www.ibiblio.org/hyperwar/USN/USN-Chron/USN-Chron-1942.html.

190. USCG Log: Sea Girt Station, notes for 11:00 a.m. under "Miscellaneous Events of the Day," July 22, 1942. Photographed at NARA, in SGL Collection.

191. Excerpt from a three-page typed manuscript, June 21, 1975. The author is unknown, but the manuscript is believed to have been a speech delivered by Mayor Tom Black.

192. Donald Ferry, phone conversation with the author, April 7, 2013.

193. Ibid.

194. USCG Log: Sea Girt Station, notes for 1:00 p.m. to 3:00 p.m. under "Miscellaneous Events of the Day," January 18, 1943. Photographed at NARA, in SGL Collection.

195. Dring, e-mail exchange with the author, May 10, 2013.

196. USCG Log: Sea Girt Station, notes for 12:30 p.m. to 3:30 p.m. under "Miscellaneous Events of the Day," June 16, 1943. Photographed at NARA, in SGL Collection.

197. Dring, e-mail exchange with the author, July 19, 2013.

198. Ferry, phone conversation with the author, April 7, 2013.

199. Dring, e-mail exchange with the author, April 25, 2013.

200. Dennis L. Noble, *The Beach Patrol and Corsair Fleet: The U.S. Coast Guard in World War II* (Washington, D.C.: USCG Historian's Office, 1992).

201. *Coast Guard at War*, 10.

202. USCG Log: Sea Girt Station, notes for 4:00 p.m. to 12:00 a.m. under "Miscellaneous Events of the Day," September 23, 1944. Photographed at NARA, in SGL Collection.

203. Dring, e-mail exchange with the author, September 11, 2013.

204. Ibid.

205. Henry Wapelhorst, phone conversation with the author, October 2, 2013, as well as numerous previous conversations.

206. Ibid.

207. Ibid.

208. True copy of the resolution unanimously adopted by Sea Girt Borough Council on April 12, 1955, certified by Agnes M. Purcell, clerk.

## Chapter 10

209. Walter F. Downey, typed letter signed on General Services Administration letterhead, March 23, 1956.

210. Biennial Report on Sea Girt Light Station, Sea Girt, New Jersey, August 10, 1958, 1.

211. Peg Krauss, phone interview with the author, July 29, 2013.

212. Anita Rafter Riley, interview with the author, July 28, 2013.

213. Biennial Report on Sea Girt Light Station, Sea Girt, New Jersey, August 10, 1958, 2.
214. Sea Girt Council Meeting Minutes, April 9, 1963, vol. 26, 11–12.
215. Bruce Beckmann, conversations with the author, July–August 2013.
216. Joseph G. Bilby, *Sea Girt, New Jersey: A Brief History* (Charleston, SC: The History Press, 2008), 104–05.
217. Sea Girt Council Meeting Minutes, September 1967, vol. 29.
218. Ibid., April 8, 1969, vol. 30, 42–43.
219. *Evening News*, "End of an Era," May 25, 1971.
220. Joseph G. Bilby, "Sea Girt: New Jersey's Summer Capital," *Garden State Legacy* 8 (June 2010), 1–5. http://gardenstatelegacy.com/files/Sea_Girt_NJs_Summer_Capital_Bilby_PRINT_GSL8.pdf.
221. Ibid.
222. Sea Girt Council Meeting Minutes, July 25, 1972, vol. 32, 74.
223. Ibid., November 27, 1972, vol. 32, 122.
224. Ibid., March 20, 1973, vol. 32, 186.
225. Karen DeMasters, "Sea Girt Has Changed Little During 100-Year History," *Asbury Park Press*, June 21, 1975.
226. Sea Girt Council Meeting Minutes, October 14, 1980, vol. 36, 376.
227. Ibid., October 28, 1980, vol. 36, 378–79.

## Chapter 11

228. Sea Girt Council Meeting Minutes, November 25, 1980, vol. 36, 394.
229. Sea Girt Lighthouse Citizens Committee Inc., Board of Trustees Meeting Minutes, April 1, 1981, 1–2.
230. Elin Jones, carbon copy of typed letter to Mayor Thomas Black and Sea Girt Borough Council, April 20, 1981. Attachment to SGLCC April 20 board minutes.
231. Lease agreement between Borough of Sea Girt and the Sea Girt Lighthouse Citizens Committee Inc., August 30, 1981.
232. Ford Farewell Mills & Gatsch Architects and Integrated Conservation Resources, "Exterior Condition Analysis for the Sea Girt Lighthouse," August 1998, I-1, Appendix I, Introduction.
233. Sea Girt Lighthouse Citizens Committee Inc., Board of Trustees Meeting Minutes, September 14, 1982, 3.
234. Dring, e-mail exchange with the author, September 11 and 17, 2013.

## Chapter 12

235. Krauss, phone conversation with the author, July 29, 2013.

236. Sea Girt Council Meeting Minutes, April 24, 1990, vol. 41, 16.

237. Extension and Modification of Lease Agreement between the Borough of Sea Girt and the Sea Girt Lighthouse Citizens Committee Inc., signed by Mayor William M. MacInnes and SGLCC president William J. Binnie, August 1990.

238. Robert L. Doremus, CPA, Statement of Assets, Liabilities and Fund Balance of the Sea Girt Lighthouse Citizens Committee Inc. as of April 30, 1991. Notes to Financial Statements, Section I: Summary of Significant Accounting Policies: Building Restoration and Preservation.

239. Ibid., Revenues and Expenses and Changes in Fund Balance, April 30, 1991 and 1990.

240. Ford Farewell Mills & Gatsch Architects and Integrated Conservation Resources, "Exterior Conditions Analysis for the Sea Girt Lighthouse," I-1, II-2-3, III-4, Figures 7–8, 10.

241. Dring, e-mail exchange with the author, January 25, 2014.

242. Thomas J. Werner, typed letters signed on letterhead of Duall Building Restoration Incorporated, July 28, November 10 and December 14, 1998, with handwritten marginal notes by Douglas Bohrer, SGLCC president, on the July 28 letter.

243. Brian O'Keefe, "Council Appropriates Extra $150,000 for Pavilion Project," *Coast Star*, August 10, 2006.

244. Wreck Pond Brook Watershed Regional Stormwater Management Plan, "Book 1: Watershed Characterization." http://www.nj.gov/dep/wreckpond/docs/wreck_pond_brook_regional_stormwater_management_plan.pdf.

245. Dan Radel, "Six Sluice Gates to be Installed at Wreck Pond," *Asbury Park Press*, December 20, 2013.

## Chapter 13

246. Ed Colimore, "Lighthouse Still Telling the Tales of Sea Girt," *Philadelphia Inquirer*, August 7, 2013. http://www.philly.com/philly/news/new_jersey/20130807_Lighthouse_still_telling_the_tales_of_Sea_Girt.html.

247. *Coast Star*, "Benefactor Issues Memorial Challenge in Lighthouse Membership Drive, Lighthouse Committee Also Hosts Annual Meeting," May 23, 2013.

## *Chapter 14*

248. Dorothy Holthusen, comments to the author, September 8, 2004, at the seventieth anniversary Morro Castle memorial program at Sea Girt Lighthouse.

249. Shannon Mullen, "A Piece of Shore History Being Brought Back to Life," *Asbury Park Press,* July 4, 2007.

250. Grover Donnelly, phone conversation with the author, July 6, 2007.

251. Shannon Mullen, "Sea Girt Welcomes Another Piece of History," *Asbury Park Press,* July 12, 2007.

252. William Sciarappa, Monmouth County agricultural agent, Rutgers Cooperative Research & Extension, typed letter signed and dated July 19, 2007.

253. Katherine Francis, "Morro Castle Lifejacket: Conservation Treatment 2006–2007," CD.

254. Dring, "The U.S. Life-Saving Service: New Jersey Origins of the Coast Guard's Predecessor," May 21, 2013.

255. Steve Dunham, "Coast Cities Railway Co. Historical Pictures," Steve Dunham's Trains of Thought. http://www.stevedunham.50megs.com/Coast_Cities/coast_cities.html.

256. Robert McKelvey, interview with the author, September 19, 2013.

257. "Idawalley Zorada Lewis (-Wilson), Keeper, USLHS," USCG Historian's Office, last modified January 26, 2012. http://www.uscg.mil/history/people/IdaLewis.asp.

258. Mary Louise Clifford and J. Candace Clifford. *Women Who Kept the Lights: An Illustrated History of Female Lighthouse Keepers* (Alexandria, VA: Cypress Communications, 1993), 90–98.

259. Commander C.D. Stearns, U.S. Navy, Tenth Lighthouse District inspector, undated and untitled circular announcing Ida Lewis's death in 1911.

# INDEX

# ABOUT THE AUTHOR

Bill Dunn, a Sea Girt Lighthouse Citizens Committee trustee, is also a docent and the lighthouse historian. His association with the lighthouse goes back to his childhood, when it was the recreation center. Bill, who was a reporter at the *Detroit News* and, later, *USA Today*, has written several previous books.

*Photo by Christine H. Dunn.*

*Visit us at*
www.historypress.net
..................................................

*This title is also available as an e-book*